HISTORY & TECHNIQUES OF THE
Great Masters

MONET

HISTORY & TECHNIQUES OF THE

Great Masters

MONET

Trewin Copplestone

CHARTWELL
BOOKS, INC.

A QUANTUM BOOK

Published by Chartwell Books
A Division of Book Sales Inc.
114 Northfield Avenue
Edison, New Jersey 08837
USA

ISBN 0-7858-1642-9

QUM2MON

This book is produced by
Quantum Publishing Ltd.
6 Blundell Street
London N7 9BH

Printed in China by Leefung-Asco Printers Ltd.

CONTENTS

INTRODUCTION
— 6 —

CHRONOLOGY
— 16 —

THE PAINTINGS

WOMEN IN THE GARDEN
— 18 —

BATHING AT LA GRENOUILLERE
— 22 —

IMPRESSION, SUNRISE
— 26 —

AUTUMN AT ARGENTEUIL
— 30 —

THE GARE SAINT-LAZARE
— 34 —

BOATS AT ETRETAT
— 38 —

GRAIN STACKS, END OF SUMMER
— 44 —

POPLARS ON THE BANKS OF THE EPTE
— 48 —

ROUEN CATHEDRAL:
HARMONY IN BLUE AND GOLD
— 52 —

MORNING WITH WILLOWS
— 56 —

INDEX
— 62 —

ACKNOWLEDGEMENTS
— 64 —

INTRODUCTION

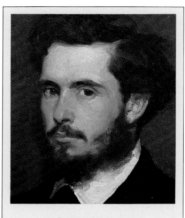

CAROLUS-DURAN
Portrait of Claude Monet
1867
Musée Marmottan, Paris

Monet's paintings carry a peculiar magic. They are ordinary enough in subject matter, consisting almost exclusively of basically direct treatments of landscape — figures rarely appear, and after 1890 not at all. The paintings have little obvious drama or planned appeal to the emotions, and they make no kind of political or social statement. Nevertheless they evoke a constant delight from most viewers, and this very delight in many ways obscures Monet's really extraordinary achievement. It could be claimed that Monet, more than any of the Impressionists, opened the path to a new understanding of the nature of painting.

At first sight Monet appears as an uncomplicated, non-intellectual painter, constantly excited by the world around him, drawing his subjects from nothing more ambitious than his local countryside, and dedicated to exploring the effects of light on the natural landscape. We think of him as a simple, direct person leading a quiet life and blessed with an equable temperament, unbeset by any of the tensions and anxieties that afflicted painters such as Van Gogh and Gauguin. He seems to personify, not just the "happy painter" but also the nature of the Impressionist movement itself, and indeed it was one of his paintings, *Impression, Sunrise* (see page 27), exhibited at the First Impressionist Exhibition in 1874, that gave the movement its name. (The word "impressionist" was in fact intended as a derisory comment, but was taken by most of the group as an acceptable description of its aims.)

In fact Monet's main characteristics were determination and single-mindedness, and his nature was much more complex than his paintings would lead us to believe. His life was a constant struggle with what he saw as insoluble technical problems, and he was frequently so dissatisfied with his work that he would not allow it to be taken from the studio. In his home life he was an autocrat, demanding total punctuality from both his family and his servants. With his friends he was more relaxed, and he enjoyed parties and the café life that was such an important part of the Parisian artistic scene. Although a Parisian from commercial necessity, he always loved the countryside, which he treasured for its infinite variety as well as for the solitude it offered. The landscape, and particularly the sea coast and water, was his passion throughout his life.

But passion is not really the word that provides the key to either the Impressionist movement as a whole or to Monet in particular. Perhaps the most significant thread running through the movement and unifying its varied strands is a concern with vision rather than with emotion or social statement. When Degas painted his laundresses he was not concerned, as Dickens would have been, with the sweatshop conditions in which they worked, but with colors and the effects of light on sharply pressed, clean fabrics. Similarly, it would be unwise to assume that because Monet painted the façade of Rouen Cathedral many times it was because of any strong attachment to the faith it embodied.

Despite the absence of dramatic, emotional and social involvement on the part of its central figures, the Impressionist movement initiated a great artistic revolution, and one that has had a lasting effect, not only on artists, but also on the art-aware public. It changed all the ideas of what constitutes a painting, distinguishing, in effect, between a "picture" and a "painting." Any appreciation of what the movement achieved hinges on an understanding of Monet's own achievement; he was its pivot and its center, and his long life documents its development and evolution well into our own century.

Monet's intention, developed over his entire painting career, was to paint what he saw. This may seem to us a straightforward, even commonplace ambition, but it is important to realize that it was far from being a universal preoccupation of artists of the past, nor is it often a primary concern of artists today. In Monet's own time the well-known academic painters were concerned, not

with painting what they saw, but with producing highly finished, often idealized works with a social or religious message, and it was the Impressionists' emphasis on vision that not only distinguished them but gave rise to the hostility and ridicule that greeted their first public appearance.

The simple presentation of landscape or still life was regarded in the nineteenth century as an inferior, if attractive, form of painting, although the beginnings of a change could be discerned with such painters as Constable and Turner in England and the Barbizon school of painters in France. However, even though these painters exerted a considerable influence on the Impressionists they were less concerned with color and light than with tone and form; even Eugène Boudin, Monet's first mentor, built his open-air paintings on a tonal base, seeing his forms in terms of light and dark rather than of color. The Impressionsts, on the other hand, saw the whole of nature in terms of color and light: color was everywhere, even in the deepest shadows, which traditionally had been rendered simply as dark brown or gray. This preoccupation with color made their paintings quite startlingly different from any that had gone before, and no one was more determined in the pursuit of color than Monet himself.

The struggle to record nature

Monet came up against one essential problem presented by the observation of nature: the constant changes caused both by an ever-moving light source and by the movement of the forms themselves — clouds, trees, grasses and water were perpetually in flux. What he saw never stayed the same long enough for the painting of it. For an artist dedicated to painting what he saw the challenge was relentless, and the problem ultimately insoluble.

Thus Monet's apparently commonplace ambition was actually a much greater task than it seems, and it caused him both mental anguish and physical exhaus-

CLAUDE MONET
Regatta at Argenteuil
1872, Musée d'Orsay, Paris

Monet's painting during his settled life at Argenteuil has a particular joy, freshness and visual delight, reflecting his pleasure in the small town and surrounding country, especially the river. This painting, a small *esquisse*, or preliminary sketch, is constructed of broad directional, form-following brushstrokes creating the impression of sunlight with great immediacy. The luminosity of color and the flat patterning both show the influence of Japanese prints, of which Monet owned many at this time. The painting was almost certainly bought by his friend Gustave Caillebotte, a rich collector and painter who exhibited in the Impressionist Group Exhibitions.

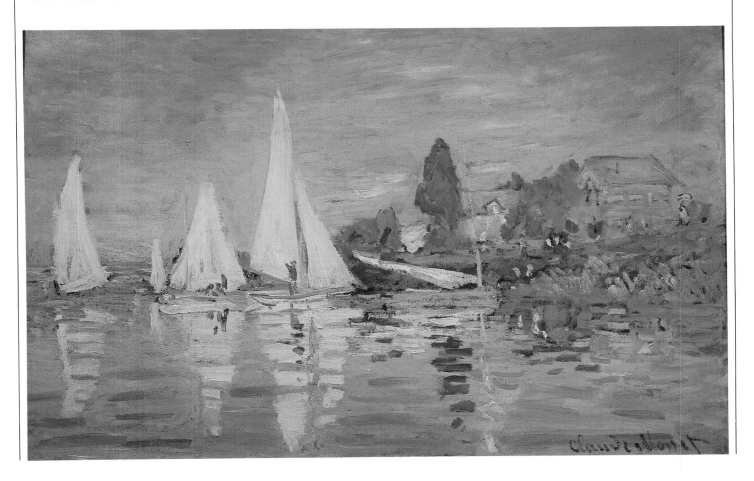

tion. Also, however, it transformed his paintings from the hard, Japanese-print-like shapes of his early works such as *Women in a Garden* (see page 19) to the evanescent, ethereal images of the water gardens in the late *Nymphéas* (*Waterlilies*) panels (see page 57).

As his studies and experiments advanced, Monet perceived a further, even more daunting complication. In consciously attempting to paint what he saw, he was actually seeing himself observing the changes of light, and thus was chasing not what he had seen but what he himself had retained of what he had seen. He could never catch up with himself.

But during the process he unconsciously made the most far-reaching discovery of all. His vision, which permitted him only to translate a sensation of color to the canvas, was not spatial but flat, but in spite of this a spatial element did appear on the canvas. By the time he had begun work on the *Waterlilies* paintings the problem had been compounded by the surface of the water he was painting, which was both visually present and transparent. So where was the canvas surface — under the water, on its surface, or in the air space in between?

Monet's painting from 1872, when he settled at Argenteuil (near Paris on the banks of the Seine) onwards, could be seen as the presentation of the direct sketch from nature as the finished work. From this period until his death his basic method was established. Although in his later paintings representationalism and the clear delination of volume became less important, he continued the brush and paint application he had learned when painting with Renoir, Pissarro and other artist friends. Energetic and varied, his technique

CLAUDE MONET
The Bank at Gennevilliers
About 1870, Private collection

Gennevilliers was a small town on the opposite side of the river from Argenteuil, the two being linked by a bridge.

This small sketch, almost certainly done rapidly on the spot, presages the bold brushwork of *Rue Montorgeuil* (opposite), particularly in the treatment of the path, though this was painted at a much earlier date.

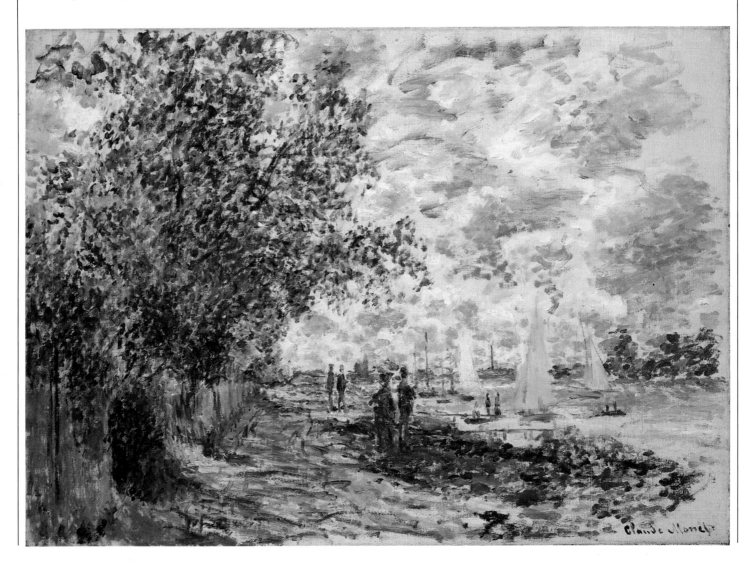

ranged from heavy impastos built up in short, jabbed strokes to long, thick "drawn" brushstrokes. His color was broken into small, fluttering areas where dense foliage was being described, or tense, long, thin or broad strokes where water or sky was treated. He was not a technician by temperament, but his painting methods were marvelously appropriate to his needs.

The artist's early life

Monet's early life was beset by the usual lack of recognition and attendant financial problems, but unlike Van Gogh he did not remain unrecognized, and was relatively affluent when he died in 1926. Although his early life had been disrupted by the great social and political upheavals of late nineteenth-century France, he played little part in them. Throughout the First World War he remained in his house at Giverny, and the great artistic movements of the early twentieth century, Fauvism, Cubism, Futurism and Surrealism, completely passed him by; when Monet died, Picasso was forty-five and already famous.

Claude Monet was born in 1840, the son of a successful wholesale grocer in Paris who moved with his family to Le Havre when Claude was five. He grew up there and was conscripted into the army in 1861, being sent to Algeria but invalided out the following year.

He had already begun to paint before his conscription, and was introduced to open-air painting by the seascape painter Eugène Boudin, whose canvases have a fresh directness, with great luminous sweeps of sky. At the same time he met the Dutch landscape painter J.B. Jongkind, and it was not long before he decided that he wished to become a professional painter. His father somewhat reluctantly agreed to support him provided he studied in the *atelier* of a reputable academic artist in Paris, and accordingly he joined Charles Gleyre's academy in 1862. Some academics gave little or no attention to their students, but Gleyre's reputation was high and he had many students, among whom at the time were Bazille, Sisley and Renoir.

Frédéric Bazille was Monet's first close friend in the art world, and his studio was the focus for a group of young painters from Gleyre's academy who were impatient with the academic processes and teaching methods. They were also dismayed by the commercial ambitions they encountered in the official painting world, where success was more important than achievement, and reputation than quality of work.

Monet and his friends left Gleyre's when it closed in 1864, but Monet, still attracted by the idea of painting in

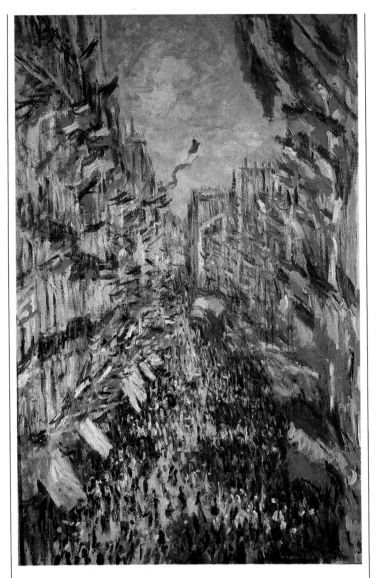

CLAUDE MONET
Rue Montorgeuil:
Fête Nationale
1887, Musée d'Orsay, Paris

In his series of paintings of the *Gare Saint-Lazare* (see page 35) Monet had begun to handle paint and color in a way that made the paint surface itself the subject of the painting, with figures and details often described with just a flick of the brush. This is one of a series of paintings of Paris done in 1887 in which this concept was taken even further; here the individual details, such as figures and flags, are seen as a pattern of inter-relating verticals, diagonals and areas of color.

the open air, stayed in Paris and painted in the nearby countryside or on the Normandy coast. At the same time he began living with Camille Doncieux, and in 1867 she bore a son, Jean. This was a lean period for Monet, and when he and Camille finally found themselves penniless he was forced to return home to Le Havre.

In 1870 Monet and Camille were married in Paris, but in autumn of the same year the Franco-Prussian war broke out, and this was to have a dramatic effect on

French cultural life, particularly in the aftermath of the siege of Paris. The young painters working in and around Paris were dispersed, and Bazille was killed in a futile engagement early in the war. Degas joined the National Guard and participated in the siege of Paris, but Monet took Camille and Jean on their honeymoon, after which they went to London, avoiding both war and siege. In 1871 they returned to France and settled in Argenteuil.

CLAUDE MONET
*The Seine at Porte-Villez;
Winter, Snow*
1885, Private collection

The river and its different moods was a source of endless fascination for Monet, and here the effects of snow and icy water are captured with singular effectiveness. The earlier form-following brush strokes seen in *Regatta at* *Argenteuil* (see page 7) have now given way to the *tache* method of building the painting. A darker laying in of thin green-brown underpainting is covered with a thick white, near white or blue dashes of dry paint. The warmest color is in the house behind the trees and the strongest is found in small touches of cobalt blue in the water.

Argenteuil is now a suburb of Paris, but then it was a charming country town sufficiently close to Paris to provide the twin benefits of café life and the delights of the countryside and river banks. It became Monet's home for the next six years as well as a home from home for his artist friends, among whom was Renoir, who often stayed with Monet and frequently painted the same subjects as they sat together on the river bank. These paintings were the real beginnings of Impressionism, and this was one of the most formative periods of Monet's art as well as one of the happiest in his life.

New beginnings

It was also a period of great expansion and prosperity in France, in the aftermath of the Franco-Prussian war. During the 1870s the country, and particularly Paris, established the artistic pre-eminence which it was to hold right up to the Second World War. The feeling of a

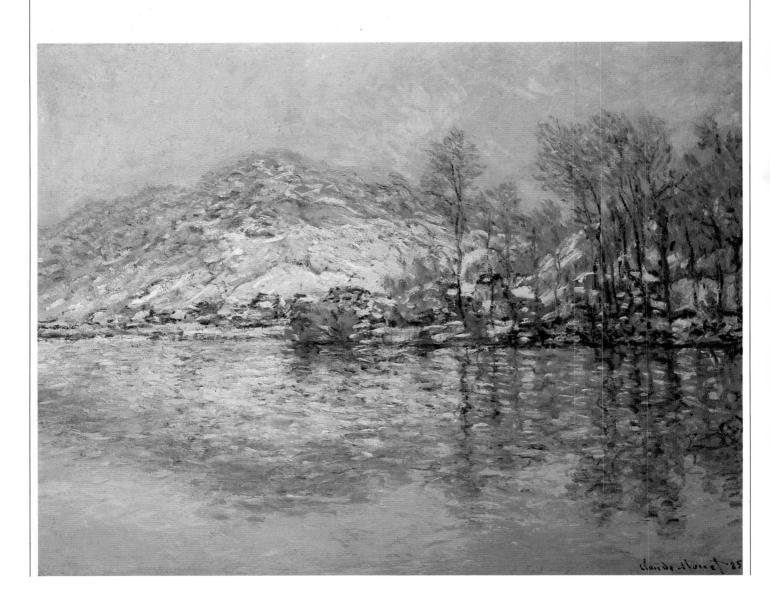

new beginning was heightened by the rebuilding of Paris which had been carried out during the 1860s at considerable expense. All signs of past conflict were obliterated, and a new age had dawned, not only in art but in literature, with such names as Victor Hugo, Flaubert, Balzac, George Sand, Stendhal and de Maupassant leading an impressive rollcall.

When we look at Monet's work during this period it becomes obvious that the old academic tradition represented by such artists as Gleyre and Adolphe Bougereau were no longer relevant to the new creative energy. Undoubtedly society was not conscious of new needs — it seldom is — but the needs were there, and Impressionism, with its directness and immediacy, was able to fill them, at least after the first shock of unfamiliarity had worn off.

At this time the important annual art exhibition in Paris was the Salon, which had opened in the seventeenth century to exhibit the works of the newly formed French Academy. By the nineteenth century the Salon had become so restrictive that even to exhibit was difficult for a non-Academician (so many were rejected that in 1863 a Salon des Refusés was inaugurated as a short-lived alternative). Nevertheless, all young and aspiring painters wished to exhibit, since not only did it bring public recognition, it was also the best marketplace, and Monet was no exception. In 1865 he had been accepted with two seascapes (which he appears to have sold), and a year later a portrait of Camille and a landscape were also hung. But despite this *succès d'estime* he was rarely able to sell his work and often had to rely on funding from his father and his friends.

A change came in 1870 when Monet met Paul Durand-Ruel in London, where both had taken refuge from the war. Durand-Ruel was a picture dealer, one of a newly developing breed of sophisticated and well-educated men who appreciated good paintings, bought them themselves, and were able to persuade potential buyers of their worth. Hitherto, picture dealing had been largely a sideline for shopkeepers selling artists' materials, stationery and so on, and they were little interested in the quality of the works they sold. Durand-Ruel became the most important supporter of the Impressionists during the 1870s and 1880s, and Monet was one of his most successful painters. By the end of the century other dealers had become interested, and Monet and the other Impressionists could afford to ignore the Salon route to success.

Sadly, in 1873, Durand-Ruel found himself in financial straits and was forced to stop buying, causing prob-

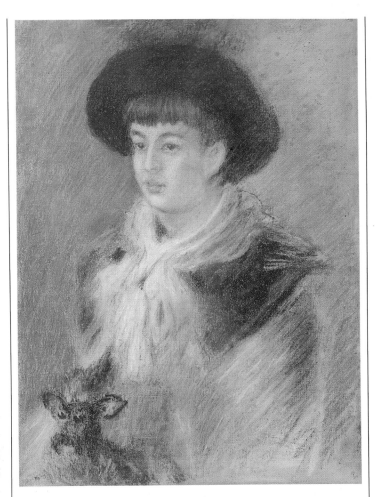

CLAUDE MONET
Suzanne Private collection

Although pastels did not form a large part of Monet's body of work, he produced a number of them, both early and late in his career, finding the medium well suited to his self-imposed task of capturing rapid impressions. This portrait, done in the Giverny period, is of Suzanne Hoschedé, Alice's daughter. In 1892 she married an American painter, Theodore Butler, but became ill after the birth of a child and died in 1899, causing great grief to Monet and his wife.

lems for Monet too. However, at much the same time Monet struck up a friendship with an apparently wealthy businessman, Ernest Hoschedé, and his wife Alice, and the relationship was to have a long-term effect on his life. For the present, it gave him some income from sales to Hoschedé, as well as loans from him.

Monet's life at Argenteuil with Camille and his son provided the stability of a settled household, enabling him to concentrate on the development of his art. In 1874 he became one of the organizers of the First Impressionist Exhibition. Called the "Société Anonyme des Artistes, Peintres, Sculpteurs et Graveurs," the group held its first show in Paris in the studio of the photographer Nadar. The critic Louis Leroy attacked it, suggesting in his article that a "real" (i.e. academic) painter

would be driven mad by the works to be seen. Subsequent reviews of other group shows were no more favorable. Another critic, Ballou, reviewing the work of Monet and Cézanne in 1877, wrote: "They provoke laughter and are altogether lamentable. They show the most profound ignorance of design, composition and color. Children amusing themselves with paper and paint could do much better."

But in spite of the poor reception the group shows became an annual event, and Monet exhibited in the first four, the seventh and the last, after which he had "arrived," and was able to sell his work and arrange one-man shows whenever he wished.

His domestic life was again disrupted when in 1877 Ernest Hoschedé became bankrupt. The two families decided to pool their resources, and they moved to Vetheuil, also on the Seine but considerably further — forty miles — from Paris. Monet managed to keep a small *pied à terre* in Paris to show his paintings, since he could not bring his customers so far from the capital.

The Giverny years

Soon after their arrival at Vetheuil Camille, who had recently borne a second son, Michel, died. Monet became distraught and was unable to work. Alice Hoschedé looked after Monet's children as well as her own six, and the families remained linked, moving together first to Poissy and then to Giverny in 1883. While they were still at Poissy, Ernest Hoschedé, disenchanted with poverty

JOHN SINGER SARGENT
Monet Painting on the Edge of a Wood
1885/7, Tate Gallery, London

Monet became friendly with Sargent after they met at Durand-Ruel's gallery around 1884/5, and Sargent became a regular guest at Giverny in the later 1880s. The two artists painted together in the open air during this period, and this direct sketch, showing all Sargent's considerable virtuosity, is a most convincing impression of Monet at work. The other seated figure is probably Blanche, Monet's daughter-in-law, who often carried his equipment and was his most attentive assistant.

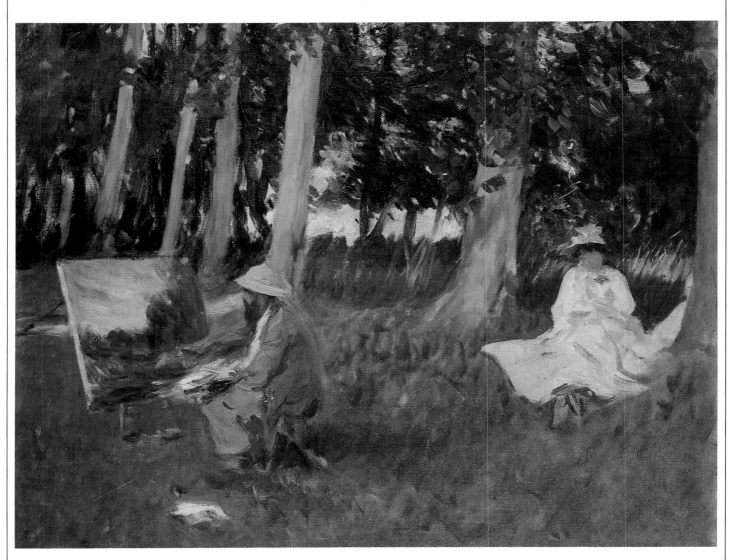

MONET'S PAINTING METHODS

In Morning at Etretat *Monet used a gray-tinted canvas, here visible through the thinly applied paint in the shore area.*

In paintings such as Rue Montorgeuil *Monet has used his brushstrokes to form a vibrating pattern of verticals and diagonals.*

This detail of the foreground of Grain Stacks *shows how Monet saw each area as composed of many different colors of the same tonal value.*

Monet usually painted on standard-sized canvases with a white priming, a break from earlier tradition, in which forms and tones had been built up from dark to light on a dark-toned ground. However, although he said in 1920 that he "always insisted on painting on white canvases, in order to establish on them my scale of values," this statement is not entirely true; in fact he used a wide range of mid-toned primings, often a warm beige or light gray. From about 1860 the color of these primings became an element in the paintings, with small areas either being left unpainted or very lightly covered.

Monet always stood up to work, whether outdoors or in the studio, and he never believed his paintings were finished, frequently reworking them in the studio in spite of his often-stated belief in instantaneity. Except in the earlier works he did little or no underdrawing or tonal underpainting, beginning each painting with colors approximating to the finished ones, and working all over the canvas at the same time with long thin bristle brushes. His brushwork varied from painting to painting as well as through the course of his long career, but one of the main characteristics of his work, and of other members of the group, is the use of what is known as the *tache*, the method of applying paint in small opaque touches, premixed on the palette with the minimum of mixing medium. This provides a patchwork-like fabric of all-over color, described by Zola as "as ensemble of delicate, accurate *taches* which, from a few steps back, give a striking relief to the picture."

The colors shown here, plus lead white, are those used in Bathing at La Grenouillère *(see page 23), and are typical of Monet's palette at the time. In early paintings he also used black, and it is probable that he sometimes extended his range with yellow ocher, burnt sienna and ultramarine.*

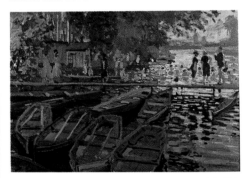

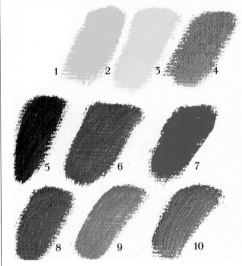

1 White; 2 Chrome yellow; 3 Lemon yellow; 4 Vermilion; 5 Prussian blue; 6 Cobalt blue; 7 Emerald green; 8 Viridian; 9 Chrome green; 10 Cobalt violet

and provincial family life, gradually disengaged himself and took up a bachelor life in Paris, where he built up a new business from the sale of a few paintings he had managed to keep.

The move to Giverny coincided with the death of Manet, and Monet went to Paris to be a pallbearer, but his close association with the city was now over, and Giverny became the focus of his life and the subject-source of most of his later paintings. He had purchased a farm-house on the outskirts of the village, which is about fifty miles from Paris on the banks of the Seine. The house was close to the river and set in water meadows, and here Monet made the water garden that became the subject of his last great paintings. He gradually became isolated from his friends, a semi-recluse.

Ernest's desertion of the family had created a somewhat unconventional situation in the household, since Alice had remained to look after the children. Neither of them was happy about it: Monet was deeply conventional in such matters and Alice was devoutly religious, so for some time there was an undercurrent of tension in the Giverny establishment. However, in 1892 Ernest died, and a quiet wedding ceremony took place.

All the reports of Monet's life at Giverny — and there were many because by this time he was famous and the subject of considerable public interest — reflect the image of a complex and moody man whose humors affected the whole household. He was irascible and

CLAUDE MONET
Blanche painting
1892, Private collection

Blanche Hoschedé, Monet's daughter-in-law, became quite a competent painter under his instruction and often accompanied him on local painting trips. On this one they were joined by another painting friend, probably Caillebotte. The woman in the background is probably Blanche, whose figure was repeated while she took a break from her own painting — a little joke perhaps. This was a private study, and unusual in that Monet rarely painted figures after the 1880s. It shows a good deal of overworking in the head and near arm, and there is less of the fluid assurance which he shows in his landscapes.

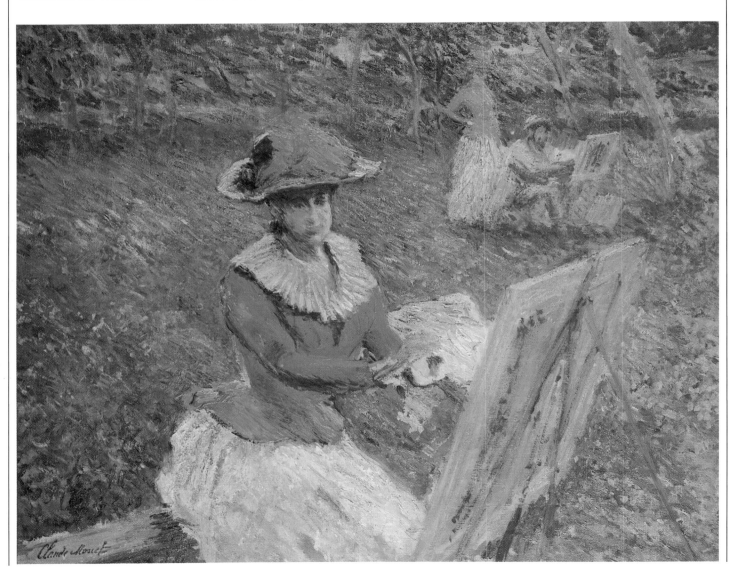

14

unbearable when thwarted, particularly when the weather prevented him from painting — and would sometimes stay in bed all day refusing any attention. He was only forty-three when he bought the house, with exactly half his life still to live, yet he had already become an autocratic patriarch, and clearly fostered the image. Altogether, he lived exactly as he wished, with scant respect for the wishes and needs of others; for instance, he forbade the marriage of Alice's daughter Germaine to Pierre Sisley, the painter's son, on the grounds that Pierre's occupation, as an inventor, was too insecure. Odd behavior from a once-impoverished painter, one might think.

The planning and development of his garden became his major preoccupation and demanded much of the not inconsiderable income he was now making from his painting. Six gardeners were employed, one of whom looked after the water garden exclusively. This, filled with a great variety of waterlilies and surrounded by willows, was developed from the purchase of some nearby land, and across its narrower part Monet constructed a Japanese bridge he had designed himself, based on a Japanese print he had bought in the 1860s.

Monet's house and garden became a place of pilgrimage for friends and admirers. In spite of his reclusive tendencies, friends still played a part in his life and he was deeply distressed as one by one they died, suffering periods of fierce melancholy which prevented him from working. The gravest blow of all was the death of Alice in May 1911, and he did not work until the end of the year.

The most important friend of his late years, and one who survived him, was Georges Clemenceau, the statesman and journalist, whose support during the time after Alice's death was crucial. But Monet's troubles were not over; he had begun to suffer from failing eyesight some years before the loss of Alice, but it was not until 1912 that he was persuaded to see an eye specialist, who diagnosed a double cataract, requiring an operation. Fearing both the operation and its effect on his vision, Monet refused, and even Clemenceau could not persuade him. (He did finally have the operation, in 1923.)

The last great works

Yet another blow for Monet was the death of his older son Jean in 1914 just before the outbreak of war. Jean's widow, Blanche, one of Alice's daughters, came to live with him and cared for him for the rest of his life. She was also a painter, and they often painted together.

Blanche and Clemenceau formed a mutually suppor-

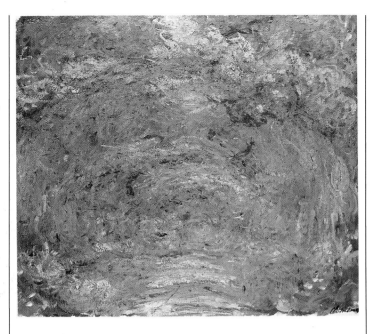

CLAUDE MONET
A Shady Walk
1920, Private collection

Monet created, as part of his garden at Giverny, a walk from the main entrance to the farmhouse itself, which included about six arched pergolas. He liked a controlled wildness, and as time passed this walk became a riot of color, with flowers spreading across the path itself to produce the effect of a shaded, multi-colored grotto. This late painting, done when his eyesight had so deteriorated that he could see the swirling motion of color but few distinct forms, is probably of this walk; he rarely left his garden in his last years. The work is a moving expression of his devotion to his painting, and constitutes a triumph of experience over physical limitation.

tive alliance, and it was through Clemenceau that Monet's last great commission was secured, for the panels known as the *Nymphéas*, or *Waterlilies* (see page 57) destined to decorate a specially constructed room in the Orangerie, Paris. Clemenceau was devoted to Monet and continued to visit him up to his death, though there were, of course, strains in their relationship, mainly caused by Monet's failure to meet his deadlines. His dissatisfaction with his work, partly the result of his failing vision, prompted violent physical attacks on his work, including the *Nymphéas* panels, which he altered constantly. He would not allow them to leave the studio, and there was a real danger that he might even destroy them, since it was his habit to make bonfires in the garden of paintings that he found inadequate. The panels were not, in fact, put in place until the year after Monet's death.

Clemenceau was present at Giverny on December 5th, 1926 when, around noon, Monet died. As he had wished, he was given a quiet funeral, with Clemenceau and the painters Pierre Bonnard, K-X Roussel and Edouard Vuillard as pallbearers.

CHRONOLOGY OF MONET'S LIFE

1840	November 4th: Claude Oscar Monet born Paris. Auguste Rodin born in same year.
1845	Family moves to Le Havre.
c.1856/7	Meets Eugène Boudin.
1859	First visit to Paris; meets a number of painters including Pissarro.
1861-2	Military service in Algeria. Discharged because of ill health. Meets Dutch painter Jongkind.
1862	Enters Gleyre's studio where he meets Bazille, Renoir and Sisley.
1864	Leaves Gleyre's studio. Paints at Fontainebleau.
1865	Shares studio with Bazille in Paris. First exhibits at Salon.
1866	Portrait of Camille success at Salon.
1867	First son Jean born. Financial problems force him to return to family in Le Havre.
1868	Lives with Camille Doncieux at Etretat during winter.
1870	Marries Camille. Outbreak of Franco-Prussian war causes visit to England where he meets Durand-Ruel.
1871	Returns to France and settles at Argenteuil. Rejected by Royal Academy, London.
1872-4	Durand-Ruel buys paintings.
1874	First Impressionist Exhibition.
1876	Meets Hoschedé family.
1877	Ernest Hoschedé becomes bankrupt. Works in Paris on *Gare Saint-Lazare* paintings.
1878	Moves to Ventheuil and is joined by the Hoschedé family. Second son Michel is born.
1879	Camille dies. Alice Hoschedé takes charge of household.
1880	Exhibits at Salon.

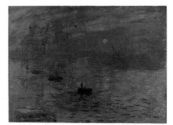

Impression, Sunrise

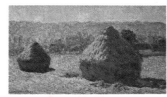

Boats at Etretat

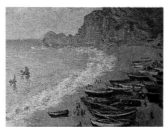

Grain Stacks, End of Summer

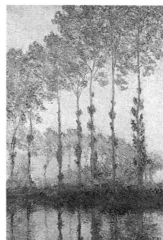

Poplars on the Banks of the Epte

1881	Moves to Poissy. Durand-Ruel resumes purchase of work after earlier financial problems.
1882	Exhibits in seventh group exhibition.
1883	Moves to Giverny. One-man show at Durand-Ruel gallery. Summer: makes first paintings of Giverny region. Trips to the Midi and Italian Riviera with Renoir. Visits Cézanne during trip.
1884-7	Paints at Giverny and northern French coast.
1888	Paints at Antibes. Refuses Legion d'Honneur.
1889	Exhibits with Rodin at Georges Petits gallery. Organizes private subscription list to purchase Manet's *Olympia* for the State.
1890	Begins "series" paintings with *Grain Stacks*. Purchases home at Giverny.
1892	Begins *Rouen* series. Marries Alice Hoschedé.
1893	Begins making water garden.
1895	Painting trip to Norway.
1896	*Early morning on Seine* series.
1899	Begins first paintings of water garden and Japanese bridge. Painting trip to London.
1900-1	Works on *Thames* series in London.
1903	Begins second *Water Garden* series.
1908	Painting journey (last) to Venice. Trouble with eyesight.
1911	Death of Alice.
1914	Builds new studio for *Waterlilies* panels. Death of son Jean.
1921	Deterioration in his sight..
1922	Bequest of *Waterlilies* to state.
1923	Has cataract operation, which is partially successful.
1926	December 5th: death at Giverny.

THE PAINTINGS

WOMEN IN THE GARDEN

1866/7

100¾×81¾in/256×208cm

Oil on canvas

Musée d'Orsay, Paris

Monet planned this painting as a major exhibition piece for the Salon of 1867. The Salon was still at this time the place where artistic reputations were made, and no young artist could afford to ignore it. Monet had previously shown small works in the manner of Boudin and a full-length portrait of his wife Camille, but this painting, a very large-scale work more than eight feet high, was clearly intended as a publicity work designed to gain commissions, and the size of the signature suggests that Monet wanted to fix his name in the mind of the public.

The work, however, was rejected, which perhaps did not surprise Monet unduly; since his time at Gleyre's studio he had had no very high regard for academic judgement. Although the painting might have appeared to conform to the pattern of figure composition that was acceptable to the Academicians it lacked one important element: the figures in the group have no dramatic relationship with each other, that is, there is no "story line" in the painting. This was then regarded as the *raison d'être* of a painting, whether it be historical, literary, religious or social, but in Monet's work the people simply exist. Also they all look somewhat alike — not surprising, as Camille posed for all of them.

But this was not the only reason for the rejection of the painting. Monet's technique itself left much to be desired in terms of academic practice. As in other early works the paint handling is close to that of Manet, with the shapes of the figures, the shadows and the foliage clearly defined, and little range of tonal modeling. This treatment may well have reminded the judges of the public scandals caused by Manet's work, first by the *Déjeuner sur l'Herbe* displayed in the Salon des Refusés in 1863 and then by the equally offensive nude, *Olympia*, two years later. Monet had intended to submit his own version of a "Déjeuner sur l'Herbe" in 1866, but

failed to complete it in time, so *Women in the Garden* was his first major attack on the citadel of the Salon.

The academic method of painting was essentially one of building form by means of tone. The painting was built on a lightly colored neutral ground, beginning with an underpainting of dark tones, usually brownish in hue. Into this dark underpainting the highlights were added in white or near-white, and the local color of the object or figure (its actual color) was introduced into the middle-toned areas. This method produced a strong sense of volume and solidity of form, but color played a secondary role, being diminished or sometimes even lost in highly illuminated or deeply shadowed areas. The method adopted by Manet, sometimes called *peinture claire*, was first to determine color areas through mid-tones and then to add highlights and darks into the wet paint, thus emphasizing shapes at the expense of form. This resulted in a strong color pattern, reminiscent of the then-popular Japanese prints, and also gave more importance to color itself, since the real colors of highlights and shadows could be given more consideration.

Monet went a stage further in this painting, giving a clear color identity to each shadow, such as that falling across the path and onto the dress of the seated figure. The resultant mauve-blue on the dress is one of the dominant colors in the work, and gives "uplift" to the tonal pattern. In the painting of the foliage there is a great variety of greens and yellows but no dark-toned shadows, and very little black is used, a color Monet was soon to abandon altogether.

The whole effect of the painting was thus antipathetic to standard academic practice, and the Salon judges were the reverse of artistically adventurous. The rejection, although undoubtedly disappointing for Monet, in no way deflected him from his chosen course.

Compositionally the painting is divided into quarters, pivoting on the springing of the branches of the small tree — an almost central spot in the work. The top half of the painting is in deep tone almost entirely occupied by foliage, while three or four figures, static and preoccupied, are concentrated in the left lower quarter. The moving figure is lit from the right and this light, falling across both the path and the dress of the seated figure, also strikes the flowers she is holding. The second bunch of flowers and flowering shrubs provide a moving ellipse through the outstretched arm, the lefthand figure, the skirt of the seated figure and across the path, giving a touch of animation.

The large scale of this work necessitated the digging of a trench into which the canvas was lowered to enable Monet to work on the top of the painting in the open air.

WOMEN IN THE GARDEN

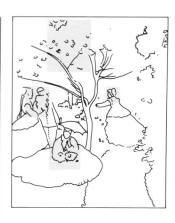

1

2

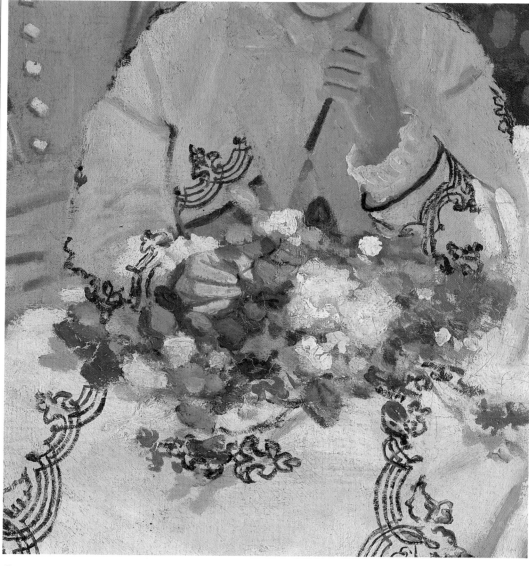

3

1 The foliage in this part of the painting is done in a variety of greens and brown with touches of black (Monet later abandoned the use of black). Some leaves are given emphasis with emerald green heightened with white and modified with yellow ocher, chrome yellow or cadmium yellow.

2 There is a curious quality about these two heads: the coyness of the eyes seen over the flowers and the pertness of the lefthand figure suggest that some dramatic relationship, or "story line," is intended, but nothing is explicit. The whole group is lower in tone, with these flowers quite muted in comparison with the others.
 Painted thickly and freely, the flowers provide an enlivening note of warm color in a part of the painting which is largely cool and shaded.

3 This is the liveliest piece of virtuoso brushwork in the whole painting, and reminds us that this large work was in part an advertisement of the artist's skill, designed to establish his ability at handling large-scale compositions. The cast shadow from the flowers is a delicate mauve-violet, a departure from the usual academic practice and the beginning of Monet's search for true color equivalents, as distinct from tones, in every part of a painting. The blue-mauve tint of the upper part of the dress, sharpened by the warm yellow-brown hat ribbon, a near complementary, provides a lively background.

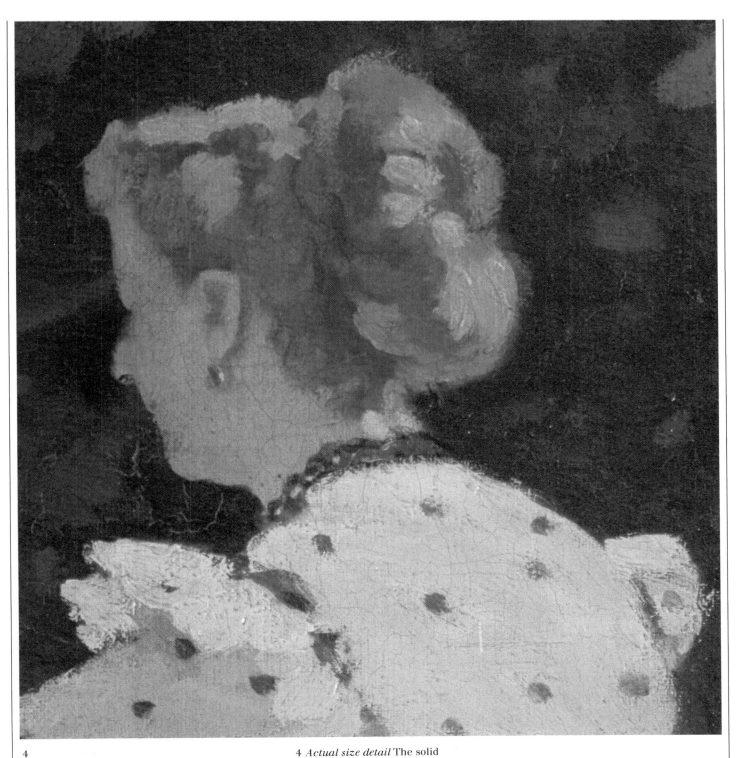

4

4 *Actual size detail* The solid
blocked paint can be seen
clearly in this detail. The basis
for the color is probably burnt
sienna with white. The blue-
green halo effect heightens
the hair color, and the flesh is
treated in a grayish tone, as
deep as possible to retain the
head shape while still laying
emphasis on the hair.

BATHING AT LA GRENOUILLERE

1869

22×29in/56×73.5cm

Oil on canvas

Courtauld Institute Galleries, London

La Grenouillère was a popular bathing and boating place on the Seine close to Bougival, where Monet was living and working in 1869. During the 1860s it had become a weekend Mecca for Parisians who enjoyed the rural surroundings and the floating restaurant (to be seen in Monet's painting). Monet and Renoir often painted together at this time, producing different treatments of the same subject.

This painting, like *Women in the Garden*, shows the influence of Manet, who was something of a hero figure to the younger painters who were to become the Impressionists. (Manet, although an acknowledged leader of the avant garde, longed for an official recognition which never came.) In one respect, however, Monet's painting practice diverged from Manet's, as the latter painted in his studio from studies while Monet increasingly painted in the open air, directly from his subject. As he became more successful the need to exhibit at the Salon diminished and he painted no more large-scale, would-be "exhibition" pieces; the outdoor paintings were usually smaller in size and much more freely painted than studio works. The rather sketch-like treatment is an important characteristic of *La Grenouillère*, which is also quite small.

Monet used a number of terms to describe his studies, among them being: *esquisse*, which was a preliminary sketch or working drawing; *ébauche*, a rough oil sketch; *pochade*, which was another term for a sketch, more commonly applied to color-key design; *étude*, a part study to resolve some specific painting problem; and *croquis*, a rough draft. He used these words in a way slightly different from their usual meanings, but for Monet the distinctions were essential. He also employed two terms that were peculiar to him, one such being "impression," a word which he incorporated into the titles of several of his works. His other specialized and individual term, *enveloppe*, had an even more precise meaning for him, and was used to describe the way an object was surrounded by light.

Bathing at La Grenouillère is not a highly finished work, the surfaces being quite rough in comparison with the fashionable Salon works. The brushstrokes are bold, broad and directional, often overlapping, with the paint used fairly wet (oily). The brushstrokes are highly descriptive, following forms and describing objects. For instance long horizontal strokes have been used for the shapes of the boats and long thin ones for the oars, while short dabs of color describe the foliage (top center). Even the human forms are drawn in flat, vertical strokes, and there is a good deal of overpainting with thick, wet paint, the figures on the duckboard being interspersed with thick strokes added later.

The composition is unconventional too. The duckboard divides the work horizontally almost across the middle, and this, with the vertical division running through the central dark foliage to the lower righthand boat, provides a quartered composition in which each quarter reflects a different character. The vertical access to the painting is emphasized by the almost central position of the dark figure on the duckboard, while in the lower half the broad shapes of the boats are a foil to the sparkling short strokes, blue and cool, used to describe the water. This in turn balances the warm colors in the upper half. The small skiff on the right is a later addition to provide a "stop" at the righthand edge, and the lefthand top segment gives enough color variety to balance both the boats below and the roughness of the group to the right. Although the painting is a direct study of the scene, the composition is as carefully calculated as that of a studio painting. Particularly interesting is the overhanging dark green foliage at the top center which comes forward to emphasize the picture plane, sending all the rest of the scene further back in space.

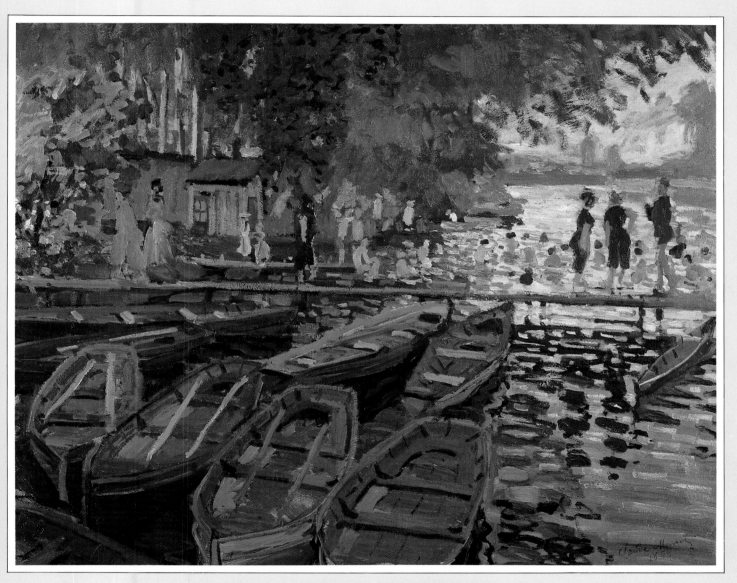

This is a very freely painted blocked-in sketch, clearly a direct study. Boldly divided across the middle by the duckboard walk,the lower half is in shadow and thus low in tone, while the upper contains the liveliest, most varied brushwork. Figures and objects are indicated by a few strokes of a paint-filled flat brush in which the color, although premixed, often carries traces of other colors which have remained on the brush.

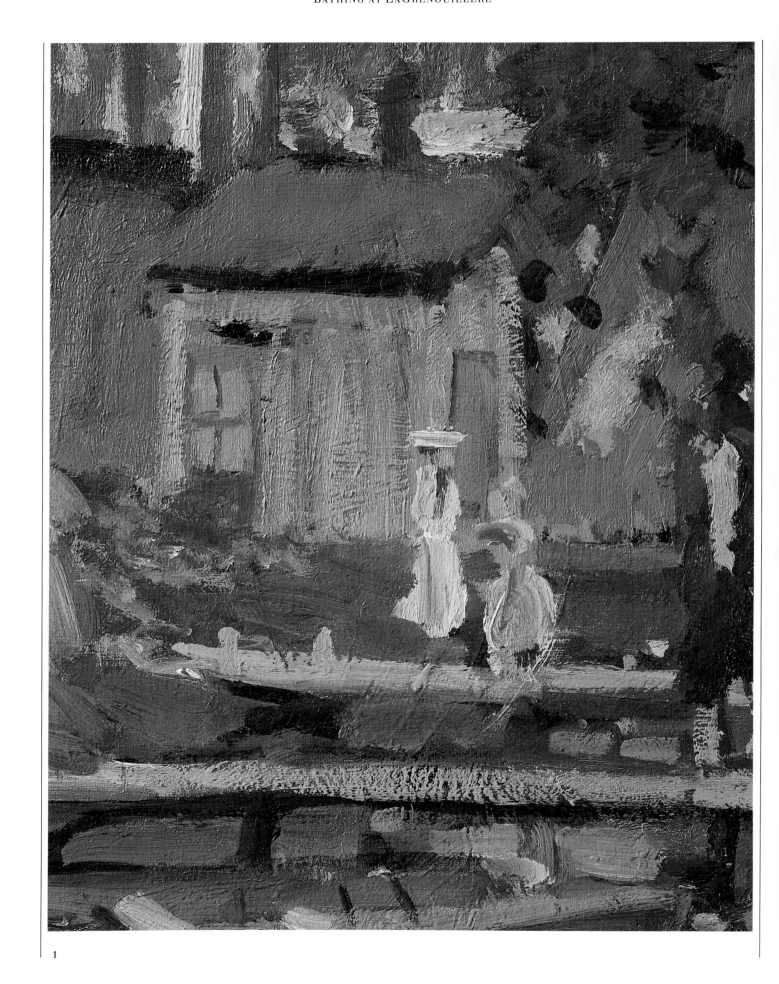

1

1 *Actual size detail* The different layers of superimposed paint reveal the quick development of the sketch. Pulled over thick, dry paint a further thick mixture of blue-gray reveals the underpainting. Single brushstrokes indicate figures, while direct dabs of a round brush, leaving impasto dots and ridges, indicate foliage. Almost pure vermilion covers a mixture of viridian and chrome green in the bottom left, resulting in a heightened color contrast.

2 The most brilliantly lit quarter of the small canvas shows a small area of cobalt violet, a then recently invented opaque color. This is mixed with white alone to give a startling luminous quality of the distance. The dark figure in Prussian blue balances this whole rapidly laid-in light area. The brushstrokes are all designed to capture, quickly and directly, the immediate visual sensation, and form is subordinated to light and dark shapes, either contrasts or similarities.

3 Although the darkest area of the painting, the brushwork here is most carefully descriptive. The shapes and colors of the boats and their steep perspective treatment draw the viewer deeply into the scene. The foliage at the top, in mixtures of black, Prussian blue and chrome green or viridian, pushes the boats into a visual "funnel." Directional brushstrokes have been used to define the forms, a method Monet abandoned in his later work when the influence of Manet's technique diminished.

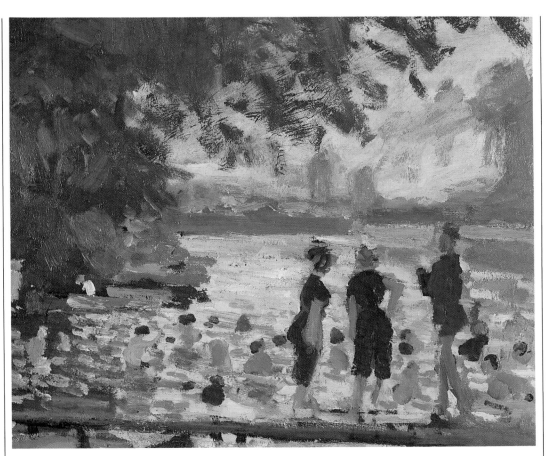

2

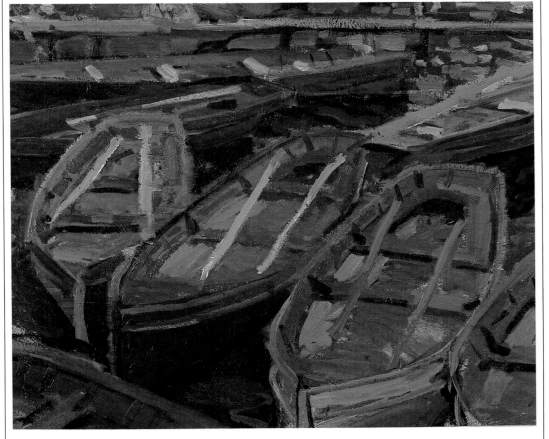

3

IMPRESSION, SUNRISE

1872
19×25in/48×63.5cm
Oil on possibly reused canvas
Musée Marmottan, Paris

This small painting has become one of Monet's most important works by virtue of the title he chose for it, and to fully understand Monet's work it is necessary to understand the significance the word "impression" had for him. One of the canvases submitted for the First Impressionist Exhibition in 1874, this was singled out by an antagonistic critic as typifying the "half-finished" look of all the works on show, and he dubbed the group "Impressionists."

In the personal terminology Monet used to describe his various types of paintings he would normally have called this work a *pochade* (sketch). However, as he said himself, he called it "impression" because "it really could not pass as a view of Le Havre," and he subsequently used the same word for a number of his paintings, all of them quick atmospheric sketches capturing a particular light effect. An "impression" for Monet was a special and limited form of sketch, and although the other Impressionists accepted the word as a reasonable description of their aims, Monet himself used it only when he felt it appropriate to a particular work.

Thus it appears that he did not really regard himself as an "Impressionist," and as a description of the diversity of aims of the other painters who exhibited in 1874 it hardly seems very revealing. However, it is the term universally adopted of the movement which became one of the most popular in the entire history of art, and is also frequently applied to painters — and even sculptors — only remotely connected with the original group.

Impression, Sunrise is a slight sketch, almost certainly completed on the spot in a single sitting, depicting the harbour at Le Havre as the sun rises over the cranes, derricks and masts of the anchored ships. The only evidence of life is the lazy action of the oarsman in the most sharply defined part of the painting. The painting gives a suggestion of the early morning mist, at that time clogged with the industrial smoke of the city, and has a strong relationship to the earlier views of mist and fog done in London in 1870. Monet had only recent returned from London, and his abiding impression of the city, recalled later, was of its fog. While there, he had seen the work of J.M.W. Turner (1775-1851), who is generally thought to have been an important influence on Monet and the other Impressionists, and he may also have seen some of the early *Nocturnes* by his contemporary Whistler.

At this time Monet was still painting scenes of urban and industrial life, though his vision was entirely that of a landscape painter and his interest mainly in the effects of light rather than in any specific architectural features or the social significance of the manifestations of industry. The most obvious characteristic of *Impression, Sunrise* is its immediacy of execution and the way it captures just one perceived instant. The forceful, clear shape and strong color of the sun provides the keynote for the work, with the dense, muted pale blue surrounding it providing the opposition of complementary colors which enhances the brilliance of both. The dark note of the nearest boat identifies and stabilizes the color key, the darkest element in the whole painting being the single near-black accented horizontal defining the waterline. With the passage of time, underpainting sometimes begins to come through, and here we can see some early drawing in the lower left- and righthand areas, further evidence of the urgency and immediacy of the painting.

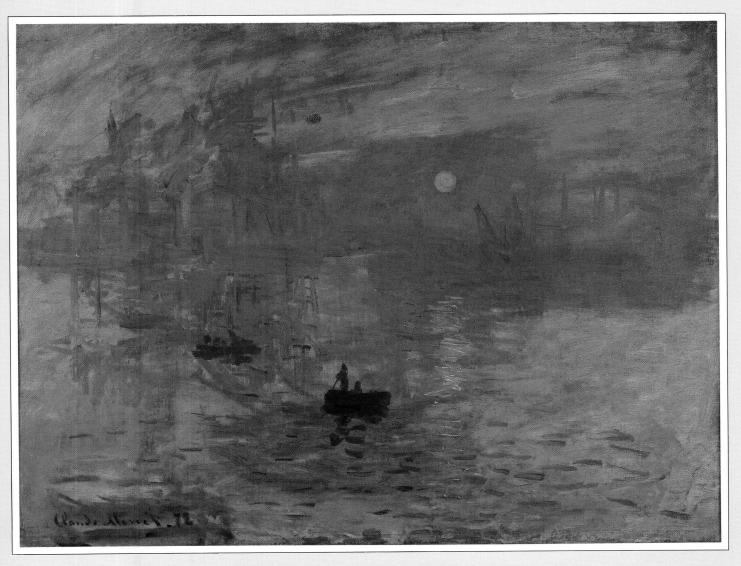

The color character of this painting relies on the opposition of complementaries or near complementaries — orange and blue. In the top left a brown (a mixture of the same orange and blue) gives a linking color note. The composition, though simple, like that of most Impressionist paintings, is nevertheless dramatically effective. The indistinct forms of the port run across the canvas at Golden Section height, and a diagonal from the left edge through the three small boats emphasizes the positioning of the orange sun, while the middle small boat repeats the sun's position in the alternative quarter. The effect is a dynamic balance in which the reflection of the sun in the water contributes the enlivening element.

27

1

2

1 Most of the rest of the painting is thin, but the sun is surrounded by an opaque blue — of cobalt and white — which emphasizes the brilliance of the sun in a way that thin, transparent paint would not have done. The sun itself, a strong orange, probably a mixture of cadmium yellow and vermilion, provides the dominant color note, and all the other forms are indistinct.

2 Although it is not easy to see in reproduction, there is some suggestion in this area of overpainting of another subject. With passage of time, underpainting sometimes begins to show through the top layer of paint. The warmth of the underpainting — an orange-pink tint — is overlaid with strong dashes of blue-green, providing a transparent effect presaging Monet's later preoccupations with water surfaces. The paint is thinly applied over a neural ground.

3 *Actual size detail* Although the sun is the dominant note, all the spatial and color patterns are set by this boat, whose waterline is the darkest note in the painting. Viridian is used to strengthen the shapes in the blue surrounding, and this also appears in both the signature and the water area leading from the boat, with white producing the intermediate tone of the middle small boat. Some touches of ultramarine are also evident.

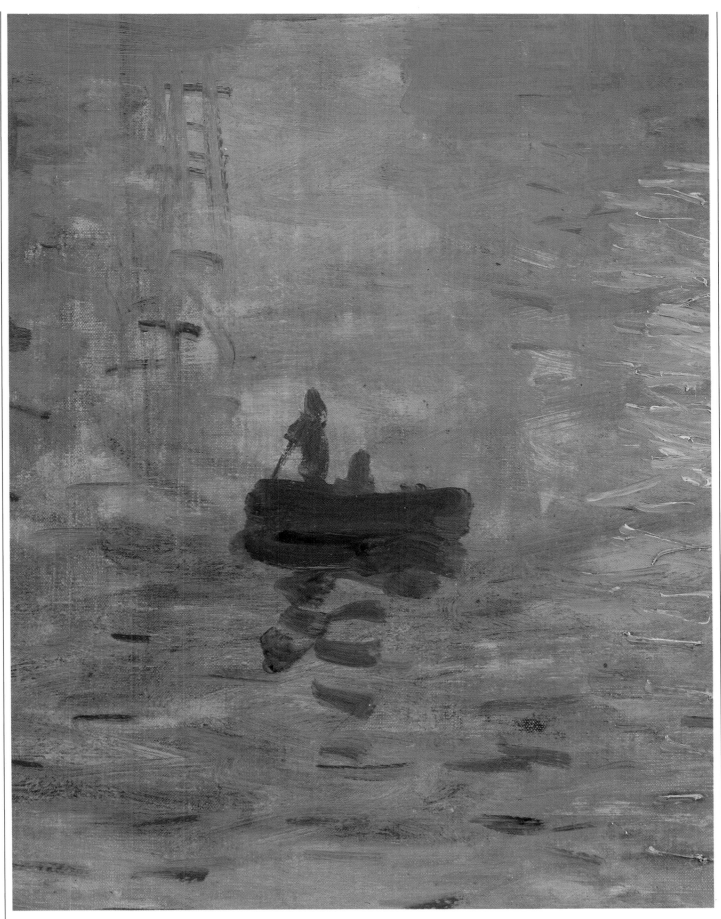

3 *Actual size detail*

AUTUMN AT ARGENTEUIL

1873

Oil on canvas

22×29in/56×75cm

Courtauld Institute Galleries, London

Monet's home at Argenteuil was his first really settled place since leaving the family house at Le Havre. With a new wife and a young son he needed a stable base, and his choice of Argenteuil gave him what proved to be some of his happiest years. Arriving in December 1871, when he had just turned thirty-one, he settled into the rented house near the railway bridge which formed the subject of a number of his paintings. During the next six years the countryside around Argenteuil and the town itself became the center for the development of the Impressionist movement, as his fellow-artists came out from Paris to work with him and to discuss their new ideas.

Monet's life at Argenteuil was more comfortable than is sometimes believed. He was beginning to sell his paintings and made a reasonable income — on a par with an office worker and about five times more than any local laborer. Dealers, too, visited him, particularly Durand-Ruel, and bought his work. Nevertheless, he was always short of money and often borrowed from his friends so that he could entertain them well.

Once settled, he painted with great enthusiasm, in the first year alone (1872) producing forty-six paintings, of which thirty-eight were sold. Most of these were views of the Seine, the town and the surrounding landscape; he had now changed from being a much traveled painter to being one who explored his own locality to the exclusion of all else.

Autumn at Argenteuil is typical of the lyrical painting technique he was developing to explore the light effects which excited him so much. This is a much more worked painting than *Impression, Sunrise*, and shows the new range of his oil-painting method. From the strong directional brushstrokes found in *Bathing at La Grenouillère* or the nervous delicate sketchiness of *Impression, Sunrise* Monet had now moved to a denser, more light-catching paint surface. Here the scene is shown bathed in the consistent and unified light that Monet believed should pervade every part of the painting and enclose it. He used the word *enveloppe* to describe this effect. It is difficult to define, but a comparison between this and *Bathing at La Grenouillère* (see page 23) makes it clearer. In the latter, each part seems to some extent separately painted, whereas in this painting there is total unity — it all seems to have come together under the all-pervading light.

As in many of Monet's paintings of water done at the time, the division between it and the sky is defined only by the strong blue horizontal which holds the delicate balance between the lefthand and righthand foliage forms. The darkest area, in ultramarine, on the righthand edge, is the hinge on which the painting sits — much as the dark line of the boat in *Impression, Sunrise* (see page 27) provides a spatial focus for the painting. There is also something of the same use of complementary colors, orange and blue, with the orange predominating, and there is opposition, or contrast, in the paint surface itself, with the broad areas of sky and water painted fluidly and the foliage done with dense dots of drier paint. It is interesting to see the change in painting technique between the actual foliage and its reflection. The foliage has a quality of solidity which in the slightly deeper color of the reflection is given a vertical floating look. The tall tree on the right reveals a further characteristic of Monet's method. The form is crossed by a number of dragged strokes made with the brush handle which slightly lighten the density of the form, an improvisation which shows a concern with effect rather than with traditional finish.

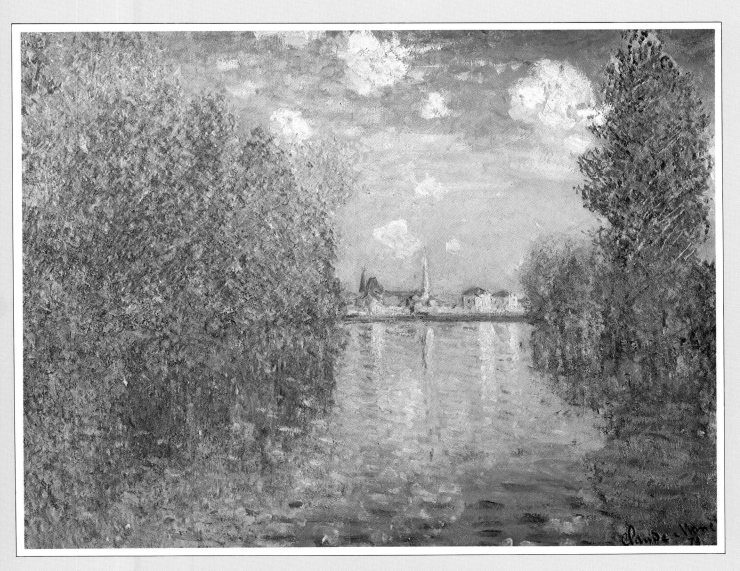

The mass of foliage on the left almost reaches to the center of the painting — the dark spire — and dominates, with its reflection, the left half of the work. A soft, almost amorphous shape, it contrasts with the sharper colors and more definite form of the tree on the right, the lower foliage on the right being indeterminately treated. Apart from the signature, the darkest tone is found, as a note of emphasis, on the middle right edge. The central section showing the town sits on a strong, thick blue line, stabilizing the whole composition. This line, although visually artificial, adds a sharp middle between water and sky, containing something of both.

1

2

1 The main interest in this detail is perhaps the revealing fact that the density of paint in these distant features is the same as in the foreground, although recessive colors — blues and violets — have been used. This similar treatment of the paint surface over the whole picture has the effect of emphasizing unity, so that it is seen as a coherent painted surface rather than a depiction of space.

2 There is a marked difference in the paint surface of the trees and that of their reflections, although they are both heavily worked, thick paint. There is no precise division between foliage and water, but there is vertical smeared brushwork in the water area which is crossed by horizontal blue dashes which determine the surface, whereas the foliage itself is worked with close, stabbed brushstrokes. Monet's usual palette can be discerned in this detail. It included viridian, cadmium yellow, vermilion and cobalt blue, in mixture and with white. Some delicate vertical strokes of yellow-orange crossed by blue enliven this area — a characteristically Monet touch.

3 *Actual size detail* Monet's impasto technique, with overlay on overlay of dry dragged paint, is clearly revealed in this detail. Flecks of wet blue and cloud white suggest fluttering movement. The thick paint, which could have been too solid, is relieved by scoring into it with the handle of the brush so that the underpainting is revealed in places. The great number of colors used, from Prussian blue to vermilion, produce a characteristic density of effect.

3 *Actual size detail*

THE GARE SAINT-LAZARE

1877

$29\frac{1}{2} \times 41\frac{1}{3}$ in/75 × 104.7cm

Oil on pale primed canvas

Musée d'Orsay, Paris

Saint Lazare station was the Paris railway terminus which served what might now be called "Monet country." It was the station not only for Argenteuil but also for most of Monet's favorite locations in northern France, including Le Havre, Chatou, Bougival, Louveciennes, Ville d'Avray, Rouen and Vernon (for the branch line to Giverny).

In 1876 Monet took a studio apartment in Rue Moncey close to the Gare Saint-Lazare, and from there, in 1877, between January and March, completed twelve paintings of the station. At this time he also had an apartment in the Rue d'Edinbourg, even closer to the station, so including his house at Argenteuil he actually had three residences. Evidently he was far from being poor.

As a group, these twelve paintings represent the last of his modern-life subjects, after which he turned completely to the natural landscape. The railway station was at that time the single most powerful reminder of the importance of industrialization to modern man, and a number of painters had treated the subject, the most emotive and romantic version being Turner's *Rain, Steam and Speed* of 1844. Turner had seen the train as a powerful force thrusting itself unfeelingly through a protesting nature, a dark and menacing beast, but Monet's train is very different — a delicate shape contained in an atmospheric web made of the intricate ironwork. His concern is with light and atmosphere, just as it would have been in a landscape of trees and water, but here they have been given a special character by the presence of the smoke and steam filtering the sunlight. The subject had an obvious fascination for a painter with his interests, and the fact that he made twelve paintings in such a short time is a testament to his enthusiasm. Another reason for his haste was that the wanted to include the paintings in the Fourth Impressionist Exhibition and the closing date was in April. In the event he exhibited only eight of the twelve. Once he had completed the group he seems to have been creatively exhausted, and only produced four other paintings that year.

Although they are a sequence of paintings, they are not, in Monet's terms of reference, a series, since they show a number of different views of the station rather than exploring the changing effect of light on the same view. The treatments vary from the oil-sketch to the studio-finished work, this painting having been done on the spot. He set up his painting stand centrally under the canopy, and the symmetricality of the composition is broken by both the large carriage shape on the left and the placing of the engine a little to the right of the center of the canopy of iron girders. The directional movement in the composition is provided by the movement toward the right of the foreground figure. Again, complementary colors have been used to enhance one another, this time the mauvish smoke and the pale yellow glowing sunlight, and the carefully constructed smoke pattern is both the whole color key and the element that gives life and rhythm to the work. The brushwork is no longer directional; it is a dense impasto laid on with such delicacy that even the harsh shape of the engine is softened into a steam-bathed form. The almost ethereal light makes the figures appear more as points of movement than as actual people going about their business.

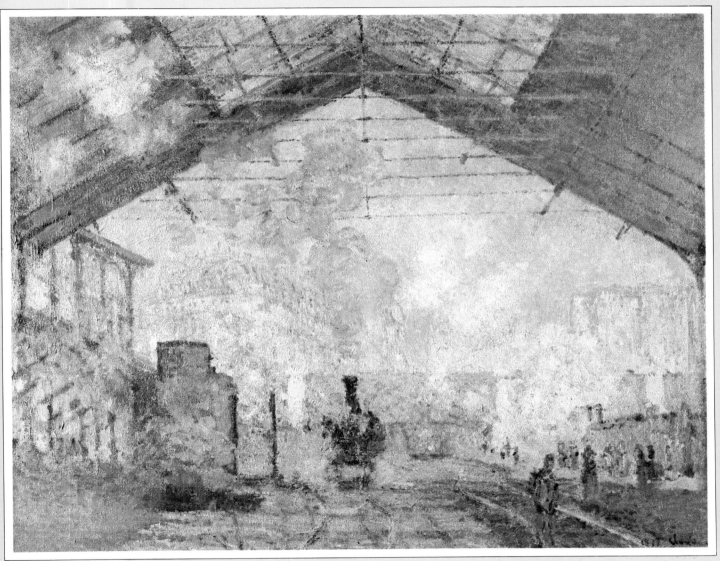

This is a carefully constructed composition which avoids too much symmetricality by simple devices of balance and placing. Although the canopy is exactly central (reflecting Monet's painting position), the engine is a little to the left, and the bulky shape of the carriage and the direction of the smoke from the engine continue the emphasis on the left side of the painting. The framework of the side of the shed extends this further, while the right side is left open, filled with light sharpened by the small dabs of sharp color suggesting figures and objects. The general warmth of color is emphasized by the floating areas of steam and smoke in white and cobalt violet tints — at once exciting and surprising. As Monet's painting developed it became increasingly high in key until the time of the later water garden series (see pages 56-61), when the deep blues and greens returned, used with an even greater mastery.

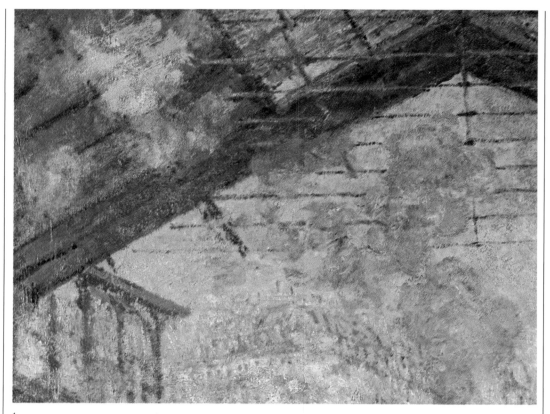

1

1 In this area Monet is accurate to an unusual degree, and the structure is clearly defined, providing a firm framework for the delicacy of the distant sunlit apartment buildings. The strong forms of the canopy are softened by the wisps of smoke which direct the eye to the dark engine smoke-stack.

2 This detail shows how roughly and sketchily the figures have been treated, with single blobs of flesh tint standing for faces and hands. The carefully placed pattern of dark brown and light red on the lefthand figure of a woman suggests the shape of the dress, but no precise description has been attempted.

3 *Actual size detail* The characteristic density of overpainting and the spatial implications it can acquire are very evident here. No form is precisely delineated but everything is seen, statically and in painterly terms. Although the brushstrokes are no longer form-following, as in *La Grenouillère*, each one nevertheless relates to form, for instance, the engine shape is specifically identified. The apparent use of black dryly overpainted on a dry underpainting is significant in suggesting Monet's desire for a deep, dark luminosity — he had not yet begun to reject the use of black on principle. The surrounding area, with orange and blue in lively conjunction, adds a forceful contrast.

2

3 *Actual size detail*

BOATS AT ETRETAT

1883

26 × 32 in / 66 × 81 cm

Oil on canvas

Musée d'Orsay, Paris

Throughout his painting life Monet was fascinated by the effect of water. From his earliest seascapes at Le Havre and Trouville, inspired by his first mentors Boudin and Jongkind, to the last greater *Waterlilies* panels (see page 57) of his water garden at Giverny, he pursued his obsession with the surface of water. Its opaque restlessness in a choppy or rough sea, its reflectivity in strong sunlight, and its paradoxical non-presence in still dark ponds, all fascinated him. This is not surprising since the most constant concern of Monet and the other Impressionists was with the ever-changing surfaces in nature.

This is one of several paintings done between 1883-86 during visits to the cliff coast near Etretat, north of Le Havre. Unlike the later true "series" paintings, such as the *Grain Stacks* or the *Poplars,* where the same view was seen under different lights, Monet chose a variety of viewpoints and locations for the Etretat paintings.

During his first three-week visit in February 1883, he started but did not finish a number of paintings intended for an exhibition at Durand-Ruel's gallery in March. After a period of estrangement Durand-Ruel had again become Monet's dealer, but in the event Monet was unable (and unwilling) to supply any Etretat paintings for this show. This particular view was probably the one that was eventually taken by the dealer in 1886 after it had been further worked on in the painter's studio. There is a degree of finish in the foreground boats that suggests studio work.

The writer Guy de Maupassant, a valued friend of Monet's, stayed with him at Etretat in one of his visits in 1885 and he has left an interesting and revealing account of Monet's working methods at the time. "Off he went, followed by children carrying his canvases,

five or six canvases representing the same subject at different times of the day and with different light effects. He picked them up and put them down in turn, according to the changing weather."

Etretat also had many artistic associations. Monet later owned a Delacroix watercolor of it; he knew Courbet's painting of boats on the beach there (one of his paintings used a similar composition) and Boudin had also used it as a subject. By 1883 Etretat had become a popular resort and, although Monet usually stayed later in the year after the Parisian trippers had left, he was nevertheless aware of its popularity with the Parisian public to whom, eventually, his paintings would be exhibited.

Fishing was an important means of livelihood all along the Normandy coast, a constant battle between the uncompromising power of the sea and the courage of the fishing folk with their small but sturdy boats, and this painting gives an impression of impending activity, with bustle on the beach and the sea choppy. The treatment of the hard forms of the boats, painted directionally as in *Bathing at La Grenouillère* (see page 25) is at variance with the looser, more atmospheric treatment of landscape and sea. It should also be noted that there is a curious inconsistency of scale in the painting: the boats on the right, whose size is established by the standing foreground figures, suggest that the two sailing boats on the left are very small indeed, while the figures in the middle distance seem out of scale with those in the foreground. The overall effect of this is to thrust the cliffs forward in the painting and to make the shore, as it approaches them, rather unconvincing. Altogether, although it may be possible to see what the artist's intentions were, the result is not completely convincing or unified.

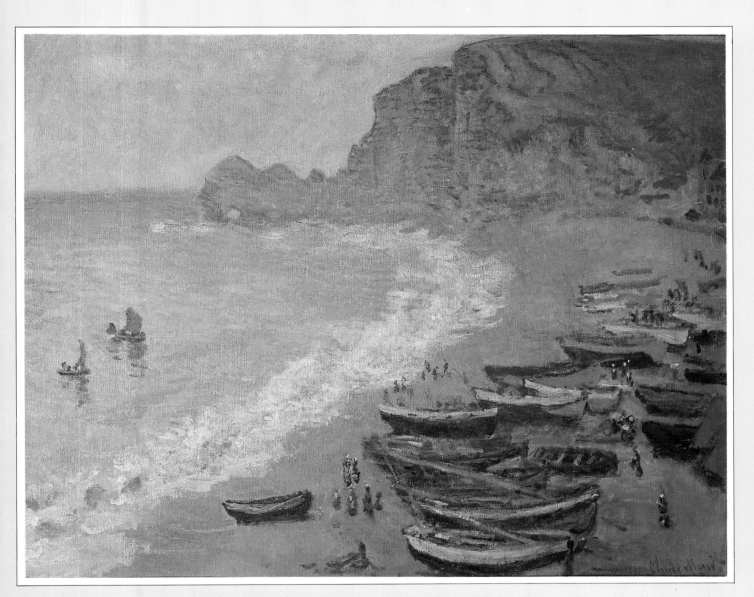

The work is thinly painted on a pale-tinted primed canvas without, for the most part, the thick impasto of the earlier *Gare Saint-Lazare* or the later *Grain Stacks*. It is essentially a small open-air sketch with all the vibrant quality of direct observation. Compositionally it is rather unbalanced, the strength of the boat forms pulling to the right. A diagonal taken from the bottom left to the top right shows two different painting procedures, with that on the left being much looser and more luminous.

1 *Actual size detail*

1 *Actual size detail* The strength of this detail lies in the full colors — viridian, cobalt, ultramarine, vermilion and cadmium yellow combined with a dark near-black Prussian blue-vermilion mixture for the shapes and shadows. The strokes are form-shaping and directional, and the figures are indicated simply and with touches of near-white for emphasis. The unity of color is helped by the fact that the tinted ground has been allowed to show through in places.

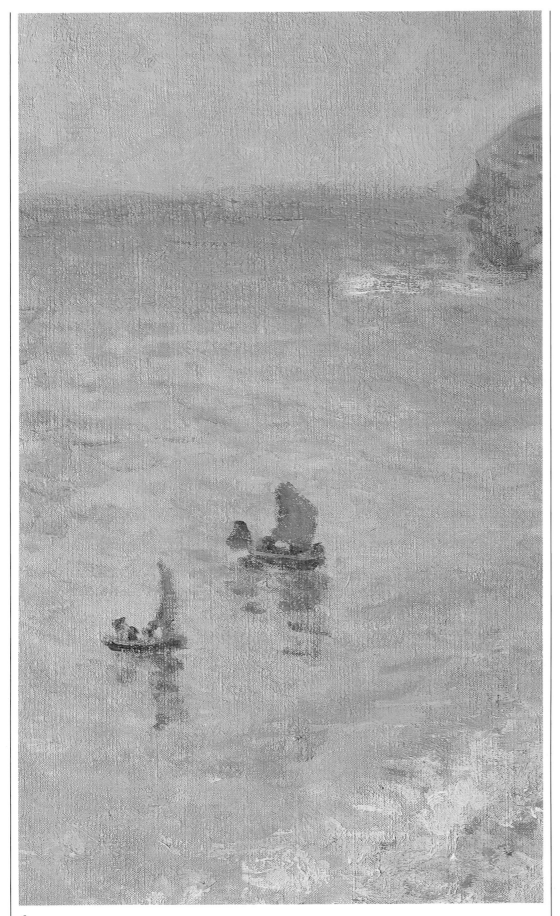

2 The sea is painted quite thinly, with the warm, creamy tint of the canvas ground being allowed to show through. The red sails, their color echoing that of the foreground boats, are composed of just one or two rapid brushstrokes of vermilion, with a little darker red-brown blended in to suggest form.

Opposite page Monet painted a great many studies of Etretat and the coastal villages nearby. *The Sea at Fecamp* is essentially a sea study, the cliffs being sketched in without, it seems, great analytical interest, but the sea evidently carefully studied to create the feeling of the great Atlantic rollers as they follow each other in quick succession to break on the beaches. *Morning at Etretat*, taken from the same position as *Boats at Etretat*, and painted on a pale gray-tinted canvas, shows a different mood and treatment. A rougher, more changeable weather pattern with sunlight on the cliffs and shadows on the sea is treated in nervous, jerky brushstrokes. There is more overpainting on the left and the color contrasts in the water are stronger — viridian, Prussian and cobalt blues with touches of yellows.

2

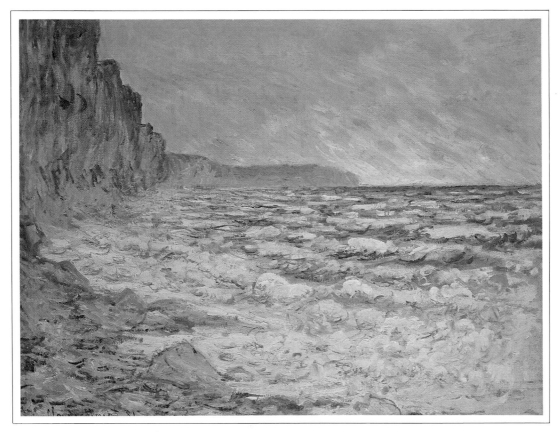

The Sea at Fecamp 1881, Private collection

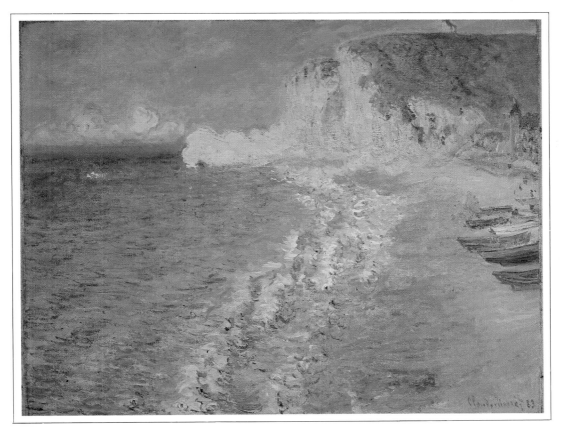

Morning at Etretat 1883, Private collection

GRAIN STACKS, END OF SUMMER

1890/1

23¾×39¼in/60×100cm

Musée d'Orsay, Paris

Once Monet had settled at Giverny with Alice Hoschedé he had a firmly established base from which, during the last years of the 1880s, he was able to make extended painting trips to other locations.

In 1890 he began a series of local paintings which marked an important stage in his development and which he himself regarded as a turning point. He continued to undertake occasional painting excursions in France and abroad, but from this time on the focus of his work, as of his life, was Giverny.

In the field facing his studio window there was a group of grain stacks from which he made his first true series paintings. Although these are frequently described as haystacks they are in fact stacks of grain or corn — the basic livelihood of the local people. In the hands of another painter, François Millet for example, these might have had a social or symbolic significance, but for Monet they were bulky indefinite forms whose structure, loose undefined shapes and varied light and color effects provided a marvelously appropriate model for his preoccupations.

For Monet the decision to paint a series came as a fresh and exciting new direction, refocusing his work from subject painting to the expression of a surrounding, ever-changing, all-embracing light revealed through color. It was not the grain stacks themselves that held the intrinsic interest for him, but the light that revealed them and the atmosphere that surrounded them. His main preoccupation, the quick changes in light effect that he encountered as he painted, had now also become his main problem. Each perceptible change really demanded a new painting since the real subject was "instantaneity'" itself. The only solution, he concluded, was to do a series of paintings each from the same spot but at different times of the day. The changes in light and color were so frequent that he evolved a method of working on a number of paintings each day,

returning to them in rotation on subsequent days when the light was exactly right. This, not unnaturally, caused him to have frequent outbursts of rage and frustration when the weather failed to co-operate.

This first series resulted in over thirty paintings, all completed between the summer of 1890 and May 1891 when fifteen of them were exhibited in a one-man show at Durand-Ruel's gallery. Monet had originally intended to show only the *Grain Stacks* series, but at the last moment he included a number of other subjects. The success of the show probably strengthened his determination to continue the series paintings.

This first series was followed by several others and, as with Turner before him, light became his master. It was when he was working on these paintings that he said: "For me, a landscape does not exist in its own right since its appearance changes at every moment; but its surroundings bring it to life — the air and the light which vary continuously." And again: "the *motif* is an insignificant factor; what I want to reproduce is what lies between the *motif* and me." Painting became a constant struggle with change — "the sun moves so quickly I can't keep up with it." And indeed he could not. Before he sent these paintings to his exhibition he worked on them, retouching them in his studio to strengthen the qualities of light and atmosphere.

This later studio working can be seen in the *Grain Stacks* paintings, in many of which the *pentimento* (the "ghost" of an old form showing through the new) and the dense, almost consistently textured impasto, particularly where the forms meet the sky, indicate the extent of his struggles. In his earlier paintings the treatment is direct and, although there is sometimes considerable overpainting, it comes from fresh vision insights, whereas in the *Grain Stacks* the surface of the canvas has become almost a battlefield of "instantaneity."

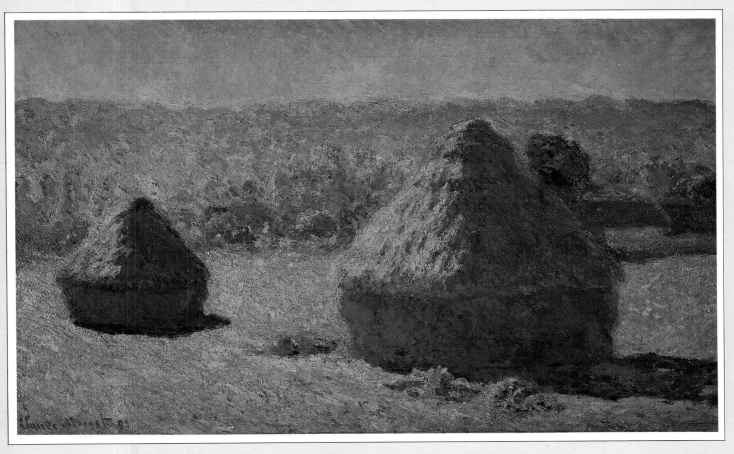

One of the last of the summer *Grain Stack* series, this one begins to show the first signs of autumn mists. The cobalt blue tint in the distant upland and the warm gray of the sky suggest a thick atmosphere that will in time roll down to cover the whole landscape, first the bright green trees and then the grain stacks themselves.

There is an interesting difference in tonal character between the two stacks. The more distant smaller stack is in a darker, muddier color with a viridian/Prussian blue cast shadow; the other is more luminous, and with the mauve and cobalt blue shadowed areas lighter in tone. The usual tonal treatment is therefore reversed.

1 In this detail the density of overpainting and the constant reworking to produce a shimmering atmospheric evening light of blue luminosity over the backing upland can be clearly seen. The free working of the trees in bright green and yellow adds the sharp touch which emphasizes the effect of warm color in the drying grain stacks, with wet paint in blue-gray drawn over a warm ocher-colored underpainting.

2 This shadow and sunlight area clearly shows the range of Monet's colors. The mauve and cobalt blue used for the stack appears again in the shadow, which is enlivened by touches of the warm oranges and greens used for the sunlit patch in front.

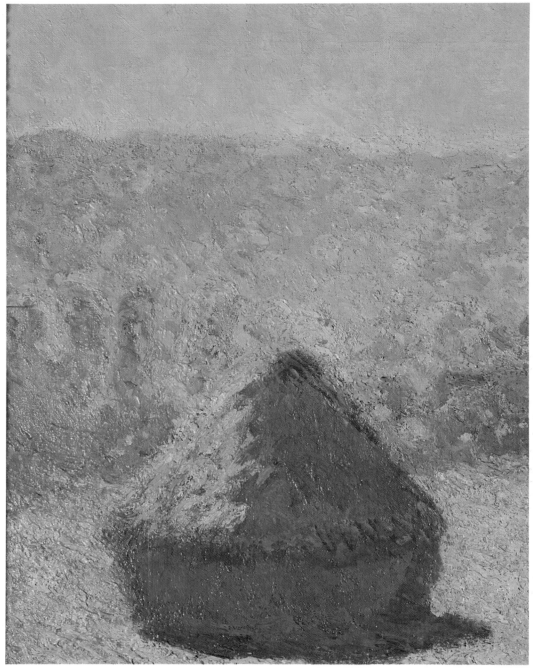

1

2

3

3 *Actual size detail* The grain stacks were painted rapidly, largely on the spot — during the course of one day Monet worked on several paintings successively. There is thus a great deal of wet paint overlaying the lower impasto as well as some fluid overpainting in the last stages.

Sometimes the paintings were finished or reworked in the studio. In this detail the warm underpainting of the stack itself has blue-violet thin paint partially covering it, which was probably added later. The touches of viridian and yellow are also probably studio embellishments.

POPLARS ON THE BANKS OF THE EPTE

1891

39¾×26in/101×66cm

Oil on canvas

Private collection

After his first Giverny series of *Grain Stacks*, with their bulky, solid forms, Monet chose a linear subject — a row of poplar trees by the side of a small river. The delicate tracery of foliage around the sharp vertical lines of the trunks and the strong horizontal emphasis of the river bank gave him the opportunity for new exercises in light. Here his *enveloppe* presented a new and exciting challenge; there was more air and sky than solid form.

Monet found the poplars marked for felling and paid their owner to leave them standing until he had finished painting them. He started in July 1891 and worked on the paintings until October, choosing mainly afternoon and evening effects, with the light falling from the right. The weather was poor at Giverny that year, and Monet, always bad-tempered when prevented from painting, became frustrated and irascible, fearing also that the trees would have to be felled before long. He complained about "this appalling weather which makes me fear for my trees."

As with his other series, he worked on a number of canvases during the same painting session, moving from one to the other as the light changed. His speed of working is astonishing: he allowed himself only seven minutes on one of the poplar paintings — "until the sunlight left a certain leaf," were his own words.

The compositions are generally of two types. The first is a vertical pattern of bars — created by the trunks — opposed to the single horizontal of the river bank, usually placed low on the canvas with the reflections carrying the line of the trunks right down through the horizontal. The second, as in this painting, takes the form of a single sweeping zigzag of foliage set against the sometimes broken verticals of the tree trunks. Here again the river bank provides a firm horizontal, and both foliage and tree-trunks are continued in the reflection.

The pictorial effect, very unusual and often very dramatic, emphasizes a characteristic which was to become a significant element in Monet's influence on later painting. It demands a positive effort of visual interpretation to turn the dramatically effective pattern of a painted surface into acceptable three-dimensional representation of a particular landscape. Because the surface is so insistent, the painting tends to thrust forward instead of receding in space. The consciousness of surface, of the paint texture rather than illusionist space, is so much a part of twentieth-century pictorial consciousness that it is easy to forget the importance of Monet and the Impressionists in the formation of this concept. The poplar series is much concerned with space, and this element is very evident.

Poplars on the Banks of the Epte was probably painted in the flat evening light, the time when the direct sun has left the scene but dusk has not begun to remove the color. We cannot be sure of this, as the time of day is not indicated in the title as sometimes it is, but there is a very closely related painting in Philadelphia which is clearly in full sunlight, and it is likely that this version was painted soon afterward.

Monet's signature, which he came to consider a significant part of his paintings, is in red, which echoes the red on the tops of the trees and provides a balancing note at the base. The signature here is used as an element in the composition rather than being an "advertising" feature, as it is in *Women in the Garden* (see page 19).

The whole series of poplar paintings was exhibited at Durand-Ruel's gallery in February 1892 — the only one of Monet's exhibitions which was devoted to a single series. This painting was included and was brought to what Monet considered "exhibition standard" by later work in his Giverny studio. Durand-Ruel was quite firm with Monet in insisting on the need for "finish."

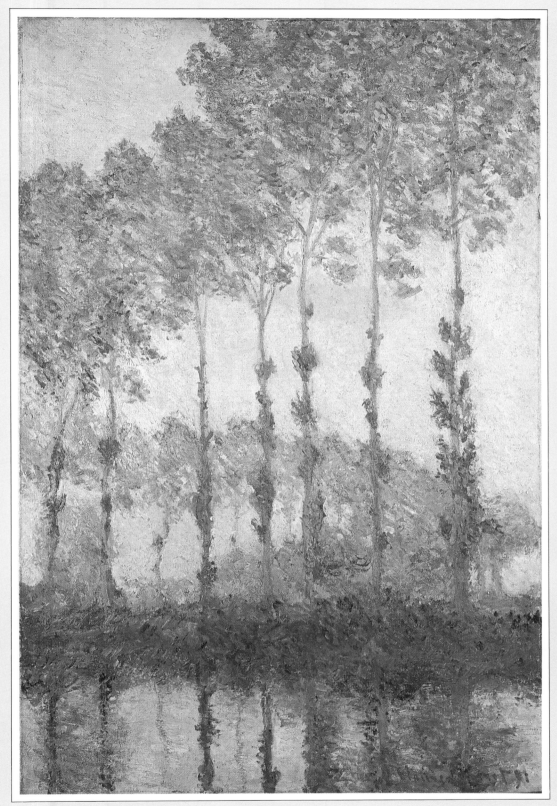

This is one of several treatments of the same view of trees, one of which shows more of the linear direction of the trees as they follow the bends of the river. Monet must have been interested in the criss-crossing of the lines as they receded along the banks to provide a pattern of receding tones and tints with a consequent loss of detail and narrowing range of tone. All these elements are to be discerned in this work, and particularly evident is the change of tone where the near bank meets the distant foliage. On the lower right the deep Prussian blue and viridian in the bank are thrust forward by the warm area, enlivened by touches of vermilion. This is the darkest and most intense area of the painting, and the foliage appears almost to float away from it.

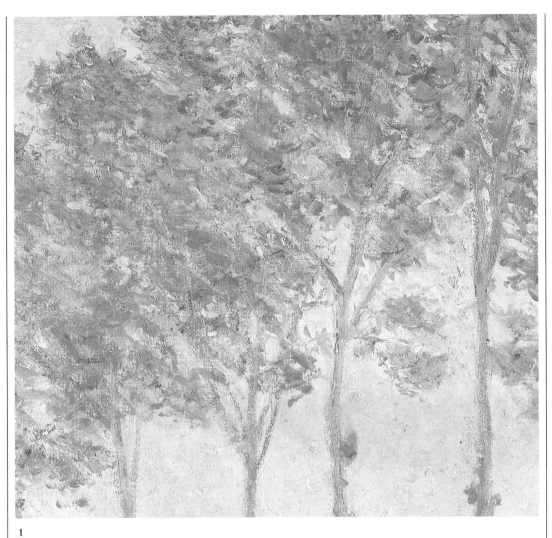

1

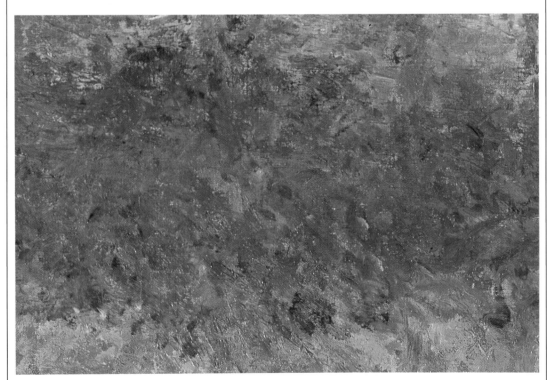

2

1 There is a delicate energy and visual delight in this area. Monet's experience in painting leaves in fluttering movement at differing times of the day enabled him to tackle this in a way that suggests enthusiasm and pleasure. Though the paint is solidly opaque, it is not heavily worked and contains flecks of many colors, deftly placed. The thin trunks of the poplars, although giving a strong vertical emphasis to the painting, are also delicately painted.

2 The density of overpainting, done in sharp, nervous, directional strokes, suggests that the resolution of this area of the painting presented the greatest difficulty. The waterline is not precise, and the bank must have been in deep shadow. The relationship of the enshrouding *enveloppe* of light with the freely painted upper area must have given problems.

3 *Actual size detail* A surprisingly separate detail — another tree or group of trees, standing apart from the poplar row, casts its reflection in the water. The color range is strongest here: bright blue-green (cobalt and viridian tints) provides a complementary balance for the strong if amorphous yellow-orange shape of the tree form and also for its darker reflection. This is painted with crossing horizontal and vertical brushstrokes expressing the water surface.

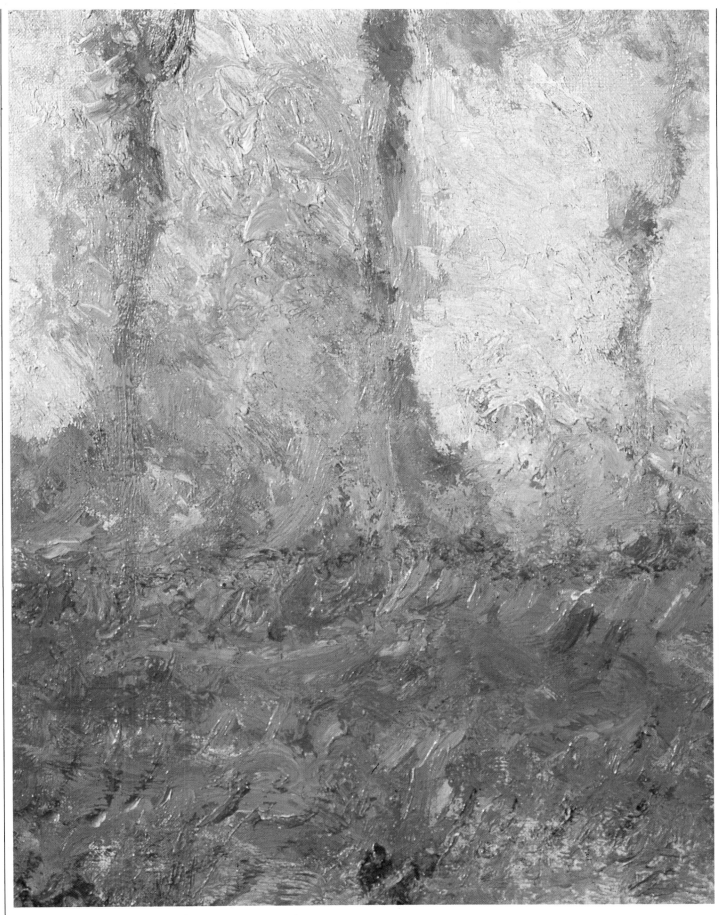

3 *Actual size detail*

ROUEN CATHEDRAL:
HARMONY IN BLUE AND GOLD

1893/4
42×28¾in/107×73cm
Oil on canvas
Musée d'Orsay, Paris

The series of paintings of the west front of Rouen Cathedral on which Monet worked during a number of visits in 1892 and 1893 are among the most important and revealing in his entire *oeuvre*. They show his full maturity as a painter, his command of technique, and his devotion to the series method of subject treatment. His ability to translate his vision into paint and his understanding of the nature of his own art were all established in front of this massive, gray, sculptured structure.

Although, as he said when he was painting the *Grain Stacks* series (see page 45), he was not so much concerned with the *motif* as what lay between the *motif* and him, the cathedral itself probably did have some emotional significance for him. The critics of the time certainly believed that this was so, and in a strongly Catholic country any subject even remotely connected with religion inevitably carries some overtones. Monet was painting at a time when Symbolism, as a literary and an art movement, was very much in vogue, and one critic went so far as to suggest that the closed doors of the west portal in Monet's painting symbolized Man's exclusion from the spiritual world. One might speculate as to whether Monet's own rejection of the Church might have had a bearing on his choice of subject. Certainly there are grounds for the theory that in these paintings Monet was looking for some extra dimension, since he was reported as telling a friend, while he was working in Rouen, that he was looking for "more serious qualities."

Most of the *Rouen* series are of the west front of the cathedral, showing most of the central portal and part or most of the tower situated to the left. They are all fully worked paintings with thick encrusted impasto surfaces, which in some cases have been subjected to drastic overpainting in colors varying considerably from the under-painting. Most, if not all, have been further worked on in the studio at a later date; the majority of them are dated 1894, the year after his last visit to Rouen. There is even a suggestion that some were entirely constructed in Monet's Giverny studio much later in his life. A friend of his, the painter Berthe Morisot, visited him after his last trip to Rouen and listed twenty-six Rouen paintings as the complete count, but at least thirty are now known. If there is truth in this implication it provides another interesting insight into Monet's attitude. We have already seen that the subject may have become more important to him than he intended, and now another of his tenets, that of *plein air* painting (giving the impression of open air by painting on the spot), seems also in question. The essence of Monet's painting and the genesis, at least in part, of the idea of series painting was his obsession with capturing the immediacy of light and atmosphere. The idea of retouching in the studio seems to contradict Monet's purpose, and the construction of a painting entirely from experience and visual memory was quite contrary to his own words. Part of the explanation for this seeming contradiction may lie in Monet's increasing success. The demands for his work were ever-growing and it is probable that in order to meet them successful *pochades* (sketches) were worked on and unsuccessful beginnings reworked in the studio, to be completed when an exhibition was imminent.

In this series Monet's major concern was with the possibilities of painting a heavy, static, large-scale sculptured form in the shape of a flat plane, on which the intricate architectural details were thrown into high relief as the light moved across it. The local (actual) color of the building is a dull gray, but in the paintings the light gives the color, almost dematerializing the forms themselves in the embracing *enveloppe* of atmosphere.

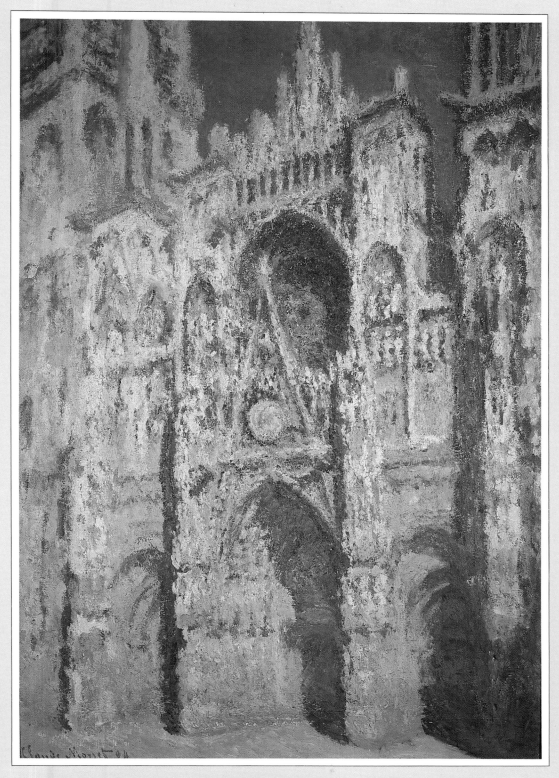

The whole painting
The title of this painting recalls Whistler's *Nocturne, Blue and Gold*, and suggests similar preoccupations; Monet knew Whistler and admired his work. Sunshine and shadow are suggested, and the heavily worked canvas also washes into white those areas not dominated by blue or golden yellow. As is often the case with Monet's paintings, the darkest area is located on the edge, in this instance at bottom right. This pulls the righthand side toward the picture plane, giving a recessive angle to the façade and a steep perspective slant to the roof line, adding a sense of movement to the heavy, solid form. The other two darker areas, the doorway and the circular west window recesses, contain within them the strongest colors, the most intense blue and gold. The shadows are consequently suffused with light and color, which washes out to the color from the full sunlight, and the whole painting is in a high key.

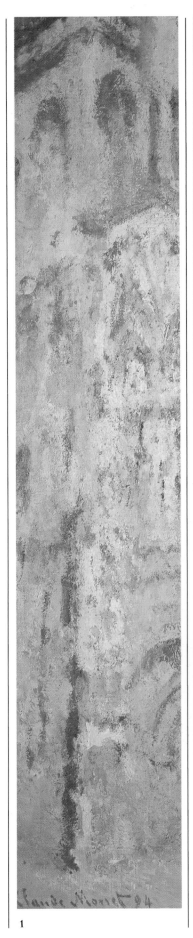

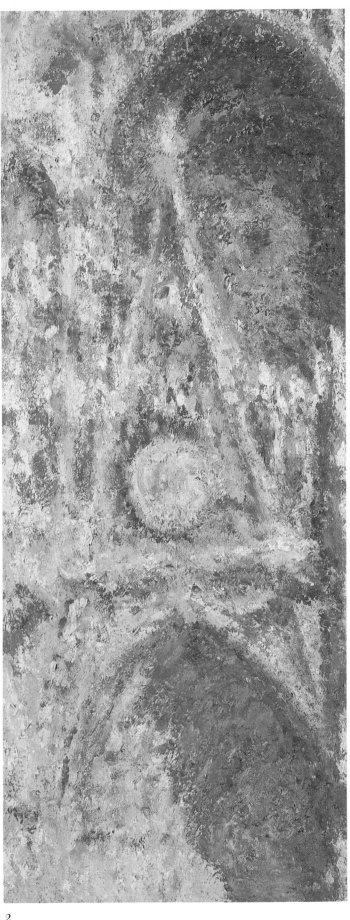

1 Comparison of this detail with the right side shows a marked difference in treatment. While on the right side the paint is, as usual, thickly and dryly applied, the left side suggests smooth pale overpainting with thin wet paint. The effect is to draw the left side into recession, focusing interest on the central portion. The brownish gray overpainting suggests a mixture of white with a little vermilion and cobalt.

2 The clock over the central doorway features in most of the cathedral series. Here the sharp red dot is almost exactly central, and with the cadmium yellow and near white, marks the brightest focus point in the painting. Its form is emphasized by the Prussian blue which surrounds it. The heavily worked paint, thickly encrusted, may well have been reworked in the studio later.

3 *Actual size detail* This detail reveals the thick, crusty paint characteristic of the *Rouen* series. Dry impasto is overlaid with touches of bright color. The yellows (probably cadmium) and the browns (probably gold ocher with some cadmium yellow) create the sunlight effect on a near white paste. The blues, violets and mauves using both cobalt and ultramarine tints are complementary to the yellows and give a luminosity to the shadows. Although forms seem indistinct the architectural structure is carefully maintained.

1

2

3 *Actual size detail*

MORNING WITH WILLOWS

One panel of the *Décoration des Nymphéas (Waterlily Decorations)*
1916-26
6ft 8in×42ft 6in/2m 3cm×12m 95cm
Musée d l'Orangerie, Paris

After his second wife Alice's death in May 1911, Monet was distraught and unable to work, shunning his friends and even losing interest in his garden. He was close to despair, which was exacerbated by concern for his failing eyesight, shortly to be diagnosed as caused by a double cataract. Although by the end of the year he had begun to paint again, he seemed to feel none of the dedication and purpose that had typified him in the past. When his son Jean died in 1914 at the age of forty-seven Monet became almost a recluse, his only human contact being with his friend Clemenceau and Blanche, Jean's widow, who cared for him until his death.

Clemenceau, at this time Prime Minister and in charge of the French war effort, still managed to find time to support and encourage Monet and to give him a new enthusiasm which carried him through the last decade of his life. Clemenceau persuaded Monet to reconsider an idea that the artist had projected earlier — for a series of large mural-sized water landscapes. Monet financed this project through the sale of old works; he had few newly painted canvases to sell since he had produced very little for the previous three years. He had a large new studio designed and built especially for the project (although with the shortage of labor caused by the war it was not completed until 1916.) Although Monet disliked the look of this huge, factory-like structure in his idyllic garden setting he nevertheless worked in it on the *Waterlilies* panels for the next ten years. The work tormented him; at moments he felt like destroying everything he had done and starting again, while at others he was buoyed up by the success of his efforts. He painted and repainted, employing thick impasto underpainting and thin wet over-painting; he spent hours in contemplation and then worked either furiously or steadily for short periods. He felt he had never completed the paintings and that he never would, but nevertheless they became an ever-deeper expression of his vision.

Although he had concentrated on waterlilies and the water garden since 1905 these panels marked a new departure for Monet. Firstly they extended horizontally to provide a much wider field of vision than he had considered before, and secondly they were on a much larger scale than anything he had previously attempted. These two factors alone might have daunted even an energetic young

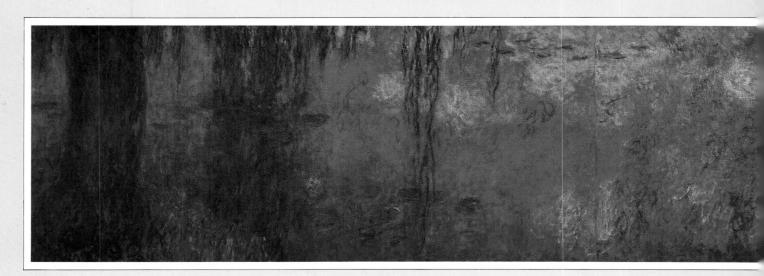

painter, but Monet was old and his eyesight was poor and failing.

But the problems were not only physical and emotional. Much later Walter Sickert (1860-1942) expressed the view that Monet had "yielded to a fatal enlargement of scale that called for the strictest limitations of area." What he meant was that the paintings were on a huge scale while the subject — the surface of the water in his own water garden — was not. There are twelve panels, all exploring the same subject, this one alone being over six feet high and over forty-two feet long. No other large mural project in the history of art has attempted such concentration on one limited subject.

Sickert's comment gives rise to the question of whether the scale is actually too large for the content. Monet's obsession with water surfaces, particularly those he observed in his own water garden, can possibly be seen in the last analysis as a program of decoration, more of a record of obsession than a progressively renewing sense of discovery. Even so, the achievement is immense. No one can be in the presence of these panels without a feeling of spiritual enlargement as well as a pure physical delight in the paint surface and color. The very presence of the works is affecting and their scale is such that no reproduction can really convey their atmosphere.

The paint quality contributes enormously to the feeling of this floating world, as consisting of points of light over a varying blue depth; dense overpainting combines with lightly drawn-on color to pull the eye across the surface with constant pleasure. What is so captivating is the paradox of flat depth; the consciousness of the painting surface, mentioned earlier, here becomes palpable.

Monet donated these panels to the nation by an agreement signed in 1922 and they were placed in the Orangerie in 1927, a few months after his death. He never believed that he had finished them.

The subject matter of these panels is a panorama of the water surface of Monet's water garden, and the color consists for the most part of cool blues, greens and deep mauves, given heightened value by the luminous yellows and pinks and by the flowers picked out in sharp contrast. Monet saw the whole decoration as a continuous horizontal for a circular room.

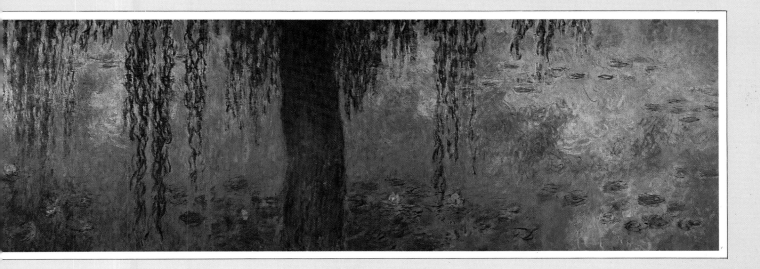

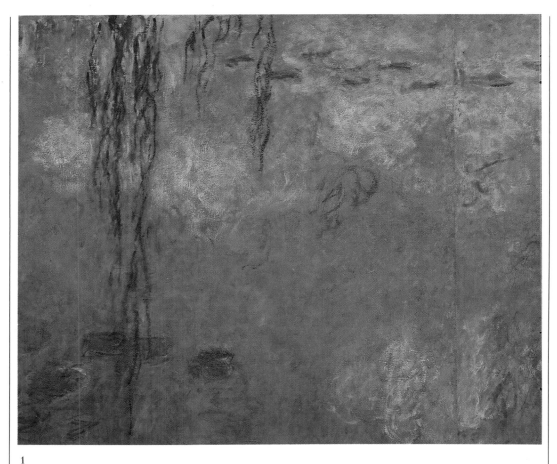

1

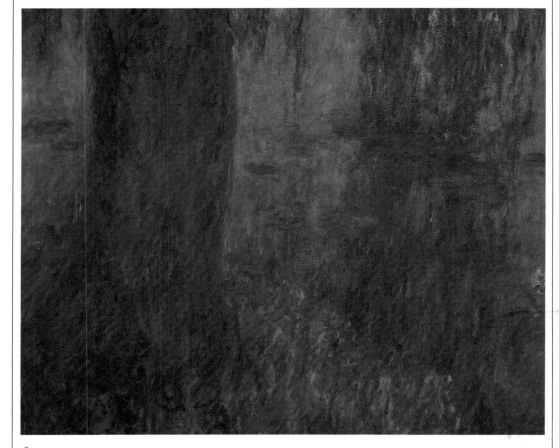

2

1 "The essence of the motif is the mirror of water whose appearance alters at every moment thanks to the patches of sky that are reflected in it, and which give it light and movement." This detail exemplifies Monet's comment, suggesting the sky within the water, sunlit with roseate clouds. Painted with thick paint in large action strokes and delicate touches, it expresses the controlled mastery achieved after a lifetime of experience.

2 The predominating paint quality of Prussian blues, ultramarine and viridian, mixed in the light areas with white, is balanced by the introduction of warm browns on the trunk of the tree and points of sharp yellow in the grasses. The deep, almost mysterious, shadowed water thrusts the bright green bank into prominence. It is part of the marvelous coherence of these panels that this balance of strong vertical notes and floating and amorphous areas of rich color is maintained in a moving balance throughout the whole project.

3 *Actual size detail* This detail of a single waterlily flower painted in sharp color in a dense impasto pigment gives, by implication, an insight into the great physical tenacity Monet showed in the production of these immense panels. When one reflects that this work was carried over hundreds of square feet of densely painted canvas, with layers of overpainting and repainting one can only be amazed at Monet's physical and mental reserves.

3 *Actual size detail*

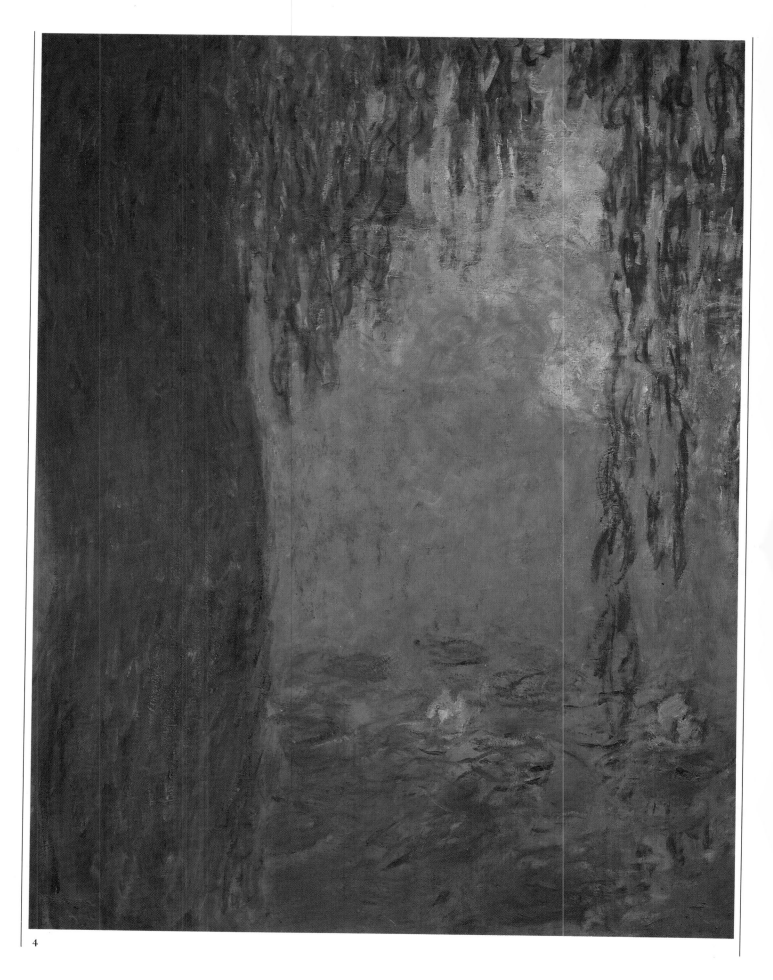

4

4 The floating indeterminate surface is thrust into its proper relationship with both the edges and the picture plane by the use of solid forms either in the water or on the banks. In this detail the falling fronds of weeping willow send the cloud reflection into a steep perspective recession which is brought back to the water surface through the use of dark and strong color on the lower edge.

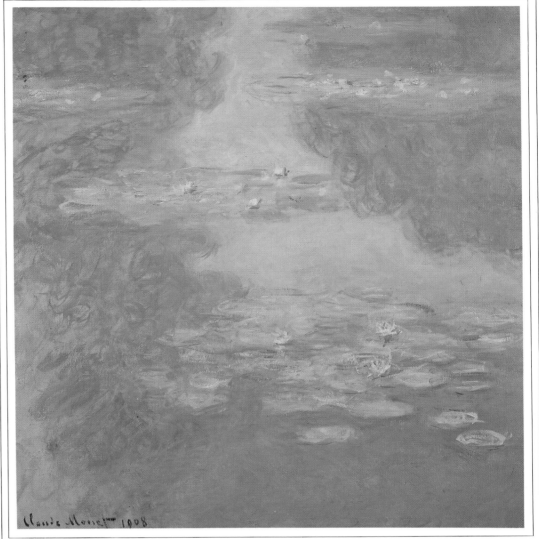

Waterlilies, 1908

Right Monet made his first paintings of the water garden in 1892, and by 1900 it had become his main subject. The earlier paintings, of the Japanese bridge spanning the pond, had taken a standard eye-level perspective, but now he began to concentrate more and more on the water itself, looking down from a high viewpoint, with nothing visible except the water, the floating flowers and water plants and the ever-changing reflections of the sky. In 1909 a group of forty-eight of Monet's waterlily paintings was shown as the Durand-Ruel gallery, and it was at this time that the idea of the great decorative panels began to take shape in his mind.

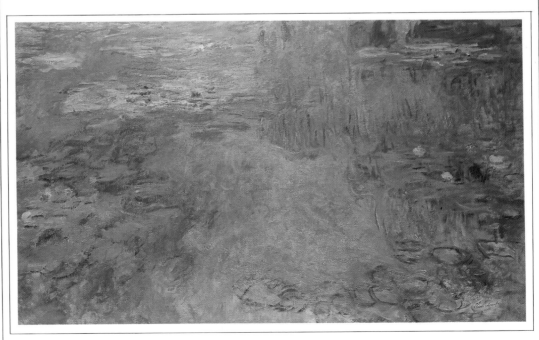

Waterlilies, 1919

INDEX

Page numbers in *italic* refer to the illustrations and captions

A

academic painting, 18
Academicians, 11, 18
Algeria, 9
Argenteuil, 7, 8, 10, 11, 30, 34
Autumn at Argenteuil, 30, *31-3*

B

Ballou, 12
Balzac, Honoré de, 11
The Bank at Gennevilliers, 8
Barbizon school, 7
Bathing at La Grenouillère, *13,* 22, *23-5,* 30, *36,* 38
Bazille, Frédéric, 9, 10
black, Monet rejects, 18, *20,* *36*
Blanche painting, 14
Boats at Etretat, 16, 38, *39- 42*
Bonnard, Pierre, 15
Boudin, Eugène, 7, 9, 18, 38
Bougival, 22, 34
Bouguereau, Adolphe, 11
brushes, 13
 handles, 30, *32*
brushstrokes, 13, *13, 20,* 22, *23*
 'drawn', 9
 enveloppe, 30
 impasto, 9, *25, 32,* 34, 44, *47, 52, 54, 56, 58*
 sketches, *7*
 tache method, *10,* 13
Butler, Theodore, *11*

C

Caillebotte, Gustave, 7, *14*
canvases, 13
Carolus-Duran, *Portrait of Claude Monet, 6*

Catholic Church, 52
Cézanne, Paul, 12
Chatou, 34
chronology, 16
Clemenceau, Georges, 15, 56
color: academic painting, 18
 color range, *50*
 complementary, 26, *27,* 30, 34
 contrasts, *25, 42*
 Impressionists' preoccupation with, 7
 Monet's painting methods, 13
 palette, *13, 32*
 recessive, *32*
 shadows, 18, *20, 46*
 unity of, *41*
complementary colors, 26, *27,* 30, 34
composition, *19,* 22, *27,* 34, *35, 39,* 48
Constable, John, 7
Courbet, Gustave, 38
croquis (rough draft), 22
Cubism, 9

D

Degas, Edgar, 6, 10
Delacroix, Eugène, 38
Dickens, Charles, 6
Doncieux, Camille *see* Monet, Camille
Durand-Ruel, Paul, 11, *12,* 30, 38, 44, 48, *61*

E

ébauche (oil sketch), 22
England, 7
enveloppe, 22, 30, 48, *50, 52*
esquisse (preliminary sketch), *7, 8,* 22

Etretat, 38, *39-43*
étude (sketch), 22

F

Fauvism, 9
figures, *14,* 18, *19,* 22, *25,* 34, *36*
First World War, 9, 56
Flaubert, Gustave, 11
foliage, *19, 20,* 22, *25,* 30, *31, 49*
form, academic painting, 18
Franco-Prussian War, 9-10
French Academy, 11, 18
Futurism, 9

G

The Gare Saint-Lazare, 9, 34, *35-7, 39*
Gauguin, Paul, 6
Giverny, 9, 12-15, *12, 15,* 34, 38, 44, 48, 52
Gleyre, Charles, 9, 11, 18
Golden Section, *27*
Grain Stacks, 13, 38, *39,* 44, 48, 52
Grain Stacks, End of Summer, 16, 44, *45-7*
La Grenouillère, 22

H

highlights, 18
Hoschedé, Alice (Monet's second wife), 11, 12, 14, 15, 44, 56
Hoschedé, Blanche, *12, 14, 15,* 56
Hoschedé, Ernest, 11, 12-14
Hoschedé, Germaine, 15
Hoschedé, Suzanne, *11*
Hugo, Victor, 11

I

impasto, 9, *25*, *32*, 34, 44, *47*, 52, *54*, 56, *58*
Impression, Sunrise, 6, *16*, 26, *27-9*, 30
Impressionist exhibitions, 6, 11-12, 26, 34
Impressionists, 6-7, 10, 11, 26, 30

J

Japanese prints, *7*, 8, 15, 18
Jongkind, J.B., 9, 38

L

Le Havre, 9, 26, 30, 34, 38
Leroy, Louis, 11-12
London, 26
Louveciennes, 34

M

Manet, Edouard, 14, 18, 22, *25*
 Déjeuner sur l'Herbe, 18
 Olympia, 18
Maupassant, Guy de, 11, 38
Millet, François, 44
modeling, 18
Monet, Camille (Monet's first wife), 9-10, 11, 12, 18
Monet, Claude: at Giverny, 12-15, *15*, 44
 character, 6, 14-15
 death, 15
 early life, 9-10
 failing eyesight, 15, 56, 57
 influences, 22, *25*, 26
 painting methods, 8-9, 13, *13*
 struggle to record nature, 7-8

Monet, Jean (Monet's son), 9, 10, 15, 56
Monet, Michel, 12
Morisot, Berthe, 52
Morning at Etretat, 13, 42
Morning with Willows, 56-7, *57-61*
motifs, 44, 52

N

Nadar, Felix, 11
Normandy, 9, 38
Nymphéas (Waterlilies), 8, 15, 38, 56, *61*

O

open-air painting, 9, 22, 52
Orangerie, Paris, 15, 57
overpainting, 22, *25*, *28*, *36*, *42*, *46*, *47*, *50*, 52, *54*, 56, 57

P

palette, *13*, *32*
Paris, 9-11, 12
pastels, *11*
peinture claire, 18
pentimento, 44
perspective, *25*, *53*, *61*
Picasso, Pablo, 9
Pissarro, Camille, 8
plein air (open-air) painting, 9, 22, 52
pochade (sketch), 22, 26, 52
Poissy, 12
Poplars, 38
Poplars on the Banks of the Epte, *16*, 48, *49-51*
priming, canvases, 13

R

railway stations, 34, *35-7*

recessive colors, *32*
Regatta at Argenteuil, 7, *10*
Renoir, Pierre Auguste, 8, 9, 10, 22
Rouen, 34
Rouen Cathedral, 6, 52
Rouen Cathedral: Harmony in Blue and Gold, 52, *53-5*
Roussel, Ker-Xavier, 15
Rue Montorgueil: Fête Nationale, 8, 9, *13*

S

Saint Lazare station, 34, *35-7*
Salon, 11, 18, 22
Salon des Refusés, 11, 18
Sand, George, 11
Sargent, John Singer, *Monet Painting on the Edge of a Wood*, 12
scale, 38, 57
The Sea at Fecamp, 42
Seine, river, 8, 12, 14, 22, 30
The Seine at Porte-Villez: Winter, Snow, *10*
series paintings, 34, 38, 44, 48, 52, 56-7
shadows, *53*
 colors, 18, *20*, *46*
A Shady Walk, 15
Sickert, Walter, 57
signatures, 48
Sisley, Alfred, 9
Sisley, Pierre, 15
sketches, *7*, *8*, 22, *23*, 26
Société Anonyme des Artistes, Peintres, Sculpteurs et Graveurs, 11-12
Stendhal, 11
Surrealism, 9
Suzanne, *11*
Symbolism, 52
symmetricality, 34, *35*

T

tache method, *10*, 13
texture, 48
tone: academic painting, 18
 changes in, *49*
 tonal character, *45*
 tonal underpainting, 13
Trouville, 38
Turner, J.M.W., 7, 26, 44
 Rain, Steam and Speed, 34

U

underdrawing, 13
underpainting, 13, 18, *25*, 26, *28*, *32*, *36*, *46*, *47*, 52, 56

V

Van Gogh, Vincent, 6, 9
Vernon, 34
Vetheuil, 12
Ville d'Avray, 34
Vuillard, Edouard, 15

W

water, 30, 38, *50*, 56, 57, *57-61*
Waterlilies (Nymphéas), 8, 15, 38, 56, *61*
Whistler, J.A.M., *Nocturne, Blue and Gold*, 53
 Nocturnes, 26
Women in the Garden, 8, 18, *19-21*, 22, 48

Z

Zola, Emile, 13

PHOTOGRAPHIC CREDITS

The photographs in this book were provided by the following:
Bridgeman Art Library 10, 31-33, 35-39, 49-53; Cleveland Museum
of Art 59-61; Courtauld Institute Galleries, London 45-7; Hans Hinz,
Basel 41-43; Hubert Josse, Paris 7, 8, 12, 19-21, 55-57; National
Galleries of Scotland 23-25; Stedelijk Museum, Amsterdam 9;
Victoria and Albert Museum, London 14; Visual Arts Library,
London 6, 11, 12, 15.

Publication of this volume was made possible through the generous
support of Denison Mines (USA) Corporation and White Mesa
Incorporated. It is the intention of the donors that proceeds from
the sale of this volume be used to further the educational mission of
the museum through public programs and exhibits. Grants from the
Utah Office of Museum Services and San Juan County Economic
Development assisted with writing, editing, and graphic design.
Additional funding was provided through Utah State Parks.

White Mesa Inc.

UTAH
OFFICE OF
museum
SERVICES

UTAH
LIFE ELEVATED

San Juan County
www.utahscanyoncountry.com

THE
DONNING COMPANY
PUBLISHERS

Edge of the Cedars
State Park Museum

COLLECTIONS

Winston B. Hurst, Archaeologist
Teri L. Paul, Museum Director/Park Manager
Rebecca G. Stoneman, Curator of Education
Deborah A. Westfall, Curator of Collections

Edited by Teri L. Paul

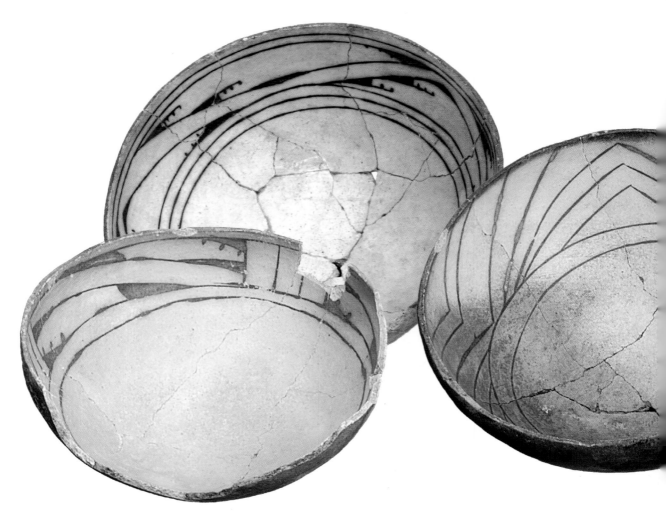

The Donning Company Publishers
184 Business Park Drive, Suite 206
Virginia Beach, VA 23462

Library of Congress Cataloging-in-Publication Data
Edge of the Cedars State Park Museum collections, / written by Winston B. Hurst ... [et al.] ; Teri L. Paul, editor
 p. cm.
Includes bibliographical references.
ISBN 978-1-57864-542-8
1. Indians of North America—Four Corners Region—Antiquities. 2. Four Corners Region—Antiquities.
3. Pueblo Indians—Utah—Antiquities. 4. Edge of the Cedars Museum (Blanding, Utah)
I. Hurst, Winston. II. Paul, Teri L. III. Edge of the Cedars State Park Museum (Blanding, Utah)
E78.S7E34 2008
979.2'59—dc22

 2008052640

Printed in the United States of America at Walsworth Publishing Company

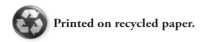 Printed on recycled paper.

Dedication

This volume is dedicated to the responsible individuals who have discovered important artifacts while hiking in the backcountry and, resisting the temptation to keep the objects or sell them, have instead reported them to the land managing agency or the museum. This allowed the discovery sites to be properly documented, so that these artifacts will forever be linked to their places of origin. These people are unselfish heroes, and the documented artifacts that they found are worth immeasurably more than all of the artifacts that were carried off and whose discovery contexts are forever lost. Many of these documented finds are featured in the museum's exhibits and pictured in this book.

The book is also dedicated to the ancient people who once lived here, and to their descendants. Edge of the Cedars Museum strives to present exhibits and programs in a culturally sensitive and appropriate manner, and works directly with contemporary Puebloan people to ensure their voice is represented in the interpretation of their own culture. The museum has worked in consultation with members of the Cultural Resource Advisory Team at Kykotsmovi, Hopi Mesas, Arizona. This has greatly enhanced the museum's ability to educate the public about past lifeways and the continuing cultures of contemporary Puebloan communities.

Thank you.

Contents

Foreword *Dr. William D. Lipe* viii

Preface x

Acknowledgments xi

Footprints of the Ancestors xii

Our Mission 2

One: A Brief History of Edge of the Cedars State Park Museum 4
 Teri L. Paul

Two: Archaeology of the Northern San Juan 16
 Deborah A. Westfall

Three: Prehistory and History of Southeastern Utah 26
 Deborah A. Westfall

Four: Artifacts at Edge of the Cedars 34
 Winston B. Hurst

Five: Pottery Collections at Edge of the Cedars 70
 Winston B. Hurst

Six: Stewardship: 86
 The Human Connection *Rebecca G. Stoneman* 86
 Stewardship in Action *Teri L. Paul* 87

 Glossary 106
 Bibliography 110
 About the Authors 116

Foreword

It's an honor to have been asked to contribute to this volume about the archaeology of Southeastern Utah and Edge of the Cedars Museum. My first responsible position in archaeology was in southeastern Utah, as a crew chief on the Glen Canyon Archaeological Project, which was designed to record and study some of the sites that would be affected by the formation of Lake Powell. Starting in 1958, I spent four summers in the field, and two winters writing excavation reports. That experience not only gave me my first publications and data for my PhD dissertation, but set me on course for a successful career in teaching and research. Fifty years later, I'm still fascinated by the early peoples and cultures of the Four Corners area.

In the late 1950s, the Glen Canyon area was a pretty remote place, so we worked out of field camps and only came into Blanding every couple of weeks to get supplies. On those trips to town, we sometimes visited Edge of the Cedars Pueblo, marveling at its size and at the thousands of potsherds scattered over its surface—it was a much larger site than anything we were encountering in the narrow canyons that fed into the Colorado River.

I also remember visits with Albert Lyman—Blanding's first settler and San Juan County's premier historian and author. Mr. Lyman was interested in what we were doing, and was always ready to share his vast knowledge of the region's history. In 1960, we were working in Lake Canyon, and Mr. Lyman told us about the time he had spent there as a very young boy, watching his family's cattle and exploring the canyon's ruins.

Albert Lyman's fascination with the past led him to envision a museum that would preserve some of southeastern Utah's remarkable archaeological record, so people from near and far could come to know, appreciate, and enjoy it. It's been exciting to see that vision become a reality with the development of Edge of the Cedars State Park Museum. In addition to providing exhibits and educational programs for thousands of visitors a year, it has well-cared-for research collections that are an irreplaceable resource for future studies.

The way that important new information can come from old collections was brought home to me a few years ago by archaeologist Phil Geib's research. Phil radiocarbon-dated fragments of woven sandals from our earlier excavations in Glen Canyon, confirming his hypothesis that certain sandal styles were several thousand years older than previously thought. Back when we did the original excavations, we had failed to recognize the significance of these artifacts. Because they had been saved, along with the records of the excavation levels they came from, Phil was able to use them to demonstrate that the Glen Canyon area had been occupied during the Early Archaic period. To add another example of the research value of museum collections: I'm working with a colleague who is attempting to extract DNA from remains of turkeys found in Ancestral Puebloan sites and preserved in museums. We hope this work will shed new light

on the as-yet-untold story of how and when this important food animal was domesticated by Native Americans.

Museums, like libraries, are part of society's collective memory. The special role of museums is to preserve physical objects that have survived from the past into the present. The pottery, stone tools, basketry, and other objects on display at Edge of the Cedars form a tangible, physical, link between our lives now and lives that came before. To me, knowing that these objects are the very things made and used by people many centuries ago makes it easier to feel a kinship with those people, and to get a glimpse into what their lives may have been like.

And, as noted above, objects that have been saved in museums can continue to be studied to help flesh out a picture of life in the past. New techniques of chemical and microscopic analysis are greatly enriching what can be learned from the study of ancient artifacts. Furthermore, these studies can usually be done on the broken fragments that make up the bulk of the research collections, rather than on the whole artifacts that are valuable for display.

Southeastern Utah has one of the richest and most interesting archaeological records of any part of the American Southwest, or of the North American continent, for that matter. San Juan County is lucky that Albert Lyman and successive generations of local residents worked so hard to build a museum that could be a center for exhibiting and studying this area's deep human history. Edge of the Cedars Museum is a tribute to their vision and their hard work in making that vision become a reality. The museum today is a vigorous organization with a highly professional staff. It plays an important role in preserving this region's Native American heritage, it serves as an educational center for students and adults alike, and it houses a treasure trove of opportunities for future research.

William D. Lipe

William D. Lipe is professor emeritus of anthropology at Washington State University and a member of the board of directors of the Crow Canyon Archaeological Center in Cortez, Colorado. From 1995 to 1997, he was president of the Society for American Archaeology. In addition to his research in the Glen Canyon area, he has done surveys and excavations in the Cedar Mesa area of southeastern Utah and in the Dolores and Sand Canyon areas of southwestern Colorado.

Preface

For many years visitors to Edge of the Cedars State Park Museum have requested a catalog of collections to have as a souvenir of their visit. Our goal for this volume was to create not just a coffee table book of beautiful photos of objects, but a resource that puts those objects in the context of the culture and landscape from which they came.

Chapter One provides a brief history of Edge of the Cedars State Park Museum and explains the significant contributions to the museum from the citizens of Blanding as well as from members of the state legislature. Chapter Two gives an overview of archaeological research and discovery in San Juan County from the early years to the present and sets the stage for the development of the museum. Chapter Three offers a background in the culture history of the area and describes the lifeways of the prehistoric population of the area, the Ancestral Puebloans. Chapters Four and Five give detailed explanations of artifact types, styles, and development over time. Chapter Four also gives a description of the major collections of the museum while Chapter Five focuses on pottery. In Chapter Six we examine the human connection that can be made with people of the past that comes through caring for cultural resources. Some personal accounts of hikers who were good stewards of cultural resources are found in Chapter Six. In addition this volume includes a bibliography for those who wish to dig deeper as well as a glossary of terms. Artifact catalog numbers are noted in the captions.

Edge of the Cedars State Park Museum's mission is to preserve, protect, study, and celebrate the diverse lifeways of native peoples of the Four Corners through dynamic exhibits and programs. With our exhibits and programs we endeavor to engage the visitor through multiple learning styles and interest levels, providing diverse routes to access and understand information about prehistoric and contemporary Native American culture. Likewise through this volume we seek to provide information to appeal to the casually interested reader as well as the scholar looking for more depth. We hope this book inspires the reader to ask more questions and seek out opportunities to learn about the indigenous cultures of the Four Corners. We also hope that the book inspires readers to spread the word about the importance of protecting and preserving cultural resources for generations to come.

Acknowledgments

Edge of the Cedars Museum began as the dream of one forward-thinking man, Albert R. Lyman, pioneer and founder of Blanding. His dream became a reality with the hard work of Blanding residents and state legislators. Since the museum opened in 1978 many people have made significant contributions to the museum as donors, volunteers, and dedicated staff members. Today, Edge of the Cedars State Park Museum is considered to be one of the finest museums in the country with a federally accredited archaeological research facility and repository, professionally presented exhibits and programs, and Edge of the Cedars Pueblo, a one-thousand-year-old Ancestral Puebloan village site.

Graphic designer Theresa Breznau of Living Earth Studios in Bluff, Utah, assisted Teri Paul with the layout and design of this volume. Erica Olsen provided invaluable editing assistance. Four professional photographers provided photos. Tom Till of Tom Till Gallery in Moab, Utah, donated use of the image of the Perfect Kiva ladder for the book and has also donated a framed print that is on display at the museum opposite the kiva ladder itself. Dewitt Jones's photo of Kent Frost with the macaw feather sash was first published in *National Geographic* in November 1982. The photo is reprinted here courtesy of Dewitt Jones/*National Geographic* Image Collection. Moab photographer Bruce Hucko worked tirelessly with Curator Deborah A. Westfall and guest author Winston B. Hurst to compose many of the artifact photos in Chapters Four and Five. J. R. Lancaster of Bluff, Utah, photographed the beetle-leg necklace in Chapter Four.

Utah State Parks Southeast Region Manager Tim Smith provided encouragement and enthusiasm for this project. His endless support of the staff at Edge of the Cedars is greatly appreciated. The staff consists of Museum Director/Park Manager Teri L. Paul, Curator of Collections Deborah A. Westfall, Curator of Education Rebecca G. Stoneman, Facilities Manager/Historic Replicator Andrew Goodwin, Museum Store Manager Kathrina Perkins, Curation Assistant Marcia Hadenfeldt, and Store Assistant Madalyn Bills. Their contributions, comments, and support throughout the process have assured the successful completion of the book.

As we move into the future the staff at Edge of the Cedars State Park Museum is committed to providing continued high-quality educational experiences for our visitors and an exceptional research facility for scholars from all over the world. We also acknowledge our role as a community museum and appreciate the ongoing support and participation of the people of Blanding, as well as the citizens of San Juan County.

Footprints of the Ancestors

It is said after the people had emerged from the reed, they were tested. Having passed the test, they were taught to build homes both round and square using stone, and were instructed to migrate to the four corners of this world. As the clans migrated they placed their naatoyla *alongside their* wu'yas *as proof of their fulfillment of their covenant with the Guardian of the Fourth World. These signs are known today as* pictographs *and* petroglyphs *by archaeologists and can be seen in many places throughout the Southwest and North America.*

Clay Hamilton, Sowihayiwma
Ala-lenya Wungwa (Horn Flute Clan)
Walpi, First Mesa, Hopi, Arizona

Rock art, pottery sherds, ruins, and all physical remains from the past are considered to be evidence of the migration. These things are considered to be the footprints of the ancestors and as such, all are sacred. In this way, the Hopi know the places of their ancestors.

The story has often been repeated that the Ancestral Puebloans "abandoned" their homes and villages. By 1275 the area was largely emptied of human occupation. The Hopi do not accept the idea of abandonment. Rather, they view the time when their ancestors left the ancient cities, towns, and villages as a continuation of migrations.

The people migrated for hundreds of years under the spiritual guidance of Masaw, the Guardian of the Fourth World. Hopi oral tradition says that long ago the people lived in the world before, known as the Third World. Something happened in the Third World and the people had to flee. They climbed a reed up into the Fourth World, the world we all live in now. Masaw told the people to leave their mark along the migration route to show that they had been there. Symbols seen in rock art imagery such as spirals, mountain sheep, or flute players are evidence that clans, some still existing today, passed by many years ago.

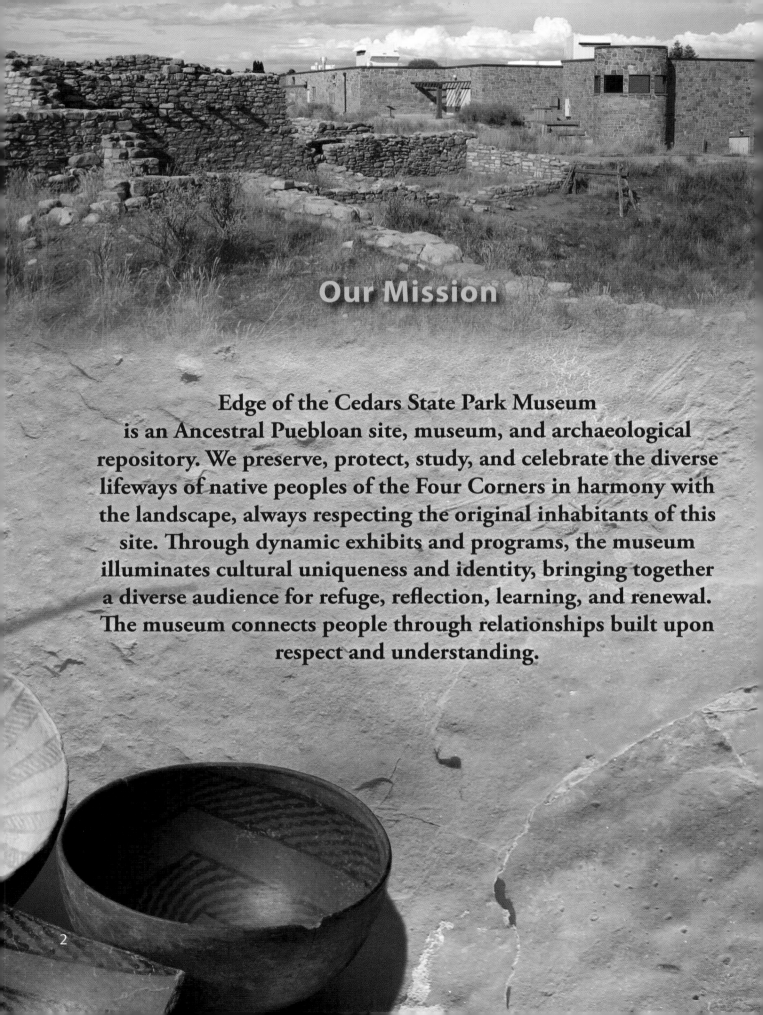

Our Mission

Edge of the Cedars State Park Museum
is an Ancestral Puebloan site, museum, and archaeological
repository. We preserve, protect, study, and celebrate the diverse
lifeways of native peoples of the Four Corners in harmony with
the landscape, always respecting the original inhabitants of this
site. Through dynamic exhibits and programs, the museum
illuminates cultural uniqueness and identity, bringing together
a diverse audience for refuge, reflection, learning, and renewal.
The museum connects people through relationships built upon
respect and understanding.

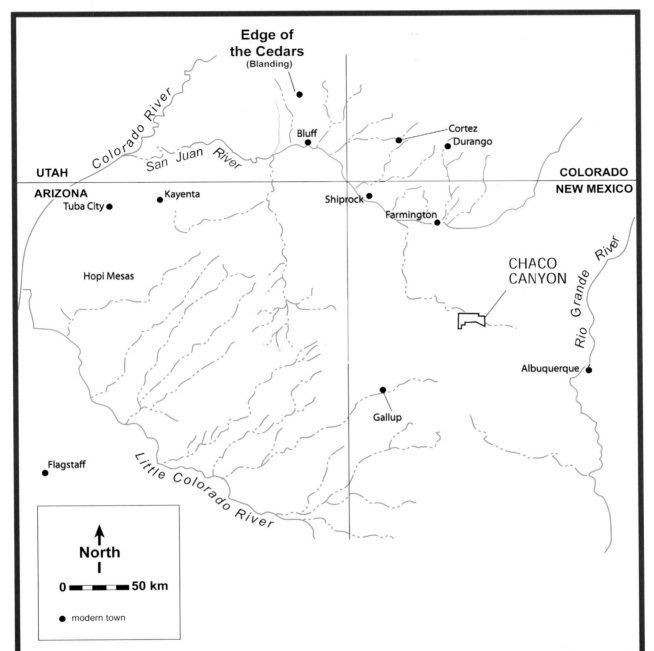

**Edge of
the Cedars**
(Blanding)

Colorado River

San Juan River

Bluff

Cortez
Durango

UTAH
ARIZONA

COLORADO
NEW MEXICO

Kayenta

Shiprock

Tuba City

Farmington

CHACO
CANYON

Hopi Mesas

Rio Grande River

Albuquerque

Gallup

Flagstaff

Little Colorado River

↑
North
|

0 ▬▬▬ 50 km

● modern town

Figure 1.1. Four Corners Region Map.
Edge of the Cedars State Park Museum is the location of an Ancestral Puebloan village site, a world-class museum with educational exhibits, and a facility for archaeological research and *curation* of documents and artifacts. The museum is located on White Mesa, a south-sloping bench of the Abajo Mountains where the pinyon-juniper and sage-grassland habitats come together. Immediately to the east is the pioneer town of Blanding, settled in 1905. To the east, west, and south of Blanding the wild canyon country spreads out as far as the eye can see—a part of the northern San Juan River drainage that ultimately joins the Colorado River at Lake Powell. From the museum one can see all the way to the Hopi Mesas in northern Arizona, to Sleeping Ute Mountain in Colorado, and to Shiprock in northwestern New Mexico. The Ancestral Puebloans and the pioneers found this to be a good place to settle. It offered ample water, good farmland, and plentiful game and wild plant foods. (Graphic by W. Hurst.)

A Brief History of Edge of the Cedars State Park Museum

Edge of the Cedars Village lay silent for eight hundred years, as if waiting for a future time to share its secrets. This place was once home to the Ancestral Puebloans. They were people similar to us—living, dying, raising children, gathering, growing, harvesting, hunting, and appreciating the bounty and beauty of the land. They were artisans and builders living on the frontier of what we now call the Chacoan world, referring to the Ancestral Puebloan cultural center of Chaco Canyon, New Mexico. The people built their homes of stone and mud in the style of the Chacoans with many rooms, multiple stories, small clan or family-size kivas, and a *great kiva*. These features tell us that this settlement, the largest on White Mesa, was an important ceremonial gathering place for people from the surrounding mesas and canyons. They lived here for several hundred years. Then, perhaps slowly at first, people began to drift away.

Edge of the Cedars was depopulated around *AD* 1225. Many retreated for a time to larger villages in the area or to remote, nearly inaccessible alcoves and caves in the canyons, taking up residence in hidden and seemingly defensive places. Within three generations the entire northern San Juan region was largely empty of Puebloan people. There are many theories of why they left. Some say a thirty-year drought drove them away. Others suggest that resources were depleted. Perhaps competition for what was left led to raiding and a climate of fear and scarcity. They may have been under pressure from encroaching ancestors of the Utes or Navajos. Probably they left due to a combination of these reasons and others we may never know. Most went south to join large Pueblo villages in Arizona and New Mexico. Their living Puebloan descendants say they left because their deity told them it was time to continue their migrations.

Theirs was a community-oriented way of life, where neighbors, clans, and families were interdependent for survival. Imagine how it might have felt to see family and friends moving away. Imagine being the last ones

Figure 1.2. Rubble mound, 1968.
This is the view that greeted the first Anglo settlers to White Mesa—a cluster of rubble mounds and depressions was all that was left of the village. Edge of the Cedars Village is located on White Mesa on a bluff above Westwater Canyon. The open site is subject to the ravages of weather and time. Eight hundred years of driving wind, pouring rain, harsh sun, and extreme temperatures have taken their toll. Sand and clay mortar that held the rock together deteriorated, and walls fell in. Wind-blown sand filled rooms and hollows, and grasses and brush reclaimed the soil, leaving low mounds of earth and broken stone dotting the landscape. (Edge of the Cedars photo, ECPR-95055.) (For more about ECPR, see Glossary.)

left. There would not have been enough people to do the planting, harvesting, and food preparation and storage for the long winter. There would not have been enough people to keep traditions and ceremonial life going. They left behind their structures, broken pottery, chips of stone, tools, rock art, and family members who had passed on. All clues left for the future to unravel.

Others moved through the area after the people left. The Navajo and Ute people used the resources from the Abajo Mountains to the San Juan River Valley for several hundred years. The homes of the ancient people were generally avoided and unused. With the coming of the first Anglo explorers and pioneers in the late 1800s, this would change. As the newcomers settled and got to know the land, they were intrigued by the ruins of villages like this one. Exploring parties from East Coast universities and museums undertook collecting expeditions in the early days of archaeology for the purpose of filling museums and learning about the past. Local settlers looked on the ruins in wonder even as they used fallen stone from the old structures in the foundations of their new homes.

Blanding's Visionary Founder

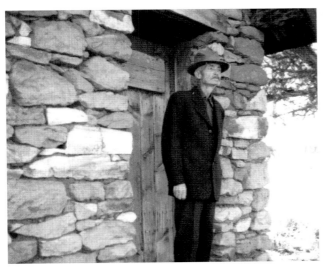

Figure 1.3. Blanding founder Albert R. Lyman in front of his writing room called the Swallow's Nest, 1930s. The restored building stands at the Blanding Visitor Center. (Photo courtesy of the San Juan County Historical Society.)

In 1905 Albert R. Lyman was the first Anglo settler of the townsite of Blanding. A writer, historian, schoolteacher, and active religious leader, Lyman was intrigued by the many ruins throughout the area and had a strong interest in local history and archaeology. He had a great influence on the community's sense of identity and destiny, and he dreamed of a community museum as a place to teach about the past.

The Blanding Chamber of Commerce was committed to the idea from the beginning and in 1960 rented the first building for Lyman's museum, later to be moved to the Blanding Library. In 1967 the Blanding Museum Committee was formed to promote the development of a larger museum. They looked for sources of funding, considered different museum sites, and discussed ways of creating exhibits. Later that year the

When first I looked in wonder at the big mound, now known as "Edge of the Cedars," and considered that it had once occupied two or three acres on this splendid elevation, and that it stood three or four stories high, I envisaged the teeming life which had once made it a place of great attraction, of which the mute ruin was but a solemn reminder. A. R. Lyman, 1966

committee's work was taken over by the Blanding Chamber of Commerce. The Chamber of Commerce purchased the Edge of the Cedars ruin and some adjacent property in 1967. In 1968 the Chamber of Commerce transferred leadership of the project and property title to the San Juan Resource Development Council, which later became the Utah Navajo Development Council.

In order to open the site for tourist visitation, extensive excavations and some reconstruction were conducted. Weber State College and Brigham Young University were invited to excavate the ruin, and field schools were held during the summers of 1967–70. The college students were assisted in the excavation and stabilization by small crews provided by the federally funded Neighborhood Youth Corps program.

Lyman died in 1973 at the age of ninety-two, but the community of Blanding worked hard to carry on his vision. His enthusiasm for a community museum led to the establishment of Edge of the Cedars State Park Museum. The name "Edge of the Cedars" is from the title of one of his books, an account of the settlement of Bluff and Blanding. The title also refers to the location of the town as being on the edge of the pinyon-juniper (locally known as cedar) woodland and sage-grassland habitats. This is significant because a place where multiple habitat zones meet provides a rich resource area with a great diversity of plants and animal life. This was important to the survival of the ancient inhabitants and the pioneers.

Gathering community support, the Utah Navajo Development Council worked closely with State Representative Calvin Black to pass Senate Bill 18, which established Edge of the Cedars State Monument and Museum of Indian History. The bill was signed into law on April 4, 1974. The council then donated the ruin and property to the State of Utah for the park. Senate Bill 18 gave authority to manage the property and ruin to the Department of Natural Resources, Division of Parks and Recreation. Over $180,000 was raised for the construction and operation of the museum.

The museum opened to the public in 1978, the result of a long quest to develop a quality museum to educate the public about the cultural heritage of southeastern Utah. The Utah Navajo Development Council helped assemble artifact collections from San Juan County and provided exhibit cases. In the late 1980s additional property was purchased to protect against encroachment and to allow for increased vehicle and bus parking and building expansion.

Figure 1.4. Edge of the Cedars Museum under construction in the late 1970s.
(Edge of the Cedars photo, ECPR-95072.)

Figure 1.5. Completion of building, aerial view, 1978.
Note the excavated ruin in the upper right corner.
(Edge of the Cedars photo, ECPR-95078.)

Figure 1.6. Inset: Close-up aerial view of ruin, 1978.
(Edge of the Cedars photo, ECPR-95078.)

Weber State College Field School 1969–70

The 1969 and 1970 summer excavations were directed by Dee Green of Weber State College. Green supervised Neighborhood Youth Corps crews and Weber State students in excavations into the *great house* mound. They excavated Kiva 1 and several adjacent rooms and located various walls throughout the big mound. Accomplishments of the Weber State College field school included the drawing of the first map of the site. They recognized the importance of the central pueblo and the great kiva and noted that Kiva 2 was Chacoan in style making the first connection to the greater Chacoan culture centered in New Mexico. They found that the site had been occupied twice during the Pueblo I and Pueblo II periods and that parts of the ruin had been burned at the end of its occupation. Excavations uncovered trade items such as copper bells and pottery from as far away as Mexico. Only a brief preliminary report was ever completed on these excavations.

Figure 1.7. Mapping rubble mound, 1968.
Evan DeBloois and crew from Weber State College mapped the rubble mound and surrounding site. (Edge of the Cedars photo, ECPR-95029.9.)

Figure 1.8. Excavations, 1969.
Lyman Redd stands beside a partially excavated wall at the northeast edge of Kiva 1. This photo shows late fill above the kiva and under the building rubble and reveals one of several clues that the Kiva 1 roof should have been restored at the level of the second-story floor. (Edge of the Cedars photo, ECPR-95029.9.)

Excavations of 1971: The Lost Year

In 1971 the Utah Navajo Development Council hired Brigham Young University archaeology student Tim Taylor to supervise continuing excavations. His crew consisted of workers from the Neighborhood Youth Corps and several local volunteers. They excavated Kiva 2 and some of the eastern rooms in the great house, and dug several test trenches into the great kiva. All notes from the 1971 season were kept in one field notebook, which was unfortunately lost. Except for some photographs and an artifact inventory, no documentation from the year's work survived. However, numbers written on the artifacts with permanent ink preserved the connection between the artifacts and their context.

Figure 1.9. Excavations, 1971.
Tim Taylor works in Kiva 2. All the field notes for the 1971 excavation were lost although important information is preserved in photos and documents that are keyed to the numbers inked on the artifacts. (Edge of the Cedars photo, ECPR-95029.9.)

Field Season: Summer of 1972

Excavations continued for one final season in the summer of 1972, under the direction of Jeff Fee, a student from Weber State College. The Utah Navajo Development Council hired Fee to supervise a crew of Neighborhood Youth Corps workers and local volunteers. The 1972 excavations focused on the southeastern portion of the great house. Fee's notebook documents the use of intramural beams inside one of the great house walls, extensive remodeling west of the great kiva, and at least one major reflooring of the southeast room. A trench outside the east wall exposed the only intact burial ever found at Edge of the Cedars, a child, buried just outside the great house wall.

Figure 1.10. Excavations, 1972.
Jeff Fee, John Phelps, and Brent Oleson restoring the great house roof. (Edge of the Cedars photo, ECPR-98029.9.)

State Park Excavations: 1978 to Present

Since 1978, limited excavations have been undertaken by several museum curators. Some of these were necessary to record disturbances during construction projects for the ruin trail, fencing, building and parking lot expansion, ruin stabilization efforts, and installation of signs and sculptures. Other excavations were designed to retrieve specific information or to collect comparative samples.

Museum Curators Investigate the Site

In 1980, Terry Walker taught a field archaeology course at Edge of the Cedars Pueblo. He excavated a pit structure near the south end of the *prehistoric* village (Kiva 4). This structure was not roofed, and its age was unclear.

Sloan E. Schwindt (1982, 1983) excavated two test pits in Kiva 2 to clarify architectural details prior to stabilization. Excavations determined that the floor had not been cleared by earlier excavators. A third test pit was excavated in the sediment mound east of the great house.

Winston Hurst (1986–89) conducted excavations in support of ruin stabilization activities and obtained comparative samples from trash *middens*. He located rich trash deposits on the east slope and identified key architectural features in the great house. Limited exploration of a room block from the early village was also conducted.

Marshall Owens (1993) completed a survey, map, and surface collection to prepare for the impact caused by the construction of the museum repository wing and the new parking lot.

Figure 1.11. Excavations, 1986.
Kendall Shumway excavates a Pueblo I era floor. Notice evidence of earlier features under later ones in this photo. The stone walls were built as part of the great house, great kiva complex around AD 1100. The fire pit at the lower right and the pit excavated by Shumway were used three hundred years earlier by the Pueblo I occupation. (Edge of the Cedars photo, ECPR 00.86.P17.6.)

Figure 1.12. Excavation, stabilization, and documentation, 1989. (Edge of the Cedars photo ECPR 00.89. P23.25.)

Todd Prince (1995, 1996) did surface collections and small-scale excavations for the Solar Marker sculpture construction, maintenance yard fencing, and placement of the Navajo hogan northwest of the museum.

Deborah Westfall (2000–present) has conducted limited excavations to clear test pits for new signposts and has led stabilization work in partnership with the National Park Service and the Hopi Foundation.

Figure 1.13. Stabilization of ruin, 2003.
Excavations of 1967–70 exposed the ruin to the weather and led to deterioration. Since 1978 the ruin has been stabilized periodically. In 2003 the museum began a partnership with the Hopi Foundation and the National Park Service to create a program for ongoing stabilization. (Edge of the Cedars photo.)

Visible Storage Exhibit

Edge of the Cedars is known for having one of the most outstanding collections of Ancestral Puebloan pottery in the southwestern United States. In the Visible Storage Exhibit visitors can view several hundred pieces of pottery and use the computer to scroll over photos of the pots to learn details of their style, construction, and origin. The interactive program is available through the museum store and is the perfect companion to this book. It may also be accessed online at http://stateparks.utah.gov/stateparks/parks/edge-of-the-cedars/collections.html.

Figure 1.14. The Visible Storage Exhibit displays many examples of Ancestral Puebloan pottery. (Photo by T. Paul.)

Museum visitors often ask, "Are you going to excavate the rest of the ruin?" For a number of reasons, there currently are no plans for further excavation.

In order to learn from what is buried in the ground, archaeologists must excavate carefully, taking meticulous notes about the exact *provenience* (location) of each object and its relationship to other objects, in other words, carefully recording its context. Once dug, the site is destroyed. Excavation might be done to train future archaeologists through university field schools when there is an important research question to explore. Sometimes it is necessary to excavate if a site is in danger of being destroyed due to a construction project like a road or a dam. In these cases total data recovery is done. Conducting a full-scale excavation is labor and time consuming and very expensive. These days, even when excavation is done, sites are never completely excavated, leaving intact deposits for less destructive analysis techniques that may be developed in the future. Then there is the question of where to put all of the objects found during an excavation. There might be hundreds—if not thousands—of artifacts found. Each object must be cared for properly and protected in perpetuity. Another issue that is very important to consider is what happens to the site itself. Standing walls and exposed rooms will deteriorate quickly when opened to the elements. Ongoing stabilization is very

expensive. Museum policy is to leave structures and objects buried where they have been safe and protected for over eight hundred years. This is also in keeping with the wishes of contemporary Puebloan tribes who prefer the places of their ancestors to be left undisturbed as much as possible.

The Archaeological Repository and Research Facility

By the 1980s, newly established federal standards for archaeological curation meant that the museum's limited storage facility was inadequate. This raised concerns that federal collections would be transferred elsewhere. Funding was secured for a major expansion and renovation to meet the new federal standards. Construction and renovation began in 1993. In 1996 the museum opened its federally accredited storage repository for archaeological collections. In the past, collections gathered through expeditions by out-of-state museums and universities had been taken out of the area because there was no local place to properly care for them. The repository allows artifact collections, documents, and photos to be cared for permanently in San Juan County, instead of being sent for curation elsewhere. The federally accredited archaeological repository is one of only two in the state of Utah. In order to be accredited, a facility must have a professional curator on staff, it must have adequate security systems in place, and light, humidity, heat, and cold must be controlled to provide the best conditions for preservation.

Even with the new storage facility, by 2000 it was evident that the repository would be full within five years. To solve this potential curation crisis, grants were secured through partnering agencies (the Bureau of Land Management, the USDA Forest Service, and the Utah State Parks) to purchase a state-of-the-art movable compact storage system. The new system increased storage capacity by 20 percent and allowed additional space for more shelving units to be added in the future as funds become available. The curation staff maintains archaeological collections that include organic and inorganic artifacts, documents, and photos from sites on state and federal land. The museum's holdings also include a growing number of donated collections from private lands.

Figure 1.15. The archaeological repository wing.
Edge of the Cedars is a research destination for scholars from all over the world who come to study the archaeology of southeastern Utah. (Photo by T. Paul.)

Spirit Windows Exhibit and Rock Art Sculptures by Joe Pachak

Throughout the museum the visitor may view numerous murals by Bluff, Utah, artist Joe Pachak. The mural project called *Spirit Windows* is a permanent exhibition of Native American rock art images reproduced on the stucco walls of the museum and featured in a book of the same title that is available through the museum store.

These murals are accurate representations of actual rock art panels found throughout San Juan County. Many of the rock art panels shown in the murals may only be seen in the museum, and not in the wild, because they now lie beneath Lake Powell.

Pachak designed and constructed the sculptures located on the museum grounds. These sculptures represent actual rock art images such as the mountain sheep, an important clan symbol, and a figure known as Cloud and Smoke Man, who is on the museum's logo, among others. One of the most interesting sculptures is the Solar Marker. It is a representation of a combination of several rock art archaeoastronomy sites where the play of light and shadow at the equinoxes and solstices of the year creates specific movements and shapes that may have had meaning to the ancient people. Note the photo of the spiral with a dagger of light. This effect occurs at sundown on winter solstice. Archaeoastronomy sites may have been constructed by the Ancestral Puebloans as a way of measuring time and the seasons to know when to plant or when to gather for ceremonies. A number of these kinds of sites have been found in San Juan County.

Figure 1.16. Cloud and Smoke Man sculpture. This symbol is also on the logo for the museum. (Photo by T. Paul.)

Figure 1.17. Mountain Sheep sculpture. (Photo by T. Paul.)

Figure 1.18. Solar Marker sculpture at sundown on winter solstice. (Photo by T. Paul.)

A Word About Context

The repository houses collections from throughout San Juan County and southern Grand County. Most objects and data originate from known sites on public lands that have been scientifically documented and properly collected. However, many objects from private collections that have no documentation of origin have come to be cared for at the museum. This is a real problem because artifacts that have been removed from their original context can tell us very little about the past. Archaeologists speak of "context" or "provenience," referring to the exact location of an object in relationship to other objects or features such as hearths or structures. When we know the context, we can make inferences about the use, age, and sometimes even meaning of an object. Without the context, the object becomes just another pretty pot, or bead, or sandal. Interesting for its stylistic attributes and crafting, but little else can be known.

As little as twenty-five years ago, pottery *sherds* still littered some sites so thickly that a person had to walk carefully to avoid stepping on them. Today, it is rare to find a pristine site that has not been looted by artifact hunters. The casual visitor is too often unaware of the effect of collecting "just one sherd" from a site as a keepsake. Consider that a site may be visited by hundreds of people in a year. If each takes "just one sherd" it doesn't take long for all surface evidence to disappear entirely. Recent technology has presented new opportunities for illegal artifact trafficking over the internet, and it is common to find artifacts offered for sale to the highest bidder. Though all of these objects are claimed to be "certified from private land," there is no such official certification to prove or disprove their origin. Meanwhile, sites on public land are being illegally "mined" for antiquities. These sites and objects belong to the public and to the future for study and enjoyment, and they are protected by national and state law.

The role of Edge of the Cedars State Park Museum is to care for all of the objects, provide access for scholarly research, and use the objects to teach the public about the past through educational exhibits and programs. One program that seeks to educate the public about archaeological site preservation and protection is the Utah Site Stewards Program. This program trains volunteers to monitor sites on public lands and creates a presence to discourage artifact theft and site destruction. These dedicated volunteers regularly visit sites and have the opportunity to teach visitors how to view sites safely with a "leave no trace" ethic: Take only photographs, leave only footprints. They discourage the practice of adding to a "museum rock," a stone where others have collected objects together. Remember that context is **everything** and moving an object, even to another place on the site, destroys the context.

Ours is a message of preservation and protection of cultural resources. If you are hiking in the backcountry please be respectful of archaeological sites and artifacts and appreciate them in place as you find them. Leave them for others to learn from and enjoy in the future. However, if you find an object or site that is clearly in danger of being destroyed or removed, contact the land managing agency and report the location. You may find yourself participating in a great adventure assisting an archaeologist to properly collect the object. Be sure to read the stories of people who did just that in Chapter Six.

Archaeology of the Northern San Juan

For over a century the impressive archaeological sites of southeastern Utah have captured the interest of scientists, the attention of collectors and museums, and the imagination of the American public. Archaeological interest began in the 1870s with a series of expeditions sponsored by the U.S. government to explore, map, and describe the natural and cultural resources of the western territories. Significant to Utah, and to the other states in the Four Corners region, was the Hayden Survey of 1875–76. Among the members were William Henry Holmes and William H. Jackson, who reported on and photographed many of the more spectacular ruins in what is now southwestern Colorado and southeastern Utah (Holmes 1876; Jackson 1876). Because of these reports, museums throughout the country sent out exploring and collecting expeditions. These expeditions were aided by people who lived in the western territories and who had already been digging in the ancient ruins for prehistoric artifacts to sell to collectors and museums (Atkins 1993).

In 1892 the *Illustrated American* magazine of New York City hired Warren K. Moorehead, an archaeologist formerly with the Smithsonian Institution in Washington, D.C., to lead an expedition into the *cliff dweller* country of Colorado and Utah. This was one of the first organized parties sent from the East with the specific purpose of exploring, describing, and publishing information about the prehistoric cliff dwellers of southeastern Utah (*Illustrated American* 1892). From Durango, Colorado, Moorehead's crew traveled along the San Juan River from the Utah–Colorado border to Butler Wash in southeastern Utah. Moorehead and the expedition's geologist, Louis Gunckel, published a series of accounts of their adventures in the *Illustrated American* entitled "In Search of a Lost Race." Calling itself the "Illustrated American Exploring Expedition," the party carved the inscription I.A.E.E. 1892 at several of the more spectacular ruins in Butler Wash.

During 1891–94, Charles McLoyd and various partners including Charles Graham of Durango, Colorado, went into Grand Gulch and dug in a number of caves. It is estimated that McLoyd and Graham took more than two thousand artifacts from sites throughout Grand Gulch and various other nearby canyons. The artifacts were purchased by private collectors who then sold or donated the collections to exhibitors and museums. In 1893 and 1894, the Wetherill brothers from Mancos, Colorado, led several artifact-collecting expeditions into Grand Gulch and other tributaries of the San Juan River, first for the Hyde Exploring Expedition sponsored by the American Museum of Natural History, then for the Whitmore Exploring Expedition. During the second expedition, at Cave 7 in Whiskers Draw, Richard Wetherill discovered Basketmaker skeletal remains and artifacts underlying the well-known cliff dweller remains, confirming McLoyd's observations and showing that the Basketmaker versus Pueblo difference was temporal and not cultural. Wetherill repeated and confirmed these observations in Butler Wash and Grand Gulch. Twenty years later, the stratigraphic relationships of these two cultural traditions would be formally recognized in the archaeological community through the work of Harvard University archaeologists Samuel J. Guernsey and Alfred V. Kidder in northeastern Arizona, who rightfully acknowledged Wetherill's work. In 1908, with an excavation permit from the Archaeological Institute of America, Byron Cummings began excavations in southeastern Utah to acquire artifacts

for the newly established University of Utah Museum. Cummings and his students continued to explore and excavate throughout southeastern Utah and northeastern Arizona, amassing large collections of artifacts up until 1915, at which time Cummings left to accept a position at the University of Arizona. Also, the LDS (Latter-Day Saints) Church's Deseret Museum acquired numerous artifact collections from pioneer settlers and collectors living in the town of Bluff; these collections were subsequently transferred to the University of Utah Museum (now Utah Museum of Natural History) and to Brigham Young University.

Figure 2.1. Culture area map (after Kidder 1924). (Graphic by W. Hurst.)

To summarize, these early expeditions and local diggings were largely aimed at acquiring prehistoric artifacts for sale to collectors and museums throughout the country. A small percentage of these collections remain at the University of Utah and Brigham Young University in northern Utah.

Around the turn of the century, the Archaeological Institute of America sponsored research in the McElmo Canyon area of southeastern Utah and southwestern Colorado, which was conducted by Alfred V. Kidder and Sylvanus Morley (Morley and Kidder 1917). Subsequently, the Peabody Museum at Harvard University sponsored research at Basketmaker cave sites in northeastern Arizona, conducted by Kidder and Guernsey. In addition, an independent medical doctor, T. Mitchell Prudden of Yale University, became interested in the numerous small open sites that occurred across the mesas of southwestern Colorado and southeastern Utah. Kidder and Guernsey's work in the Arizona cave sites documented and confirmed the stratigraphic and temporal relationship between the earlier Basketmaker and later Puebloan traditions (Guernsey and Kidder 1921). Prudden's work established the basic archaeological concept of the "unit pueblo," consisting of a block of rooms, a subterranean pit structure commonly called a kiva, and a trash midden, generally laid out in a north to south direction. Archaeologists today term these "Prudden unit pueblos." Prudden's research complemented Morley and Kidder's work in McElmo Canyon; Prudden argued that the larger ruins represented the same unit pueblo concept, only grouped into larger villages. Also, during this time, Morley and Kidder mapped the prehistoric masonry towers in what is now Hovenweep National Monument.

Anasazi or Ancestral Puebloan?

Ancestral Puebloan is the term for an ancient American Indian people. The modern Pueblo Indians of New Mexico and Arizona are their descendants. The Pueblo Indians still live in adobe and stone villages along the Rio Grande and in an area stretching from the Jemez Mountains to the Hopi Mesas.

Ancestral Puebloan is a term that is relatively new. The people have also been called the *Anasazi*. Anasazi is the Anglicized form of the Navajo word for the people who built the ancient villages. It has been loosely translated as "ancient ancestor" or even "ancient enemy." Archaeologists adopted this word as a term to refer to the people who lived in the ancient pueblos scattered across the Southwest, connected by similar ways of life.

Use of the term Anasazi is controversial among Native Americans who are considered to be the descendants of the ancient ones. Each Pueblo group has words in their own language that name the ancestors. The Hopi prefer the term **Hisatsinom**. However, some of the other Pueblo people today, such as the Acoma or Taos peoples, do not want a Hopi term used for their ancestors. The term Ancestral Puebloan is now often used to refer to ancestors of contemporary Puebloans. But the issue is complicated further. **Pueblo** is a Spanish term that means town or village. Spanish explorers and armies invaded much of the Ancestral Puebloan world in the 1600s, and so some have expressed dismay at using a Spanish term to describe their ancestors. Language is very fluid and tends to change to reflect the values and culture of the time. Perhaps in the future there will be other terms used.

In 1924 Kidder published his landmark book, *An Introduction to Southwest Archaeology*. In this book he presented the three main Anasazi (Ancestral Puebloan) culture areas that we recognize today: Kayenta, generally in northeastern Arizona and overlapping into southeastern Utah; Mesa Verde, generally in southwestern Colorado and overlapping into southeastern Utah and northwestern New Mexico; and Chaco, generally in northwestern New Mexico and overlapping into the adjoining three states. Compiling the research of several Southwestern archaeologists who had convened for the first Pecos Conference at Pecos, New Mexico, in 1927, Kidder also developed a chronological framework for the prehistoric Southwest, known today as the Pecos Classification. This was initially a simple division of the known Anasazi (Ancestral Puebloan) culture into eight developmental stages, each with its characteristic *assemblage* of architecture, artifact styles, and settlement patterns. (See Chapter Three.) With the advent and development of tree-ring dating of archaeological sites in the early years of the twentieth century, these developmental stages also became recognized temporal units. The Pecos Classification still forms the basis of chronological division for prehistoric Ancestral Puebloan culture in the Four Corners region.

Despite the initial efforts of Cummings and Kidder in southeastern Utah and northeastern Arizona to establish the stratigraphic relationship between the earlier Basketmaker and later Pueblo periods, there was little archaeological research during the years 1910–31. In 1915 Byron Cummings left the University of Utah and founded the Department of Anthropology at the University of Arizona. Not until 1922 did the University of Utah fill his position with the appointment of Andrew A. Kerr. Kerr had previously spent some time with Cummings in the field and had graduated from Harvard University. Inexplicably, however, Kerr implemented the primitive and destructive field methods of the earlier generation of relic hunters and collectors, amassing objects for the University of Utah Museum. To acquire artifacts, he paid local people in southeastern Utah to dig and bring him ancient pots. Documentation was minimal; no field records or field photographs are known to exist. By the end of his career five years later, Kerr had created a bleak landscape of cratered archaeological sites, provided the university museum with over 1,500 ceramic pots and a large number of other artifacts, and trained a crew of diggers to think that archaeology consisted of digging artifacts up with a government permit in order to fill museum shelves (Hurst 2004).

After Kerr's death, the University of Utah began to recover from fifteen years of intellectual stagnation and began again to recruit faculty on the basis of professional and academic qualifications. Kerr's position was filled by Julian H. Steward, who went on to become a world-renowned cultural anthropologist. Steward, a meticulous scientist, rehired Kerr's workers and conducted well-documented excavations in Whiskers Draw.

As the market for Southwestern antiquities grew, the destruction of archaeological sites proceeded at an alarming rate. This led some forward-thinking archaeologists to push for federal laws protecting archaeological sites. The 1906 Antiquities Act was passed to protect sites and objects found on federal, and later, tribal land. In time, states would pass their own antiquities laws to protect sites on state-held land. With this new legislation the science of archaeology came of age, recognizing the importance of the context of sites within the landscape and the context of objects within a site to the understanding of past *lifeways* and cultures. The secrets of the past slowly began to reveal themselves through careful, systematic investigation.

The crews, however, were accustomed to easy digging for pots for Kerr and were unhappy with Steward's scientific discipline. Steward subsequently redirected his research interests toward the Great Basin, from which he developed his seminal work on cultural ecology (Steward 1938).

The 1930s also witnessed two ambitious research projects: the Peabody Museum's Southeastern Utah Expedition and the Rainbow Bridge–Monument Valley (RBMV) Expedition. In 1931, John Otis Brew of the Peabody Museum began an excavation program on Alkali Ridge, northeast of Blanding (Brew 1946). Alkali Ridge was chosen because at that time there were gaps in the Pecos Classification for the period preceding Basketmaker II, and for the period between Pueblo I and III (i.e., there were no known archaeological sites that demonstrated a continuity between Pueblo I and III). By the conclusion of three seasons of fieldwork, Brew had investigated thirteen sites and had documented continuous occupation of Alkali Ridge from Basketmaker III through Pueblo III times. In addition to providing a detailed description of the architecture and material culture for the Pueblo II period, Brew's research also documented the existence of a unique red pottery, San Juan Red Ware, and demonstrated, moreover, that red ware pottery was manufactured alongside the more prevalent gray ware and white ware pottery. The largest of his sites, Alkali Ridge Site 13, is today a national historic landmark.

The Rainbow Bridge–Monument Valley Expedition was one of the last of the grand archaeological expeditions to the Southwest. Between the years 1933 and 1937, dozens of scientists and students traveled to the heart of the Navajo Indian Reservation, amid the spectacular scenery of the vast region between Rainbow Bridge and Monument Valley, to participate in the most ambitious archaeological endeavor in the Southwest up to that time. The RBMV Expedition was noteworthy for the promotional and organizational genius of its visionary leader, Ansel F. Hall, as well as for the sterling cast of specialized scientists that Hall brought to the expedition in true interdisciplinary cooperation: cartographers, archaeologists, geologists, biologists, paleontologists, and paleoecologists. The RBMV Expedition's goal was to explore, map, and excavate the prehistoric ruins of a then poorly known region of the Southwest. The goal was related to Hall's objective of studying the region for a proposed national park. Although the park did not come into being, the archaeological legacy of the RBMV Expedition stands today. The teams produced high-quality and extremely detailed maps of the Rainbow Bridge, Monument Valley, and Tsegi Canyon regions; the excavated sites demonstrated a continuous ceramic sequence from Basketmaker III through Pueblo III; the sites provided a substantial array of tree-ring dates and one of the most accurate chronologies in North America; and the ceramics and tree-ring dates together formed the basis for a detailed *ceramic seriation*, which stands today as a benchmark for ceramic analysis (Beals et al. 1945).

The 1950s ushered in the era of massive water control projects in the American West, and with it, the impetus to salvage archaeological sites in advance of dam construction and reservoirs. One of these was the Glen Canyon Project, one of four in the Upper Colorado River Basin Project and the largest at 183 miles long. The overall project was managed by the National Park Service under the Historic Sites Act of 1935, which required archaeological salvage in advance of construction projects on federal lands.

The Glen Canyon Project involved two institutions, the University of Utah and the Museum of Northern Arizona. The university undertook the north bank of the Colorado River and the entire section above the junction of the Colorado and San Juan rivers, and the museum investigated the south bank of the Colorado

River and the lower San Juan. The university's anthropology department, under the direction of Jesse D. Jennings, utilized this opportunity to train anthropology graduate students in archaeology, whereas the museum fielded professionals in archaeology, biology, geology, and paleontology. The project was completed in eight field seasons, from 1956 to 1963. Prior to this project, the archaeology of Glen Canyon and the lower San Juan was very poorly known. Previously, it had been explored largely by relic hunters seeking prehistoric collections for museums. Hence, the major emphasis was to locate, document, and investigate archaeological sites, gather essential environmental information, and compile the results into a series of descriptive reports (Jennings 1966).

The majority of the sites occurred in the side canyons, which drain into the main Colorado and San Juan River canyons. Due to different rates of sedimentation and erosion over time, many sites had either been flushed away or were overlaid by massive alluvial deposits. Among the more interesting discoveries in the project area were numerous substantial water control features, such as a masonry dam that included a water gate at the base of the wall, stone-lined ditches, and agricultural terraces; a complex network of trails indicated by hand- and toe-hold paths up the cliffs and up the sides of mesas on the uplands above the canyons; clear-cut differences in Ancestral Puebloan architecture and village layout styles, indicating differences in social structure within Ancestral Puebloan society; and better definition of the boundaries between the Mesa Verde and Kayenta culture areas, and between Ancestral Puebloan and Fremont culture areas to the north.

During the 1970s university-sponsored archaeological field schools attracted archaeologists and students to southeastern Utah. Notable projects included the survey of Montezuma Creek Canyon and site excavations by Brigham Young University (BYU), directed by Ray T. Metheny; the excavation of Edge of the Cedars Ruin by students from Weber State College and BYU under the direction of Dee Green and a succession of students (Green 1978); archaeological surveys in the Abajo Mountains by BYU students in conjunction with the United States Forest Service Manti–LaSal National Forest (DeBloois 1975); and intensive archaeological surveys and excavations in Butler Wash by the University of Denver (Nelson 1976). The Utah Division of State History conducted excavations at Westwater–Five Kiva Ruin south of Blanding (Lindsay and Dykman 1978), and the Utah Department of Transportation (UDOT) sponsored several surveys and excavations associated with the reconstruction of State Route 95 southwest of Blanding (Dalley 1973; Wilson 1973) and U.S. Highway 163 west of Bluff (Neily 1982). A singular research project—the Cedar Mesa Project—was a series of field studies codirected by William D. Lipe and R. G. Matson between 1972 and 1975, with support from the National Science Foundation (Matson and Lipe 1978; Matson et al. 1988). These projects are described in greater detail below.

The survey of Montezuma Creek Canyon, located near the border between Utah and Colorado, resulted in the documentation of over eight hundred archaeological sites and the excavation of six sites. The survey documented the full range of Basketmaker through Puebloan occupation and the excavated sites contributed substantive information about the Basketmaker, Pueblo I, and Pueblo II periods in Montezuma Creek Canyon (deHaan 1972; Forsyth 1977; Harmon 1979; Metheny 1962; B. Miller 1976; D. Miller 1974; Patterson 1975).

Edge of the Cedars Ruin had long been known to the residents of Blanding, some of whom desired to see the site developed as a visitor attraction that would benefit the town economically. Dee Green of Weber State

Figure 2.2. Artifacts from Edge of the Cedars Pueblo revealed that the people who lived here represented a local population that participated in the Chacoan regional system during the Pueblo II period. The White Mesa Black-on-white bowl (ECPR 7260) and Bluff Black-on-red pitcher (ECPR 8927) are locally made, whereas the polychrome pottery (ECPR 7400, 7825) and copper bell (Figure 2.4) indicate trade with people in what is now Arizona and New Mexico. (Edge of the Cedars photo.)

Figure 2.3. White Mesa Black-on-white bowl from Edge of the Cedars Pueblo. This design style is nearly identical to Kana'a Black-on-white in the Kayenta region in Arizona, indicating that the pottery makers participated in a widespread ceramic design tradition. (Edge of the Cedars photo ECPR 7260.)

Figure 2.4. Copper bell from the surface of Edge of the Cedars Pueblo. Similar bells have been found at Pueblo Bonito in Chaco Canyon, New Mexico. (Edge of the Cedars photo ECPR 8938.)

College was recruited to begin excavations at the site, which were conducted by archaeological field school students during 1969–70. In 1971 excavations were directed by Tim Taylor, a student at BYU, and continued through 1972 by Jeff Fee, a student at Weber State College. The result was the near-complete excavation and partial stabilization of the Pueblo II and III period central pueblo block, the discovery and definition of an earlier Pueblo I period village underlying the Pueblo II component, and a substantial assemblage of artifacts. A final excavation report was never completed, however. Subsequently, archaeologist Winston Hurst resurrected thirty-year-old field records and produced a scholarly article that demonstrated the links in architecture and material culture of Edge of the Cedars Pueblo to the regional Chaco system centered in New Mexico (Hurst 2000).

The University of Denver Butler Wash Project involved the intensive survey of ten square kilometers around the headwaters of Butler Wash, the documentation of 120 archaeological sites, and testing and excavation of three sites: Woodrat Knoll, Fallen Tree, and Cholla Knoll (Nelson 1976, 1978; Nickens 1977). The project marked the first time scientific research had been conducted in Butler Wash. Excavations at Woodrat Knoll revealed a Basketmaker III hamlet consisting of a pithouse and associated storage cists, over which was built a Pueblo II masonry room block and two kivas (Nickens 1977). The Fallen Tree Site was tested as an experiment in random sampling with a 10 percent sample using two-meter by two-meter grid units. This work revealed two slab-lined cists and recovered an assemblage of Pueblo I and Pueblo II ceramics and lithic artifacts (Nelson 1978). Excavations at Cholla Knoll were oriented toward obtaining architectural and subsistence data. This work revealed a substantial, arc-shaped series of contiguous *room blocks* constructed of slab-based *jacal* and a pit structure, in classic Prudden unit layout. Twenty-two rooms were identified, of which six

Figure 2.5. Butler Wash Incised jar from the University of Denver Butler Wash Project at Cholla Knoll. Sherds of this pottery style were also found at Edge of the Cedars Pueblo, indicating that the people had connections with their neighbors to the west. (Edge of the Cedars photo ECPR 4897.)

were excavated. One was a living room, as indicated by a floor hearth, and the others were storage rooms. All of the whole pots were Pueblo I–early Pueblo II types, whereas the majority of ceramic sherds were corrugated gray ware implying a late Pueblo II period component. In addition, a new ceramic variety called Butler Wash Incised was identified (Figure 2.5). It is thought to be a strictly local variant of a neck-banded gray ware style that was widely popular at that time (Nelson 1978). A significant contribution of the University of Denver Butler Wash Project was the definition of a substantial Pueblo I period community in upper Butler Wash and the recovery of a significant assemblage of Pueblo I period pottery. Moreover, upper Butler Wash came to be viewed as a possible recipient of Pueblo I population groups from Cedar Mesa, which was largely abandoned at that time.

Westwater–Five Kiva Ruin, located in a protected alcove southwest of the town of Blanding, was partially excavated in 1977 and 1978 by archaeologists from the Utah Division of State History (Lindsay and Dykman 1978). The work was sponsored by the Utah Navajo Development Council, which planned to develop the ruin as a tourist attraction. Although Westwater–Five Kiva Ruin had been badly damaged by decades of pot-hunting, the archaeologists found some intact cultural deposits that yielded five carved wooden plates or trays, four hafted knives, and three jars with intact yucca suspension nets (Figures 4.25 and 5.9). Substantial botanical remains were also recovered, which provided new information about prehistoric farming and wild food gathering. Architectural and artifact data indicated that Westwater–Five Kiva Ruin was occupied from Basketmaker III through Pueblo III (ca. AD 500–1200).

Based on surveys on Cedar Mesa in 1969 and 1970, William D. Lipe and R. G. Matson formulated a series of hypotheses about settlement patterns over time and tested these with data collected from surveys of

Figure 2.6. Sandal tablets.
During construction on U.S. Highway 191 at Shirttail Corner south of Blanding, Utah Department of Transportation workers discovered a burned and well preserved Basketmaker III pithouse with numerous artifacts on the floor. Among them were two sandal tablets: clay tablets with the impression of a woven sandal pattern. These have been found only in Basketmaker III contexts. (Edge of the Cedars photo, *left:* ECPR 1895; *right:* ECPR 5731.)

randomly selected quadrants on the mesa top and limited testing and excavation of selected sites (Dohm 1981; Lipe and Matson 1971, 1975; Matson and Lipe 1978). The survey data were subsequently supplemented by intensive surveys of the inner canyons of Cedar Mesa. Three main periods of Anasazi (Ancestral Puebloan) occupation were inferred from their analysis results: Basketmaker II (AD 200–400), late Basketmaker III (AD 650–725), and Pueblo II-III (AD 1060–1270). These are separated by intervals of seemingly little or no occupation (i.e., Pueblo I and early Pueblo II). It has been inferred that the basic adaptation throughout was low-

intensity farming, with frequent movement of small, dispersed settlements. This may be related to the relative marginality of the mesa for agriculture and patchy distribution of wild resources (Matson et al. 1988).

Starting in the 1970s and continuing to the present, numerous archaeological projects were conducted in advance of economic development projects (water resources development, highway construction, mineral exploration, ranching, forestry and post-wildfire rehabilitation, and public education) on southeastern Utah's public lands. These projects have been conducted by state and federal archaeologists, university and college professors and students, and independent archaeological consulting companies, resulting in a large but mostly unsynthesized body of archaeological and ethnographic information. Several of these surveys and excavations have contributed substantive information about the more immediate region surrounding Edge of the Cedars Pueblo. These are the Recapture Dam Project north of Blanding, sponsored by the San Juan Water Conservancy District (Nielson et al. 1985); the Energy Fuels Incorporated-sponsored surveys and excavations in the vicinity of the White Mesa uranium mill south of Blanding (Agenbroad et al. 1981; Casjens 1980; Davis 1985); and Utah Department of Transportation-sponsored excavations along U.S. Highway 163/191 between the towns of Blanding and Bluff and near the San Juan River (Firor et al. 1995; Hurst 2004b; Neily 1982; Westfall et al. 2003).

These legally mandated projects have been complemented by several research-focused programs: the Nancy Patterson Village Archaeological Project sponsored by Mark Evans and carried out by Brigham Young University (Hurst and Janetski 1985; Janetski and Hurst 1984; Thompson et al. 1986, 1988); excavations at early cave sites by educational institutions in cooperation with the Bureau of Land Management (Geib and Davidson 1994; Smiley and Robins 1997); independent research by Owen Severance on prehistoric roads and associated features and at the Cottonwood Falls Great House site (Severance 1999, 2003, 2004, 2005); and excavations at the Bluff Great House site and surveys and site testing in Comb Wash by University of Colorado archaeological field schools (Cameron 2009; Hurst et al. 2004).

Chapter Three

Prehistory and History of Southeastern Utah

Based on archaeological evidence, the earliest known human inhabitants of southeastern Utah were groups affiliated with the *Paleoindian* cultural tradition, dated to approximately 11,000 to 7000 *BP*. These people produced distinctive, finely made, *lanceolate* spear points, which were used to hunt now-extinct big game animals such as mammoths and giant bison (Figure 3.1). A number of isolated *Clovis* and *Plano* points have been found, and two Paleoindian sites along Comb Ridge have been investigated: the Lime Ridge Clovis Site (Davis 1989) and the Goodwin Site (Winston Hurst: personal communication 2007).

How many Paleoindian sites are out there in the wilds of southeastern Utah but are no longer evident because someone walked away with one important artifact?

Following the end of the last ice age, the Paleoindian hunting tradition ceased with the extinction of the large Pleistocene mammals, and there is evidence that the human population adapted to the warmer and drier conditions that would prevail for the next seven thousand years. Archaeologists use the term *Archaic* to indicate the time period 7000 *BC* to AD 100 as well as the population groups who lived in the American West during this time. The Archaic people were hunters and gatherers whose stone tools (*lithics*) and debris are found with open firehearth sites, commonly in sand dune-dominated areas. Their tool kits included large dart points that were propelled with *atlatls*, basin milling stones, and one-hand *manos*. Archaic people likely followed a pattern of residential mobility based on the seasonal availability of plant and food resources across different land features. Around 400 BC Archaic people in southeastern Utah began to experiment with corn

The Goodwin Site is named for Andrew Goodwin, facilities manager/historic replicator at Edge of the Cedars. Goodwin was hiking on Comb Ridge one day in 2003 and noticed a base of a Clovis point eroded out of a dune next to a well-used two-track road. He recognized the point type right away and knew that this was an important find. He carefully hid the point under a rock so that it would not be collected or moved by someone else, and returned later to the site with archaeologist Winston Hurst, who confirmed the find. What if a careless hiker had collected the point and told no one about it? The only indication that the site could be Paleo-aged would be gone. Without the point the site looked like any prehistoric campsite. With the point the site became potentially much more important to the archaeological record because of its rarity (10,000 to 9000 BP). The site was investigated, and additional evidence for a Paleoindian age for the site was found. The site also contained evidence for more recent occupations; for example, an early Basketmaker-era hearth was dated to ±2000 BP. It is not unusual that the site had been used by people throughout a great span of time because it is situated at the crest of Comb Ridge at the crossing of a prehistoric trail.

agriculture and express traits definitive of the Basketmaker II period. Only one Archaic site in this area has been investigated by archaeologists: Old Man Cave. This Archaic residential site yielded an *open-twined sandal* that was radiocarbon-dated to 6454 BC (Figure 4.4).

The Ancestral Puebloan occupation of southeastern Utah began with the development of recognizable Basketmaker II traits—corn and squash agriculture and basket-making, yet with a continuation of earlier Archaic traits such as hunting with atlatls and darts, basin milling stones, and one-hand manos. Basketmaker II sites are small, consisting of shallow pithouses with several slab-lined storage pits. The best-known and studied examples of Basketmaker II sites are on Cedar Mesa as a result of the work of William D. Lipe and R. G. Matson and their students (Matson 1991), and more recent work by Francis E. Smiley in Butler Wash (Smiley and Robins 1997) (Figure 3.3).

Figure 3.1. *The Dawson Folsom fluted point is made from* a travertine-like stone. Folsom points are associated with hunting now-extinct giant bison during the Pleistocene era, about nine thousand years ago. (Edge of the Cedars photo ECPR 1898.)

Figure 3.2. Andrew Goodwin at the Goodwin Site, 2006. (Photo by W. Hurst.) Inset, Clovis Point base. (Photo by Michael Rondeau.)

Around AD 400–500, new traits were added to the Basketmaker repertoire: pottery manufacture, the bow and arrow, deep pithouses, and the inclusion of beans in agriculture. Habitation sites became larger, ranging from single structures to small villages with several pithouses. Occasionally community great kivas are found. The recognized Basketmaker III pottery types are Chapin Gray, Chapin Black-on-white, and Abajo Red-on-orange (Figure 3.4). Sites in Basketmaker III are more numerous than in the preceding period, reflecting population growth and settlement in new areas. Some of the best-known Basketmaker communities explored through archaeological investigations were in Recapture Wash north of Blanding (Nielson et al. 1985), on White Mesa south of Blanding (Casjens 1980), and along the San Juan River near Bluff (Neily 1982).

Around AD 750, significant changes had occurred in architecture, village organization, and pottery during the transition from the Basketmaker III to the Pueblo I period. Architecture evolved into contiguous, rectangular surface rooms constructed of upright slabs and/or jacal (wattle-and-daub) with a deep pit structure to the south of the room block. A well-defined trash midden was usually located south or east of

Figure 3.3. A Basketmaker II pre-ceramic assemblage.
These artifacts, except the rabbit-fur cordage, were recovered by Northern Arizona University archaeological field school students from dry cave sites along Comb Ridge. The cave sites also contained a variety of storage cists, in which numerous artifacts and plant and animal remains were found. These provided significant information about the Basketmaker people's increased dependence on corn agriculture, although hunting continued to be important. (Edge of the Cedars photo, coiled basketry tray (ECPR 9870); hoe (ECPR 9879); digging stick (ECPR 9876); square-toe woven sandal (ECPR 9874); yellow corn cob (ECPR 9914); red corn cob (ECPR 9872); rabbit-fur cordage (ECPR 3926).)

the pit structure. These features illustrate the architectural beginnings of the "unit pueblo," which became the signature dwelling site in the subsequent Pueblo II period. Pueblo I is also notable for the formation of large villages and population concentration in high-elevation locales such as Elk Ridge and along major waterways such as Butler Wash and the San Juan River. John Otis Brew's 1933–36 work at Alkali Ridge northeast of Blanding still stands as the best-documented study of a Pueblo I village in southeastern Utah (Brew 1946). Pottery production showed increasing refinement and variation in design, yet also maintained pan-regional design similarities. The most common types were Moccasin Gray and Mancos Gray, White Mesa Black-on-white, and Bluff Black-on-red (Figure 3.5).

The Pueblo II period (AD 900–1150) marks the further evolution of architecture and artifact assemblages. Masonry architecture replaced the previous Pueblo I construction techniques. Pit structures are either earthen-walled or masonry-lined and include both dwellings and ceremonial kivas. All the while, the basic "unit pueblo" form was maintained either as isolated hamlets or as combinations of room blocks and pit structures

Figure 3.4. A Basketmaker III pottery assemblage.
Basketmaker people began making pottery around AD 500. Many vessels followed the natural forms of gourds, indicating that gourds previously were modified into containers for water (canteens and bottles) and for dry stuffs (seeds). The Chapin Gray vessel on the left (ECPR 9777) is the same form as a bottle gourd, and the Chapin Gray seed jar on the right (ECPR 3368) takes its globular form from a round gourd. The deep hemisphere of the Chapin Black-on-white bowl (ECPR 3629) is similarly rounded. Decorative elements on Chapin Black-on-white bowls tend to "float" in an empty white background and are positioned in the lower section of the vessel.

Figure 3.5. A Pueblo I period pottery assemblage.

During the Pueblo I period (ca. AD 700–900), people began to live in larger villages, characterized by room blocks that were used for storage. Archaeological excavations have revealed that many storage rooms contained large storage jars, such as the Moccasin Gray jar (ECPR 1897) in this photograph, which once held food. These indicate an increased commitment to agriculture. The establishment of villages also suggests that people migrated into the area, which is also shown by increasing diversity in pottery styles. The two black-on-white bowls on the left are Black Mesa Black-on-white (ECPR 3179) from the Kayenta region in Arizona and White Mesa Black-on-white (ECPR 7260), respectively. The two red ware vessels are Bluff Black-on-red (ECPR 8317, 3419). Note the free-flowing nature of the black-on-red designs, contrasted with the more rigid and stylized designs of the black-on-white bowls. (Edge of the Cedars photo.)

Figure 3.6. A Pueblo II period pottery assemblage.

During the Pueblo II period (ca. AD 900–1150), populations surged in the northern San Juan and created numerous small villages called "unit pueblos." Pottery during this time shows a great deal of diversity in design style and vessel forms, suggesting the immigration of people with varied artistic interests. In the gray ware pottery, the older neck-banded styles evolved into "indented corrugated" surfaces. In the white wares, Mancos Black-on-white designs often consist of repeated simple elements such as dots, lines, and terraces, although combinations of different elements may occur. Red ware pottery was made in a variety of forms: bowls, pitchers, seed jars, and animal effigies—most commonly ducks. (Edge of the Cedars photo, *upper middle*: Mancos Corrugated jar (ECPR 8795); *left top*: Mancos B/W bowl–band (ECPR 3122); *left bottom*: Mancos B/W bowl–dots (ECPR 3207); *left inside*: Mancos B/W bowl–lines (ECPR 10021); *center*: Mancos B/W mug (ECPR 3442); *far right*: Deadmans B/R duck effigy (ECPR 3506); *inside right*: Deadmans B/R pitcher (ECPR 3422); *right top*: Deadmans B/R seed jar (ECPR 3257).)

in a variety of village sizes. Pottery expressed a greater variety of design style and forms in gray wares (Mancos Gray and Mancos Corrugated), white wares (Cortez Black-on-white and Mancos Black-on-white), and red wares (Deadman's Black-on-red). San Juan Red Ware ceased to be manufactured around AD 1000 and was replaced by Tsegi Orange Ware pottery imported from the Kayenta region of northeastern Arizona (Figure 3.6).

The Pueblo II period is further distinguished by the occurrence of large, formal, two-story masonry structures termed great houses, each associated with a great kiva, and the construction of wide prehistoric trails termed roads. These are considered to be related to similar features in the Chaco Canyon area of northwestern New Mexico, implying that great houses in southeastern Utah may have been associated with the Chaco regional system that prevailed from AD 900 to 1150. Utah's great houses, however, are more provincial in their construction compared to those in Chaco Canyon, suggesting emulation of a building style despite the comparatively poorer quality of available building stone. Some of the more notable great house sites in Utah are Edge of the Cedars Pueblo in Blanding, Cottonwood Falls in Cottonwood Wash west of Blanding, the Bluff Great House in Bluff on a hill above the San Juan River, Arch Canyon Ruin, and the Comb Wash Great House (Cameron 1997).

The Pueblo III period is dated to the interval AD 1150–1350, although southeastern Utah was largely depopulated by AD 1250–1300. This time period is characterized by localized abandonments throughout the Four Corners area, population shifts and aggregations into fewer—but larger—villages, intensification of water control features, settlement-enclosing walls, towers, and the widespread appearance of the classic Pueblo III Mesa Verde architecture and ceramic *complexes*. The phenomenon of population reduction and aggregation into seemingly defensive positions contrasts with the previous Pueblo II period pattern of scattered hamlets and villages. However, it repeats a pattern seen in Pueblo I of aggregation and defensiveness. It is likely that severe drought and food shortages forced people into fewer, but more densely packed, villages. The Nancy Patterson Site, a large Pueblo III village in the Montezuma Canyon drainage near the Utah–Colorado border, is a good example of this trend (Wilde and Thompson 1988) (Figures 3.7–3.9).

By AD 1300, the Ancestral Puebloan population had made a nearly complete exodus from southeastern Utah. It is thought that they may have joined in the general population migration southward to the Rio Grande and Little Colorado River valleys, where their descendants are still found among the living Puebloan villages today.

Archaeological evidence for post-Ancestral Puebloan use of southeastern Utah is ephemeral and ambiguous. The writings of early Spanish explorers indicate that both *Athapaskan* (Navajo) and *Numic* (Ute) people were occupying the Four Corners region by the early 1700s. The nomadic lifeways of these people did not generate readily visible remains of their homes and camps; hence our knowledge of human occupation of southeastern Utah from AD 1300 to 1700 remains limited. There is, however, substantial evidence of Navajo, Ute, and Southern Paiute occupation from AD 1700 to the present.

Figure 3.7. A Pueblo III period white ware assemblage.
Mesa Verde Black-on-white is the dominant decorated pottery during Pueblo III. Ollas (water jars) and large bowls are some of the most common forms. Mesa Verde Black-on-white is distinguished by thick-walled construction, highly polished surfaces, and banded and quartered design layouts. (Edge of the Cedars photo, *lower right*: Mesa Verde B/W olla (ECPR 8810); *lower left*: Mesa Verde B/W olla (ECPR 8809); *upper left*: Mesa Verde B/W bowl–band (ECPR 3214); *upper middle*: Mesa Verde B/W olla (Pine Canyon Olla) (ECPR 8333); *upper right*: Mesa Verde B/W bowl–Tularosa style (ECPR 3175).)

Figure 3.8. A Pueblo III period red ware assemblage.
By the time of the Pueblo III period, San Juan Red Ware ceased to be produced and was replaced by orange wares imported from the Kayenta region of Arizona. (Edge of the Cedars photo, *bottom*: Tusayan Polychrome bowl (ECPR 3254); *upper left*: Tusayan Polychrome bowl (ECPR 3256); *upper right*: Tusayan Polychrome bowl (large) (ECPR 3634).)

Figure 3.9. A Pueblo III period gray ware assemblage.
Mesa Verde Corrugated was the dominant utility ware during Pueblo III and was made in a wide range of sizes. (Edge of the Cedars photo, *right*: Mesa Verde corrugated large jar (ECPR 2926); *left*: Mesa Verde corrugated medium jar (ECPR 8780); *middle*: Mesa Verde corrugated pitcher (ECPR 3577).)

Chapter Four
Artifacts at Edge of the Cedars

Artifacts and the Archaeological Record

Artifacts are far more than just interesting old objects or collector's items. When carefully studied in the context of where they were found and what was found with them, they become powerful keys to our understanding of past cultures and communities. The distribution of artifacts and other physical evidence of past human activity across the land is called the *archaeological record*, and this is the only record we will ever have of most of the human experience. Since written records have been left by just a few human societies (and those records tend to be biased), the archaeological record is the primary record of the human experience throughout time and around the world. For ancient peoples who left us no written history, the importance of the archaeological record cannot be overstated. The primary mission of the museum is to not only preserve and interpret artifacts, but also to keep a record of where the artifacts were found and what they were found with, thus preserving their place in the archaeological record.

What Is an Artifact Worth?

As a publicly funded, educational museum, Edge of the Cedars does not assign monetary value to artifacts. Here, "value" refers to an object's power to teach, to convey information, and to inspire the imagination. To archaeologists and museums, the value of an artifact depends more on what we know about its provenience, than on how rare, well preserved, or beautiful the artifact is. The most spectacularly beautiful and well preserved artifact has little value if we don't know enough about its discovery context to learn something about the role it played in the community or household that used it, or how that style of artifact was distributed

How Do We Know How Old It Is?

Some perishable artifacts can be scientifically dated by *radiocarbon* (precise measurement of residual radioactive carbon in once-living material), but this requires destruction of a small piece of the artifact. Pottery and some burned stone artifacts can be roughly dated by *thermoluminescence* (precise measurement of the intensity of a light energy burst that occurs when certain materials are heated to a high temperature, the strength of the burst being proportionate to the time that has lapsed since the last time it was that hot). Most artifacts are dated by their association with datable material, such as wood beams dated by *dendrochronology* or tree-ring dating. Many ancient structures in the American Southwest are in dry alcoves where wood is preserved. Many others were burned, leaving collapsed roof beams that were burned just enough to preserve them as charcoal but not enough to fully consume them. The beams in these sites can often be very precisely dated by dendrochronology, offering powerful clues to the age of the structures and, by extension, the artifacts that were in the houses when they burned. Careful study of the artifacts and architecture from dated contexts allows archaeologists to recognize recurrent stylistic patterns that they can then use to cross-date otherwise undated sites by matching the styles of their artifacts to those from the dated sites.

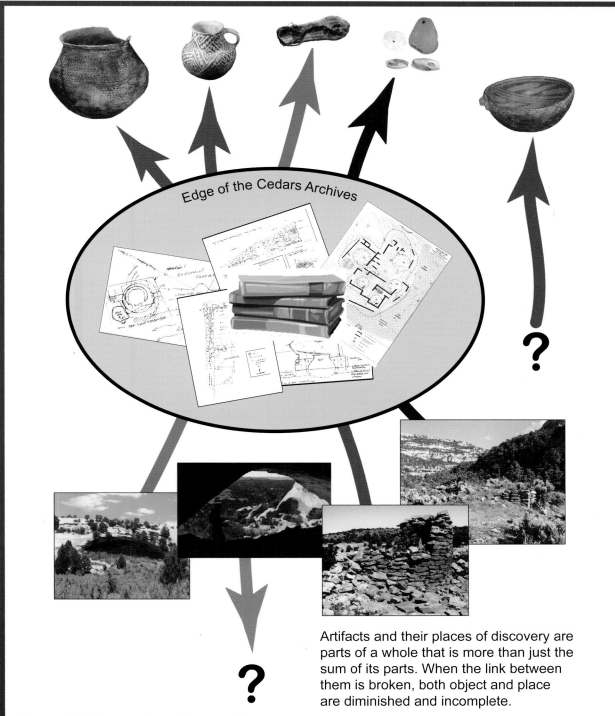

Artifacts and their places of discovery are parts of a whole that is more than just the sum of its parts. When the link between them is broken, both object and place are diminished and incomplete.

Figure 4.1. Connections: sites to objects.
More than just a repository of artifacts, Edge of the Cedars is an archive for the archaeological documentation that preserves the links between artifacts and their places of discovery. Those little numbers on the artifacts are essential, linking artifacts to their documentation and their discovery sites. In its role as archaeological archives, Edge of the Cedars is a critical link in the preservation of the archaeological record. (Graphic by W. Hurst.)

across the land. An artifact connected to its discovery context is a source of new information about where, how, and by whom artifacts of its type were used, while a disconnected artifact tells us nothing new and can only be interpreted based on what we have already learned from other, better documented artifacts of similar type.

In Figure 4.2, for example, the painted pot is certainly more beautiful than the plain gray one. We have learned enough about this style of polychrome pottery from documented sites where it has been found that we can say with some confidence that it was made in east-central Arizona or west-central New Mexico in the AD 1200s. A very small number of sherds of this and other types from the same area have been documented in southeastern Utah. Was it found in Utah? If so, it is a beautiful example of a very rare pottery type in this area, and an important clue to ancient trade patterns. Unfortunately, we know nothing about where this pot was found or what it was found with. It therefore tells us nothing new about when, how, and where such vessels were made and used, and its removal from an undisclosed site leaves a permanent gap in what can be learned from the archaeological record.

Figure 4.2. Beauty isn't everything.
The Chapin Gray cooking pot (ECPR 00005.642.2) on the left may not be much to look at, but its well-documented discovery context (the floor of a dated and well-documented Basketmaker pithouse at site 42Sa3775 south of Blanding) makes this pot more interesting and valuable than the more spectacular St. John's Polychrome bowl on the right (ECPR 8315), whose provenience is unknown. (Composite photo by B. Hucko and Edge of the Cedars.)

The plain gray pot looks less impressive but is much more interesting, because its provenience is documented (Figure 4.3). We know that:
- It was used as a cooking pot in a Basketmaker III pithouse that was built during the late AD 680s at a specific location on White Mesa, three miles south of Edge of the Cedars.
- The house was one of three in a small residential hamlet that was occupied for about two generations.
- The pot and an array of other pots, bowls, tools, weapons, and ceremonial items were left when the house was intentionally burned. Because charred remains are resistant to decay, the burning preserved many architectural details and clues to the residents' lifeway.

42Sa3775: What Does It Mean?

A site number consists of the state number (Utah is 42), the county designation (Sa indicates San Juan County), and the number of the site (3775 means the site is the 3,775th site recorded in San Juan County).

projectile point concentration
in roof fall suggests a cache
of arrows in the ceiling

Chapin Black-on-white
bowl on floor

Chapin Black-on-white
bowl on floor

Chapin Gray

Chapin Black-on-white
bowls on floor

two mano/metate
sets on floor

Bone awl
on floor

six sandal impression tablets
on floor and in roof fall

LEGEND

◎ Butt socket
● Deep post hole

Shallow pit/basin
low adobe ridge

Adobe or upright
slab partition

0 1 m
0 3 ft
N

excavation
report

Chapin Gray
pot on floor

Figure 4.3. A Basketmaker household.
The Feature 3 pithouse at the Casa Coyote site, located in the U.S. Highway 191 right-of-way south of
Blanding, yielded an array of artifacts that together offer an interesting glimpse into a Basketmaker III
household from the AD 680s. (Composite photo by B. Hucko and Edge of the Cedars.)

This body of information takes its place in an increasingly detailed and insightful (but incomplete) picture of the ancient Basketmaker III community that occupied southern White Mesa during the AD 600s. Taken in isolation, the old cooking pot is just another pot, an isolated letter from an unknown text, nothing more than another example of a common class of artifact. As part of a documented assemblage, or group of related artifacts, it helps compose a picture or a text and tells us something about a specific household and community that left us no written record. It conveys interesting information and provides a stepping-stone into a past time.

Figure 4.4 offers another good example of archaeological value. The nondescript and unimpressive bit of yucca leaf weaving in the center is of far greater value than the spectacularly well-preserved, unworn pair of finely woven sandals on the right. Why? Because we know that the coarser weaving was found in deep, early Archaic (7,000± years old) deposits in the Old Man Cave site in Comb Wash. The artifact is a fragment of a type of sandal known to have been made and used nearly 8,000 years ago, and a radiocarbon date from this artifact has confirmed that age. Its discovery context tells us that early Archaic peoples were living in the upper Comb Wash area and specifically using that cave. Other associated finds in the cave reveal various details about the way those people lived and used their landscape. In contrast, we know nothing of the discovery context of the fine sandals, which were collected by looters interested only in their value as antique objects. In the absence of meaningful discovery context, they contribute little to our understanding of the household, community, or people who made them. Because we have found other sandals of this type in known and documented contexts, we can guess that these sandals were probably made in late Basketmaker III or Pueblo I times (ca. AD late 600s–800s).

The most exciting and valuable artifacts, of course, are those that are beautifully made, perfectly preserved, **and** have well-documented discovery context. Figure 4.5 presents an example of such artifacts recovered with thorough documentation by archaeologists from a cliff dwelling in a remote location in San Juan County. These artifacts, along with an array of other ceramic vessels and baskets as well as agricultural tools, ornaments, weapons, mats, and other objects, were left behind by some of western San Juan County's latest Puebloan residents in a small cliff dwelling whose roof beams yielded tree-ring dates between AD 1197 and AD 1267.

Figure 4.4. When is ugly beautiful?
The unimpressive objects above left and center are fragments of very rare early Archaic open-twined sandals. The smaller piece in the center (ECPR 5020) is from a documented and controlled excavation into undisturbed sediments in Old Man Cave, Comb Wash, and radiocarbon-dated to 7440 BP. Its documented context gives it a value far greater than that of the better preserved, more beautiful but "orphaned" pair of unworn Basketmaker III–Pueblo I sandals on the right (ECPR 8322), which lack any documentation linking them to a site or a meaningful context. The more complete Archaic specimen at the left (ECPR 8680), dated to 8310 BP, was recovered from a looter's pit in Boomerang Shelter in Butler Wash, so at least its discovery site, though not its full discovery context, is documented. (Composite photo by B. Hucko and Edge of the Cedars.)

Just another green one...

Artifacts, like color dots in a photograph, lose meaning when taken out of context.

Sites, like photographs, lose meaning when their parts are scrambled and removed without documentation.

The Importance of Archaeological Context

An artifact in isolation is a naked orphan. Clothed in documented context, it is a piece in a complex puzzle, retaining its link to a place, to a people, to a situation, long after being removed from its discovery site. Just as people are far more productive working as families, groups, or teams than as individuals, artifacts are far more interesting and valuable when studied in groups of associated things than they are in isolation. A "family" of associated artifacts with documented discovery context is worth far more than the sum of its isolated parts. (Graphic by W. Hurst.)

Pottery

Ceramic (pottery) artifacts (Figure 4.6) are tremendously important clues to cultural behavior. Because pottery is such an important component of southeastern Utah's archaeological record and the museum's collections, it is discussed in detail in Chapter Five.

Figure 4.5. A "family" of artifacts.
Site 42Sa12785 in western San Juan County is a small and otherwise unimpressive cliff dwelling complex that had been overlooked by collectors when archaeologists found and documented it in the 1970s. This is a pricelessly rare "family" assemblage from one of the latest sites to be occupied by Pueblo people in the Elk Ridge area. *Center back*: Mesa Verde Black-on-white olla (ECPR 8389); *front, left to right*: coiled basket with prehistorically mended base (ECPR 48165); Mesa Verde Black-on-white bowl (ECPR 8376); coiled sifter basket (ECPR 48144); Mesa Verde Black-on-white bowl (ECPR 8375); Mesa Verde Corrugated jar (ECPR 8367). (Photo by B. Hucko.)

Figure 4.6. A set of nesting bowls. This *cache* of three stacked, middle Pueblo II (ca. AD 1000) bowls was found eroding out of a cutbank in Butler Wash. The find was reported to the land managing agency and the discovery site was documented. The largest bowl, a Tusayan Black-on-red (ECPR 8816), had been broken and partly lost down the wash prior to the discovery. The other two bowls are Mancos Black-on-white (ECPR 8815) and Deadman's Black-on-red (ECPR 8814). (Edge of the Cedars photo.) (See Chapter Six for the story of the discovery of these bowls and Figures 6.1 and 6.2.)

Chipped and Ground Stone Tools

The large majority of past human societies made most of their cutting, scraping, and grinding tools from stone. For this reason, stone artifacts are a fundamentally important part of the archaeological record. Their form reflects their function and offers clues as to what people were doing in a site. A tool's details reveal surprising information about how the tool was made. Subtle, sometimes microscopic, wear patterns offer insights into exactly how tools were used. The stone material from which the tools were made offers clues about how the materials were gathered or traded. Trace residues on the tools, analyzed using sophisticated detection technologies, can reveal details about the kinds of materials that the tools were used to cut, scrape, or grind.

The style or shape of stone weapons and the way they were made evolved slowly through time and varied in a patterned way between cultures. Through careful study of the tools and the *debitage* produced during their manufacture, archaeologists have learned and are continuing to learn a lot about the people who made them. As we come to recognize the ages and cultural affiliations of different styles of tools by carefully studying collections from documented sites, we are able to then identify the ages and cultural affiliation of other sites by the styles of artifacts found on them. This is called *cross-dating*. Removal of the interesting tools or even the "pretty rock" flakes from the surface of an archaeological site can seriously interfere with our ability to identify the site's age, the culture that used it, or the activities that took place there, greatly diminishing what we can learn from the archaeological record.

Of all stone tools, bifacially flaked blades (arrow points, knives, etc.) are the most useful indicators of age and affiliation. (Bifaces are the most culturally and temporally sensitive, or diagnostic, stone artifacts of a time period or cultural group; see Figures 4.7, 4.8.) The styles of the arrowheads or other *projectile points* on a site are frequently the only clues that enable archaeologists to place the site in time or link it to a specific cultural group. Unfortunately, projectile points are also the most likely artifacts to be collected from archaeological sites. Every projectile point removed from the land by a collector permanently deletes an important clue to a site's age and to ancient land use patterns.

Figure 4.7. The evolution of projectile point styles.
Selected spear and dart points from the Edge of the Cedars collections illustrate the evolution of early projectile point styles through time. Key: 1. Clovis point from the Grand Gulch Plateau, ca. 9500–8900 BC (epoxy cast courtesy of Greg Nunn) (ECPR-89.46); 2. Folsom point, ca. 9500–8000 BC (ECPR-03013.1); 3. Comb Wash square-stem point, early Archaic, Old Man Cave, Comb Wash, ca. 7000–5000 BC (private collection); 4. Bajada point (resharpened), early Archaic (ECPR-96007); 5. Bajada–San Jose point, early-middle Archaic, ca. 5000–3000 BC (ECPR-92003.49); 6. Elko Corner-notched or Basketmaker III corner-notched point, long-lived style, ca. 5000 BC–AD 700 (ECPR-86063.54.2); 7. Elko Eared point, ca. 5500–1000 BC (ECPR-87.42); 8 and 9. Armijo points, middle-late Archaic, ca. 3000–1000 BC (ECPR-83004.17, 08010.8); 10. Gypsum point, late Archaic–Basketmaker, ca. 2500 BC–AD 500 (ECPR-08010.63); 11 and 12. Basketmaker side-notched point, Comb Wash, ca. 1500 BC–AD 500 (ECPR-82014.1, 08009.23); 13. Basketmaker Corner-notched dart point, Clay Hills Pass, ca. 1500 BC–AD 750 (ECPR 5782). (Graphic by W. Hurst; Edge of the Cedars photo.)

Figure 4.8. Arrow points.
Selected arrow points from the Edge of the Cedars collections illustrate the continued evolution of projectile point styles after the bow and arrow replaced the atlatl and dart as the weapon of choice in the early centuries AD. Key: 1. Basketmaker III expanding stem point, ca. AD 500–750 (ECPR 1671); 2 and 3. Abajo Stemmed points, Pueblo I, AD 750–900 (ECPR-86.207.259, 86.150.2); 4. Early Pueblo II corner-notched, AD 900s (ECPR-89.1.61); 5. Pueblo II side-notched, AD 900s–1100s (ECPR-93025.1); 6 and 7. Late Pueblo II–Early Pueblo III side-notched, AD 1000s–1100s (ECPR-95046.3, 05004.5); 8. Pueblo III side-notched, AD 1100s–1200s (ECPR-08009.20); 9. Bull Creek point, Pueblo III, AD 1100s–1200s (ECPR-95005); 10. Desert Side-notched Ute, Paiute, Navajo, or late prehistoric Puebloan, AD 1300s–1800s (ECPR 8263); 11. Unidentified point, probably late prehistoric (ECPR-08010.5). (Graphic by W. Hurst; Edge of the Cedars photo.)

When Is an "Arrowhead" Not an Arrowhead?

Many of the artifacts that people call "arrowheads" were not used on arrows at all. Some of them were used on a more ancient and larger projectile called a "dart" that was propelled by an atlatl or "spear thrower." For this reason, people who study ancient artifacts commonly use the term "projectile point" to refer to this artifact class, reserving the terms "arrow point" and "dart point" for points that seem clearly to have been made for use with one type of weapon or the other. If a point was notched or stemmed, one way to guess what kind of weapon it was used with is to look at the width of its neck, which approximates the diameter of the shaft that it was hafted to. Arrow shafts were about as thick as a modern pencil (one-quarter inch), while dart shafts were about twice that thick. Not all points were notched or stemmed, of course, but even unnotched points can often be assigned to a class if one considers whether it would best fit on a quarter- or half-inch shaft. Another common mistake is the use of the term "spear point" to refer to bifacially flaked tools larger than a typical atlatl dart point. Although some very old examples may actually have been hafted as tips on thrusting or throwing spears, most of these artifacts were hafted to short handles and used as knives. (Graphic by W. Hurst.)

dart points

arrow point

knife

foreshaft size

(1/2 actual size)

A Basketmaker warrior (right) faces his Pueblo III descendant across a thousand years and fifty generations. The Basketmaker is armed with an atlatl and fending stick, while his fifty-times great grandson is armed and defended with a bow and a painted basketry shield. The clansman in the background is brandishing a knife and a kind of war club that was in use by the AD 1200s. (Graphic by W. Hurst.)

Projectile points and knives are just one tool category in a broad class of "chipped stone" artifacts. Other chipped stone artifacts that are of great interest and importance to archaeologists include scrapers, drills, perforators, gravers, and even the debitage left by toolmakers during the manufacture and use of stone tools. Among the museum's treasured holdings are unimpressive boxes of informal stone tools, tool fragments, and tool making debris, recovered from carefully documented archaeological contexts. Although these are not usually displayed, they are very important elements of the archaeological record and are curated as research collections. Even the most unimpressive artifacts form patterns that make sites meaningful.

The museum collections also include many *ground stone tools* from various time periods. Most are manos or *metates* used to grind corn and other foods such as grass seeds. Like ceramics and chipped stone tools, ground stone tools evolved in style through time (Figure 4.9), reflecting changes in the way food was prepared and helping archaeologists infer the site's age and function.

Figure 4.9. Evolution of grinding tools.
Grinding tools evolved in style through time and their style reflects the way they were used. The styles of the manos and metates on a site can help us identify the site's age and some of the activities that took place there. (Graphic by W. Hurst.)

The earliest milling tools were small, one-hand manos used in an oval grinding basin on a sandstone metate. These tools were used to grind wild grass seeds and other foods and were sometimes small enough to be carried by Archaic or later peoples from camp to camp or from resource patch to resource patch. One-hand manos and oval basin metates appeared in late Paleoindian times, became common during the Archaic period, remained in use throughout prehistory, and were still used by some Native American groups in the recent past. With the introduction of American corn (maize) in the first millennium BC, milling tools became heavier and more robust. Manos became larger and loaf-shaped and were used with a linear motion in heavy, open-ended, trough-style metates. By the Pueblo I period, the manos were long enough to be used with two hands, and the troughs were wider to accommodate the longer manos. With the introduction of softer corn flour in the late Pueblo II and Pueblo III periods (late eleventh through thirteenth centuries), trough metates were replaced by flat slab metates that were typically set into mealing bins lined with upright slabs in the floors of special milling rooms. Their associated manos were often even longer than their two-handed trough-style predecessors, with flat grinding facets that give them an "airplane wing" shape in cross-section. Although most were used to make flour from hard seeds, blood residue analysis reveals that some were used to pulverize small animals.

Other ground stone tools in the museum's collections include various lapstones and anvils used to grind pigments or pulverize other materials, or as work surfaces for making ornaments or tools. Stone axes for use in felling trees, clearing brush, and as weapons of war were commonly shaped by flaking and finished by pecking, grinding, and polishing (Figure 4.10).

Archaeological Type Names

In museum exhibits and books, artifacts are often identified by formal type names, such as "Bluff Black-on-red" (a kind of pottery made in the ninth century) or "Desert side-notched" (a type of arrow point made starting in the late fourteenth century throughout much of the American West). Formal types are typically given two-part names, including a name for the place or region where they were first defined, followed by a descriptive name. "White Mesa Black-on-white," for example, is a type of white pottery with distinctive black painted designs, first recognized at Edge of the Cedars and other sites on White Mesa in southeastern Utah. These formal type names, like a person's given name and surname, are always capitalized.

Type names are assigned to classes of similar objects by archaeologists to make it easier to discuss them. (It is much more efficient to refer to a class of objects by name than to describe it over and over again.) Artifacts assigned to a named artifact type share certain morphological (shape), technological, and stylistic attributes that were popular in a defined geographic area during a certain interval of time. Assignment of an artifact to a named type therefore implies a certain age and cultural affiliation for the artifact. (Ceramic types are discussed further in Chapter Five.)

Figure 4.10. Stone axes and hafted hammers
became common tools in southeastern Utah after about AD 500. These tools were usually less finely worked than their counterparts in some other regions. Most were made by pecking notches or sometimes a full circumferential groove into a flat cobble of igneous rock or silica-cemented mudstone, grinding one end to a cutting edge, and hafting the stone to a wrapped willow handle. Smaller, lighter axes and hafted hammers were used as weapons, while larger and heavier axes exhibit wear consistent with use for clearing brush and cutting trees. (Edge of the Cedars photo, *left to right*: ECPR 9794, 9798, 9795, 9800, 9799.)

Bone Artifacts

Bone has been a valuable material for tools, ornaments, and ceremonial objects for tens of thousands, if not hundreds of thousands, of years. The ancient Basketmaker and Puebloan cultures of southeastern Utah utilized this material (Figures 4.11, 4.12, 4.13) for scrapers, awls, perforators, needles, possibly daggers, gaming pieces (dice), ornaments, and other purposes. Deer and elk antlers were used for stone-flaking tools and clubs or billets. Bighorn sheep horn was used by Basketmaker people to make punches for making stone tools, and by later Puebloans to make push-hoe blades that were hafted to hardwood handles. Bone awls or perforators, scrapers or fleshers, and scoops are the most common tools found, both in archaeological sites and in the museum's collections.

Figure 4.11. Bone awls.
The Edge of the Cedars collections include numerous sharpened bone tools in a variety of styles. These tools were commonly made from deer, bighorn sheep, or turkey bone. Microscopic wear patterns reveal their use as awls or perforators in making coiled basketry, piercing hides, and so forth. (Edge of the Cedars photo, *left to right*: ECPR 9749, 9748, 9750, 9751, 9752, 9753, *top*: ECPR 9793.)

Figure 4.12. Game pieces.
Many Native American societies share an ancient tradition of gambling with sets of flat, two-sided dice made from bone or wood and often painted black on one side. The bone dice in this photo represent several different gaming sets in both round and oval styles. All were unpainted, natural bone on one side, and painted with a thick, black substance on the other side. In order to make the black substance adhere better, the painted side was first incised with patterns of lines. Some of the dice in the photo retain their black coating, while others have lost their coating, exposing the incised hatching. Provenience is unknown. (Edge of the Cedars photo, ECPR 8302.)

Figure 4.13. Bernstein-Dierking bone tool discovery cache.
These vessels were discovered in Comb Wash. The one on the left is a Dolores Corrugated olla, and the one on the right is a Mesa Verde Corrugated jar. When the soil of the pots was removed in the museum, one was found to contain a set of five bone tools made from bighorn sheep and mule deer leg bones. They may have been used as scoops or spoons. This style of pottery was produced during the late Pueblo II and Pueblo III periods (ca. AD 1050–1200±). (Edge of the Cedars photo, *back left to right*: ECPR 8817, 8818; *front left to right*: ECPR 8129, 8130, 8128, 8131, 8132.) (See Chapter Six for the story of the discovery and Figures 6.16–6.17.)

Perishable Artifacts

"Perishables" include all of those kinds of artifacts that would normally disappear through natural processes of decay when exposed to moisture, ultraviolet light, or other natural agents of decay. This includes all objects made of skin, basketry, fabric, wood, and so forth. Such objects can survive indefinitely in rare, dry environments such as protected desert caves or alcoves, or deep inside very high architectural rubble mounds; but in open-air sites, only occasional charred but incompletely burned specimens survive to be studied.

Southeastern Utah is blessed with numerous dry alcoves, in which were preserved a wealth of ancient perishable artifacts. The ancient Archaic, Basketmaker, and Puebloan peoples who intermittently inhabited these alcoves were sophisticated makers of coiled and twined baskets, sandals (Figures 4.14–4.17), and a variety of game nets and bags. Yucca and Apocynum (Indian hemp) provided the fibers of choice for spinning into cordage (Figure 4.18), but whole yucca leaves, hair, and juniper bark were used as well.

Figure 4.14. Early sandals.
Our understanding of the ages and significance of different sandal styles is becoming more refined as more sites with perishable artifacts are excavated under controlled conditions with proper documentation. Unfortunately, most sheltered sites have long since been disturbed, so new information on sandal styles is accumulating very slowly. These sandals represent several of the earlier styles in the Basketmaker–Pueblo tradition. *Left*: fine-twined and decorated, with buckskin-fringed toe, Basketmaker II (ECPR 8143); *center left*: fine-twined scalloped toe, Basketmaker III (ECPR 5731); *center right*: fine-twined scalloped toe with knotted relief pattern, Basketmaker III (ECPR 5041); *right*: weft-faced simple weave, probably Pueblo I–II (ECPR 8711). (Edge of the Cedars photo.)

Figure 4.15. Early sandals.
Top: weft-faced simple weave, probably Pueblo I–II (ECPR 10367); *left and right*: fine-twined, Basketmaker III (ECPR 5041, 3947); *bottom center*: fine-twined with buckskin toe fringe, Basketmaker II (ECPR 5024). (Photo by B. Hucko.)

Figure 4.16. Puebloan sandals
were made in a variety of styles, and their styles evolved through time. *Left to right*: weft-faced plain weave, Pueblo II–III (ECPR 3940); plaited weave, jog toe, Pueblo II–III (ECPR 5701); coarse-plaited with juniper bark padding, Pueblo II–III (ECPR 5033); coarse-plaited, Pueblo I–III (ECPR 5027). (Photo by B. Hucko.)

Figure 4.17. Sandals and yucca fiber skein.
This unworn pair of fine-twined and knotted relief-patterned sandals (ECPR 8823) and the skein of processed yucca fiber (ECPR 8824) were found in the Canyonlands area. This style of fancy sandal was made during the Basketmaker III–early Pueblo I period (ca. AD 600–800). The knotted relief pattern is on the bottom of the sole, where it would leave a distinctive track. Replicas of these designs were sometimes preserved by impressing them into clay tablets (ECPR 1895), like the inset example from the Casa Coyote site. (Edge of the Cedars photo.)

Figure 4.18. A string of arrows.
Spun yucca fiber cordage was used to twine together this arsenal of finely flaked Pueblo II–III side-notched arrow points. The two dark points are made of obsidian, the nearest sources of which are nearly two hundred miles away. The dark mass adhering to the string appears to be either mastic for use in hafting points, or possibly a cake of dried organic paint used to decorate pottery. This possible trade bundle was found and reported by responsible hikers at Turkey Pen Ruin in Grand Gulch. (Edge of the Cedars photo, ECPR 5769.)

Three-lobed sumac and sometimes willow, as well as grass, were used as foundations for coiled baskets (Figure 4.19). Yucca leaves, yucca cordage, and willow were used to make plaited baskets that are virtually indistinguishable from those made by the Hopis to the present day. Willows were used to lash together ingeniously simple ladders (Figure 4.20). Split willows or rushes were bound together by yucca cordage to make mats that were used as privacy screens, sleeping pads, clean places to work, or "suitcases" in which to wrap and transport weaving tools and other valued items (Figures 4.21, 4.22).

Figure 4.19. Horse Rock Ruin baskets.
Puebloan basket weavers were masters of their craft, as these baskets illustrate. These are some of about thirty baskets said to have been discovered by looters in a Pueblo III cliff dwelling on the Manti–La Sal National Forest. Most of the baskets in the collection were sold to collectors and have never been recovered. Although they are typical of Pueblo II–III basketry, inconsistencies in accounts of their discovery leave their actual history somewhat in doubt. (Edge of the Cedars photo, *back*: ECPR 55, 53; *front*: ECPR 56, 57; *right*: ECPR 62.)

Figure 4.20. Perfect Kiva ladder.
Most ancient Puebloan ladders employed a simple and ingenious technology using willow strips to lash the rungs to the uprights, as in this example from Slickhorn Canyon (ECPR 8808). After it began to disintegrate as a result of increasing impacts from visitors, the BLM brought this ladder to Edge of the Cedars and replaced it with a replica. (Photo courtesy of T. Till.)

Figure 4.21. Bullet Canyon loom.
This bundle of loom rods wrapped inside a split-willow mat was found by King Hastings in Bullet Canyon and reported to the responsible agency. When traffic in the area began to threaten its discovery by someone less responsible, the decision was made to remove it to Edge of the Cedars for curation. The mat has not been directly dated, but it was likely stashed in the mid-to-late AD 1200s, just before the Puebloan withdrawal from the region (ECPR 5057). (Photo by B. Hucko.)

Figure 4.22. Detail of Bullet Canyon loom bundle.
The mat was constructed by splitting willow rods, piercing the rods with an awl, then stringing them tightly together with a series of two-ply yucca cords knotted on the ends. The interior side of the mat (flat side of the willows) was rubbed smooth, while the exterior (convex) sides of the willows were left unaltered with the bark still attached. The large sticks were suspension rods, one of which would have been secured to the ceiling beams, the other to floor anchors, with the warp threads stretched between them. The smaller sticks were shed rods used to manipulate the warp threads during weaving. The loom would have been used to weave cotton yarn into blankets. (Photo by B. Hucko.)

By the Pueblo II period, domestic cotton was being grown as far north as the San Juan River and Glen Canyon, and cotton yarn was being woven into sophisticated fabrics on both upright and backstrap looms. Human and animal hair was also spun and used to create woven or crocheted bags, straps, and even stockings. Snares for trapping small game or birds were made from sticks and hair or yucca cordage. Animal skins were tanned with and without the hair for making robes, bags, arrow quivers, and other items. Cradleboards for carrying infants were made from various combinations of wood, yucca matting, and yucca or human hair cordage, depending on the time period (Figure 4.23).

Figure 4.23. Cradleboard.
This Basketmaker-style cradleboard came to Edge of the Cedars as a result of a federal investigation into a black market artifact dealer in New Mexico. The artifact was found with maps and papers suggesting that it came from somewhere in southeastern Utah, but nothing is known of its discovery context. The frame and cross-sticks are willow, the cordage used for lashing and twining is yucca fiber. The zigzag stitching that secures the rods in the center is typically cordage spun from human hair, but in this case it appears to utilize yucca cordage. (Edge of the Cedars photo, ECPR 3949.)

As early as Basketmaker II times, warm blankets were being made by twining together yucca fibers wrapped with strips of animal (usually rabbit) fur or sometimes bird skin strips with the downy feathers still attached. During Pueblo times, similar blankets were typically made by wrapping the yucca cords with split turkey down feathers (Figure 4.24).

Figure 4.24. Feather blankets.
The ancient Basketmaker and Puebloan people were skilled at making warm blankets by twining together yucca fiber cords that were wrapped with split turkey down feathers (or sometimes strips of fur). This photograph shows a close-up detail of two feather blankets. The one on the bottom (ECPR 5048) has the feathers intact, while the one on the top (ECPR 5049) illustrates the soft parts of the feathers eaten away by insects to reveal the cordage foundation wrapped with split feather quills. The top blanket probably looked like the bottom one before being infested by beetle larvae while stored or displayed in an uncontrolled environment before coming under the protection of the museum. *Bottom,* unknown provenience, Bureau of Land Management (BLM); *top,* unknown provenience, transferred without documentation to Edge of the Cedars from an old Albert Lyman collection in the San Juan County Library, Blanding. (Photo by W. Hurst.)

Wood was carved by the ancient Basketmaker and Puebloan peoples into various tools (Figures 4.25–4.27), including containers, plates, headrests, and digging/planting sticks, as well as ceremonial objects including staffs, rattles, wands, and prayer sticks with attached feathers. Wood was also carved to make weapons, including atlatls with darts, fending sticks (defensive deflecting devices used in conjunction with atlatls), and later, bows with arrows and clubs. Atlatl darts and arrows were often composite objects in two parts, a main shaft and a foreshaft (Figures 4.28, 4.29). The main shaft was made of cane, one end reinforced with a wooden nock and fletched with feathers, the other reinforced to receive the foreshaft. The shaft was typically painted in colored patterns to identify the owner. The foreshaft was tapered or shouldered on its butt end to insert into the main shaft, and carved to a sharp, fire-hardened point or hafted with a flaked stone point on its business end. Stone knives were firmly hafted to carved wooden handles (Figure 4.25), and clubs like small baseball bats were made from the ends of worn-out push-hoe shafts.

Figure 4.25. Westwater Ruin assemblage.
Westwater–Five Kiva Ruin, located south of Blanding, had suffered decades of looting and vandalism. In 1978, archaeologists from the Division of State History excavated in undisturbed sediments and recovered four nearly complete gray ware jars, a set of five carved wooden plates or trays, and four hafted knives, in addition to substantial perishable remains such as corn, beans, and squash, animal bones, and a variety of stone tools and other ceramics. Study of these items provided a glimpse into the lifeways of the people who inhabited Westwater Canyon during the Pueblo II–III period. (Edge of the Cedars photo, Jar with net (ECPR 8794); five wooden plates (ECPR 8803-8807); four hafted knives (ECPR 8799-8802).)

Figure 4.26. Wooden digging sticks
and push hoes were extremely important tools to the ancient Puebloan farmers. This photo shows three styles of push hoes. *Top*: one-piece hardwood with extended blade that would wear away with use (ECPR 8752); *center*: two-piece hardwood or one-piece with wrapped mending (ECPR 8820); *bottom*: two-piece composite with wooden shaft, bighorn sheep horn blade, and yucca cordage for hafting (ECPR 4886). (Photo by B. Hucko.)

Figure 4.27. Crook-necked staff.

This ceremonial crook-necked staff (ECPR 5054) was found by conscientious hikers who left it untouched in Pine Canyon. When dirt bike tracks and looters' shovel holes approached to within a short distance of the site, the decision was made to document its context and remove it for preservation at Edge of the Cedars. Crook-necked staffs appear in the hands of significant persons in Puebloan rock art and in the hands of certain kachinas among the western Pueblos. The crook symbolizes long life. This specimen is highly polished along its midsection from being carried. It was not a walking cane or an agricultural implement. *Bottom*, rock art images of staff bearers from Whiskers Draw North Fork *(left)* and Butler Wash. (Photo by B. Hucko.)

Figure 4.28. Atlatl kit.

Prior to the introduction of the bow and arrow in the early centuries AD, the atlatl-and-dart was the weapon of choice, and the fending stick was its defensive counterpart. *Top*: atlatl with the usual finger loops missing, handle at right, hook for engaging the dart butt at left, and a groove for attaching a bannerstone (weight or quieting amulet) in the midsection (ECPR 3929); *center*: dart components, partial wooden mainshaft at *left* (ECPR 8282), foreshaft (ECPR 8291) with hafted point at *right*; *bottom*: fending stick, C-shape instead of the usual S-shape, with hachured and black-painted ends, painted broad longitudinal stripe, and set of three longitudinal parallel grooves (ECPR 3952). The discovery contexts of these artifacts, part of an undocumented collection confiscated in a federal antiquities investigation, are unknown. (Edge of the Cedars photo.)

Figure 4.29. Arrow shaft and foreshafts.
Arrows were composite artifacts made from cane, wood, feathers, and sinew. This photograph shows part of a cane mainshaft *(center)* and two styles of foreshafts. The Puebloan mainshaft is missing the fletching feathers, but their attachment points and sinew fastenings are evident, as are the wooden string nock hafted with sinew into the end and the painted markings. The upper foreshaft is a typical Puebloan style, with a slight shoulder on the right end that socketed into the mainshaft. This was a fire-hardened "self" point, in which the sharpened foreshaft was also the arrowpoint. Although such points are more rare than stone points because of factors related to preservation, they were probably the most common type of projectile point. The lower foreshaft is a late prehistoric or protohistoric style that was used by Utes, Navajos, and many North American Indian tribes in recent centuries. These shafts lack the shoulder at the socket end *(right)*, are typically longer, and are commonly decorated (as in this case) with alternating longitudinal wavy and straight lines. The notch in the left end once received a stone or metal point that was attached with sinew, the marks of which are still evident. Blood smeared on the shaft may represent ceremonial blood smearing or residue from a kill. The blood has not yet been analyzed to determine the species. This shaft was found in Westwater Canyon within a half mile of Edge of the Cedars State Park. (*Left*: ECPR 4163; *center*: ECPR 4170; *right*: ECPR 4146.) (Photo by W. Hurst.)

Feathers from a wide variety of birds were used in many different ways. In addition to their previously mentioned use in blankets and for fletching of arrows or darts, they were used for ornamentation, decoration, and as elements of ritual paraphernalia, costume, or clothing (Figure 4.30).

Figure 4.30. Macaw feather sash.
Feather artifacts are extremely fragile and rare. This unique kilt or sash was found in a dry shelter in Lavender Canyon before that area became part of Canyonlands National Park. The artifact was later placed at Edge of the Cedars Museum for its protection. The feathers are from the scarlet macaw, a large, tropical parrot species that was occasionally traded north as far as the San Juan River. Other elements used to make this object include the skin of an Abert's squirrel, thick strips of leather (bison or elk?), and yucca fiber cordage. A radiocarbon date for the squirrel pelt indicates the sash was made around AD 1150. (See also discussion in Chapter Six and Figure 6.19.) (Edge of the Cedars photo, ECPR 12571.)

Rattles are rarely preserved in archaeological sites. A unique rattle, made of a beaver tail folded and sewn over a wooden stick, was found near the town of Bluff (Figure 4.31).

Figure 4.31. Beaver tail rattle.
Rattles of any kind occur very rarely in archaeological contexts in southeastern Utah. This unique specimen, made from beaver tail, wood, and yucca, was reportedly looted from a cave in Cottonwood Wash, and later was confiscated in the course of a federal antiquities investigation. No details are available as to its discovery context. Its age and even its affiliation are unknown. (Edge of the Cedars photo, ECPR 8144.)

By the late 1200s, shields made of coiled basketry or rawhide on a wooden frame had made their appearance. These early shields were body shields for foot warriors, protecting the area from knee or thigh to neck, unlike the smaller shields that we know from horse-mounted warriors of the historic period. Though rarely recovered as artifacts, shields are often prominently depicted as petroglyphs or pictographs at defensive citadel sites.

Careful study of perishable artifacts from documented contexts can reveal much about ancient cultures. The selection, use, and preparation of materials varied in significant ways through time and between cultural groups. For this reason, archaeologists pay close attention to such details as the direction in which cordage is spun; the number of plies in spun cordage; the directionality of basket construction; the nature of the foundation and stitching material used in coiled baskets; whether the stitches in coiled baskets are interlocked, split, or non-interlocked; the manner in which a basket rim, sandal edge, or blanket selvage was finished; and so forth. These details are most useful when artifacts are connected to a specific context in a site of known affiliation.

Because dry sites preserve much more material than open sites, they are rich with archaeological information. This leads archaeologists to try to protect and preserve them unless they are threatened by development or specifically targeted by a carefully focused and adequately funded research project. For this reason, relatively few sheltered sites have been properly excavated by archaeologists. Unfortunately, the relative rareness of dry sites and perishable artifacts also makes them very attractive to looters, who are less interested in preservation and have ravaged almost every sheltered site in southeastern Utah. (A small number of very small shelters have managed to escape thus far.)

The large majority of perishable artifacts taken from southeastern Utah's alcoves are presumed to be scattered around the world in private collections, untraceable to their discovery sites. Because these fragile artifacts are often susceptible to damage from light, handling, and insect infestation, many of them have been severely damaged and even destroyed as a result of being improperly handled, stored, or displayed after being removed from their discovery sites. A number of substantial perishable collections, mostly gathered in the late nineteenth century, are in the stewardship of various older museums across the country. These have fared much better, overall, although some damage resulted from insensitive handling, display, and storage techniques in the early years before the museums developed the standards that guide them today.

Since most of the archaeological exploration of sheltered sites in southeastern Utah occurred before Edge of the Cedars State Park was created, the museum holds a relatively small collection of properly documented perishable materials. Most of the perishable holdings at Edge of the Cedars were illegally collected by looters and came to the museum via government agencies that recovered the artifacts in the course of various legal investigations, and for whom Edge of the Cedars serves as authorized regional artifact repository. A few of these confiscated artifacts can be tentatively connected by informant testimony to a canyon, locality, or (rarely) a specific site, but very few are clothed in documented discovery context that gives them real archaeological value.

Ornaments

Edge of the Cedars Museum has stewardship of a wide range of ornamental artifacts (Figures 4.32–4.34), including various beads, pendants, bracelets, necklaces, hair ornaments, and rings. Ornaments offer fascinating insights into ancient cultures, especially when we know the full contexts of their discovery. Ornamental objects were crafted from a wide variety of materials, including various stones, shale, jet (a variety of workable coal), wood, plant seeds (juniper, hackberry), bone, shell, and even insect parts (Figure 4.34). Hollow bird bones were easily cut into sections and polished to make cylindrical beads.

Figure 4.32. Cache pot with pendants.
This cache pot was found with five stone pendants inside (ECPR 8748). The pot is part of a Pueblo II broken pitcher with the breaks ground smooth. Its discovery context is unknown. (Edge of the Cedars photo.)

Figure 4.33. Ornaments.
Ancient Puebloan people adorned themselves in a number of ways, some of which are represented in this photograph. Key: 1. Polished black stone pendant, early Pueblo I, Jensen Site, Blanding (42Sa22747 F7 pithouse); 2. White siltstone pendant, late Basketmaker III–early Pueblo I, Jensen Site F3 pithouse; 3. Polished stone pendant shaped like a deer or bighorn sheep leg, early Pueblo I, Jensen Site F7 pithouse; 4. Stone disk bead, BLM, Comb Ridge Heritage Initiative Project (ECPR-08010.209.1); 5. Red siltstone bead, early Pueblo I, Jensen Site F7 pithouse; 6. Copper bell, Pueblo II–III, probably made in western Mexico, Edge of the Cedars Ruin (ECPR 8938); 7. Spire-lopped *Olivella biplicata* shell trade bead from the Pacific coast of California, Basketmaker III, BLM, Comb Wash Heritage Initiative Project (ECPR 08010.68). (Graphic by W. Hurst, Edge of the Cedars photo.)

Jet beads were sometimes made so small that they can fall through a window screen, with holes that could only have been drilled with a cactus spine. Caches of these tiny beads have been found strung on human hair or fine yucca cordage in strings tens and even hundreds of thousands of beads long. Modified Olivella shells strung as necklaces and bracelets made their appearance as early as Basketmaker II times. Later, Glycimeris bivalve shells were carved into bracelets or froglike effigies. These shells were obtained by trade from the Pacific Ocean or Gulf of California.

Turquoise was a rare and valued material. It occurs occasionally as ear or necklace pendants. Metal artifacts are extremely rare. A unique pair of cast copper pendants was found by archaeologists in a first-century BC pithouse in the U.S. Highway 191 right-of-way south of Blanding. Cast copper bells made in Mexico or possibly southern Arizona are found rarely in late Pueblo II and later sites, including Edge of the Cedars Ruin, where three have been found.

Most of the ornaments in the custody of Edge of the Cedars Museum came in with undocumented collections lacking meaningful context. A significant few were better documented, and these are the most important ornaments in the collection.

Patterns in the locations where different kinds of ornaments, and debris from the making of ornaments, are found can tell us much about social differences, production processes, and trade patterns in the ancient Southwest. For this reason, archaeologists pay close attention to the materials that ornaments were made from, where those materials originated, how the ornaments were manufactured, and where different kinds of ornaments are found.

Figure 4.34.
Insect leg necklace.
This rare necklace was made by stringing together leg segments from iridescent beetle exoskeleta and a mother-of-pearl pendant on a fine string of yucca fiber cordage. The species of beetle has not been identified and the discovery context is unknown. (BLM, confiscated in the course of an antiquities investigation.) (Edge of the Cedars photo, ECPR 8135.)

Major Collections Held by Edge of the Cedars

As a fully qualified and authorized repository of archaeological and archival collections, Edge of the Cedars has stewardship of a number of important collections from federal and state agencies, and from a number of important excavation projects, along with associated photographic and written documentation. Following is a list of the major collections:

Edge of the Cedars Ruin Excavations

Excavations of parts of Edge of the Cedars Ruin (42Sa700) were conducted by Dee Green of Weber State College and others between 1969 and 1973. Subsequent small-scale excavations were later conducted in-house by different curator/archaeologists on the Edge of the Cedars State Park staff. The collections include photographic and written documentation as well as a broad range of artifacts, representing major occupations during the late Pueblo I–initial Pueblo II and late Pueblo II–Pueblo III periods. This important site was a community center for the surrounding region and is the only excavated example of a Chaco-era, provincial great house structure north of the San Juan River corridor. The collection includes artifacts, sediment samples, written notes, maps, and photographs.

Westwater–Five Kiva Ruin Excavations

Excavations at Westwater–Five Kiva Ruin (42Sa14, two miles south of Edge of the Cedars State Park) were conducted in the late 1970s by archaeologists from the Antiquities Section of the Utah Division of State History. Despite nearly a century of severe impact from heavy visitation and looting, this excavation yielded important information on Pueblo III and earlier occupations. Among these collections are nested cottonwood plates or trays and a set of hafted knives, both of which miraculously escaped decades of looters and are illustrated in this book (Figure 4.25). All of the artifacts collected are curated at Edge of the Cedars. Extensive field notes and photographs are archived at the Antiquities Section office in Salt Lake City, Utah.

Nancy Patterson Ruin Excavations

Excavations were conducted from 1983 through 1986 at Nancy Patterson Ruin (42Sa2110) in Montezuma Canyon by Brigham Young University for the landowner Mark Evans and a partnership of investors. The collection includes a full array of artifacts, field notes, maps, and photographic documentation. The project investigated various structures and sediment deposits from both a Pueblo I–early Pueblo II occupation and an extensive middle-late Pueblo III occupation. Edge of the Cedars has stewardship for the full array of artifacts, field notes, maps, and photographic documentation from this important project.

Lime Ridge Clovis Site

This site (42Sa16857) was investigated in 1985 by Abajo Archaeology of Bluff, Utah, for the Bureau of Land Management in connection with the development of a limestone quarry. Although the site was on bedrock with no depth and the artifact collection is small, it has extraordinary importance as the only Clovis-age (ca. 12,000± years old), late ice age hunting camp assemblage collected to date in southeastern Utah. The collection includes artifacts, notes, maps, and photographs.

Recapture Wash Excavation Project

Almost fifty recorded sites were destroyed or inundated by construction of Recapture Dam and Reservoir and associated realignment of U.S. Highway 191 northeast of Blanding. Nine of those sites were partially excavated by Brigham Young University for the San Juan County Water Conservancy District. These excavations, conducted from 1981 to 1983, recovered significant information on an array of Basketmaker III, Pueblo II, and Pueblo III sites, most importantly a Basketmaker II village with an oversized communal pit structure. This collection includes a full array of artifacts, backed up with extensive field records, maps, and photographs.

Utah Department of Transportation Highway Construction Projects

From 1990 through 2000 the realignment and expansion of U.S. Highway 191 south of Blanding and State Route 262 between Aneth and Montezuma Creek resulted in excavation of a number of important sites by Abajo Archaeology of Bluff, Utah, and Alpine Archaeology of Montrose, Colorado. The excavated sites represent the Basketmaker III, Pueblo I, Pueblo II, and Pueblo III periods. These investigations have contributed important insights into ancient occupations in the region. The collections include a full array of artifacts, written documentation, maps, and photographs.

White Mesa Uranium Mill Excavations

Construction of the uranium mill on White Mesa south of Blanding by Energy Fuels Nuclear (EFN) in the early 1980s destroyed a significant number of sites, a number of which were first excavated by a series of archaeological teams from the Antiquities Section of the Utah Division of State History, Plano Archaeology of Longmont, Colorado, and Abajo Archaeology of Bluff, Utah. These excavations contributed numerous insights into a variety of small field house and small hamlet habitation sites representing all periods from Basketmaker II through Pueblo III. All of the archaeological materials, including artifacts, field and lab records, photographs, and reports are curated at Edge of the Cedars Museum.

ML-1147 Excavation

This undisturbed Pueblo III period cliff dwelling complex in Woodenshoe Canyon was excavated in 1974 by a team of archaeologists from Brigham Young University for the USDA Forest Service. Having been overlooked by looters, the site yielded an array of baskets, pottery, vessels, wooden tools, and other artifacts that had lain undisturbed since the middle AD 1200s. This important assemblage of perishable and nonperishable artifacts and supporting documentation offers a unique glimpse into an undisturbed late Pueblo III dwelling and storage complex in the Elk Ridge area.

Utah Navajo Development Council and Utah Navajo Trust Collection
(The Shumway, Holliday, Perkins Collection)

This collection of almost nine hundred pottery vessels was purchased from Blanding residents Eugene Shumway, Jerry Holliday, and Tim Perkins in the early 1970s by the Utah Navajo Development Council. The council placed it for exhibition and curation in the new Edge of the Cedars State Park Museum when it opened in 1978. The collection includes a rich sample of whole vessels from the Pueblo II and Pueblo III periods, and a few from the earlier Basketmaker III and Pueblo I periods. There is no accompanying documentation or provenience information. In the absence of such information, this collection offers few useful archaeological insights but is useful for educational purposes as a source of representative examples of different pottery wares, types, and functional forms. Most of the vessels appear to have been made in southeastern Utah, but a few were probably made in Arizona or western New Mexico.

Bureau of Land Management and Manti–La Sal National Forest Collections

Edge of the Cedars is a designated repository for artifacts collected from federally administered lands in southeastern Utah (excluding national parks, whose artifacts are curated by the National Park Service in Moab, Utah, and Tucson, Arizona). In this capacity, it houses a wide array of artifacts collected from various survey and excavation projects on federal lands throughout southeastern Utah. It also includes artifacts reported by conscientious people and collected by agency archaeologists, recovered in the course of various investigations of antiquities law violations, or turned into the museum by repentant collectors who had realized the importance of proper documentation and curation. Edge of the Cedars also serves as archives for BLM's archaeological records, housing extensive written and photographic records and reports, as well as the primary copies of BLM's archaeological site survey files for most of San Juan County.

Wetherill-Grand Gulch Archives

During the late 1980s and early 1990s, Fred Blackburn and Julia Johnson led a team of volunteer researchers in an unprecedented effort to locate artifact collections removed from San Juan County in the 1890s and, if possible, to determine the discovery sites for different objects in those collections. In the course of the project, the team assembled a large and comprehensive collection of copied field records, museum records, collection catalogs, correspondence, and historic photographs, as well as artifact photos by team member Bruce Hucko and site maps showing locations of discovery sites. This invaluable collection is entirely housed at Edge of the Cedars.

Highway N-16 Excavation Collections

As the Navajo Nation upgraded the long road into Navajo Mountain from Inscription House, a number of important sites were excavated in a series of archaeological projects. One of these excavation phases was accomplished in 1985 by PIII Associates of Salt Lake City, who (with tribal concurrence) chose to place their collections for curation at Edge of the Cedars. This collection is an important addition to the museum's collections, providing a thoroughly documented sample of artifacts and associated documentation from an array of sites of different time periods in the heart of the Kayenta District of the ancient Pueblo world.

Butler Wash Archaeological Project

During 1976–78, the University of Denver Butler Wash Archaeological Project marked the first time scientific research had been conducted in Butler Wash. Butler Wash is an important tributary to the San Juan River that had been intensively inhabited during prehistoric times. Archaeological field school students surveyed an area 10 square kilometers around the Butler Wash headwaters and documented 120 archaeological sites. Three sites—Woodrat Knoll, Fallen Tree, and Cholla Knoll—were excavated. These provided substantial data for a Basketmaker III pithouse hamlet, a Pueblo I–II period site with storage features, and a classic Pueblo I village (Cholla Knoll). The survey and excavation collections contain the most substantial assemblage of Pueblo I material culture from Butler Wash, bracketed by Basketmaker III and early Pueblo II collections. They constitute an important source of information for both local and regional research.

Hosler and Jensen Site Excavations

Although many undocumented archaeological sites of diverse ages were identified during the settlement and expansion of the town of Blanding, none was documented inside the city limits prior to 1993. Since then, important remnants of two severely damaged sites have been formally investigated and documented by volunteers from the Trail of the Ancients (San Juan County) Chapter of the Utah Statewide Archaeological Society. Those sites are the Hosler and Jensen sites. The Hosler Site (42Sa22449) is a remnant of a burned Basketmaker III pithouse encountered during expansion of Bret and Pam Hosler's home. Excavation recovered architectural details, clues to diet, a small assemblage of floor artifacts, and charred wood beams that yielded a tree-ring cutting date of AD 693. Between 2002 and 2006, volunteer crews with small grant support from the Utah Division of State History conducted more extensive excavations in the Jensen Site (42Sa24747), a small surviving remnant of a once extensive terminal Basketmaker III–early Pueblo I period (AD 700–775) village located on property owned by Steve and Donna Jensen and Chris Webb. Architectural details, artifact assemblages, and a variety of sediment samples were recovered from two pithouses, a trash-filled house pit, and some unusually early pottery firing features. All documentation from these projects is archived at Edge of the Cedars, along with the collections, which (except for one small pot retained by the Hosler family) were generously donated to the museum by the property owners.

The L. Burton Redd Collection

L. B. Redd was an early banker, prominent businessman, and community leader in Blanding who acquired a collection of artifacts to display in the old San Juan State Bank building. Although none of the discovery contexts was documented, some of the artifacts are said to have been found during construction of the Redd home at 1st West and Center Street and/or the nearby site of the bank itself. One very interesting squared olla (Figure 5.8) is said to have been found during excavation of a water trench in the vicinity of the intersection of 200 South and 100 West streets. This collection was donated to Edge of the Cedars by Mr. Redd's descendants. Although the absence of accompanying discovery documentation limits its archaeological importance, the collection provides some useful objects for teaching and interpretation and represents an interesting aspect of Blanding's community history.

The San Juan County Library Collection

During the 1950s, Blanding's first settler, Albert R. Lyman, established a private museum in downtown Blanding. When the new San Juan County branch library was opened, Lyman's artifacts and some others from other private collections were displayed in glass cases in the library lobby. When Edge of the Cedars Museum opened in the late 1970s, those objects not claimed by members of the community were transferred there. This collection contains a number of objects of unknown origin including a pot described in several of Lyman's writings that he found while clearing stumps from his "potato patch" east of town. That site has since been found and recorded by the Trail of the Ancients Chapter of the Utah Statewide Archaeological Society.

Edge of the Cedars has stewardship of a wide and growing variety of artifacts of many different types, made of diverse materials, and backed up with widely varying degrees of documentation. This chapter presents a sampling of these objects, representing a broad spectrum of curatorial and interpretive challenges. Not shown are large collections of more mundane but equally important boxes of flakes, potsherds, soil samples, animal bones, vials of charred seeds, and other remains from excavated sites in the region. Those unimpressive remains, coupled with the documentary records describing their discovery and collection contexts, are an invaluable research resource to which archaeologists will return many times in the future, as insights evolve and research questions change.

Chapter Five

Pottery Collections at Edge of the Cedars

Pottery is one of our most important sources of archaeological information for several reasons. First, pots are fragile, but their pieces are very durable. Numerous pottery fragments are found in archaeological sites. Other kinds of artifacts, like basketry, fabrics, leather, and wood, rarely survive in open sites, often leaving pottery and stone artifacts as the main sources of archaeological information. Second, pottery is a complex technology that involves a lot of creativity and many decisions about what materials to use (clay, temper, and paint), how to use those materials (grinding and mixing the clay and temper, constructing the pot, deciding on the form of the pot), how to finish and decorate the pot (applying a surface slip, smoothing or polishing of the surface, and painting of designs), how to fire the pot, and so forth. As a powerful medium of artistic expression pottery contains information about the people who made it, where they found their materials, how they used natural materials available to them, and how they lived. Since potters in different areas selected locally available materials for making pots, and these materials varied from place to place, trained experts can identify the region where a pot was made by the clay and additives used to make it. This makes ceramic artifacts a valuable key to reconstructing patterns of production, distribution, and trade.

Pottery figures prominently in Four Corners archaeology and in the museum's collections. Following an introduction to the language used by archaeologists to describe and discuss pottery, we take a look at the way pottery styles and technology changed in this region through time and varied across space.

Wares, Types, and Vessel Forms

The conservative creativity of the Pueblo potters meant that designs at any one time were widely shared, and that they evolved slowly through time. Pots of one period have a distinctive look as compared to pots of another time period, just as a 1920s automobile has a different look from a 1940s model. But pottery also varied across space, reflecting differences in available materials as well as preferred design and form differences in different regions. These patterned differences in the pottery produced in different areas and at different times allow archaeologists to develop type categories that reflect the time period when a pottery type was made and the region where it was made.

Three terms figure prominently in discussions of ancient Southwestern pottery. They are ware, type, and style. The term "ware" is used in three different ways, to refer to broad functional, technological, and regionally specific formally named classes of pottery. In the Four Corners region of the American Southwest there are two broad functional ware classes and four broad technological ware classes of ancient ceramics. Functional classes include utility ware, which is less fancy, was produced in fewer steps, and was commonly used for cooking and storage purposes; and service ware, which typically involved more production steps such as slipping, polishing, and painting and was used for food service, storage of valued objects, or ceremonial purposes.

Figure 5.1. Ceramic production regions in the Four Corners with listed named wares. (Graphic by W. Hurst.)

Four technological ware classes of pottery are recognized by their typical color: brown ware, gray ware, white ware, and red ware (although colors can vary due to firing imperfections). Brown ware included both utility and service vessels, while gray ware was used almost exclusively as utility ware. Both brown ware and gray ware were either undecorated or decorated only by surface texturing of the clay. White ware and red ware typically include the more valued service ware vessels, which were more carefully smoothed, often slipped, often polished, and usually painted with decorative designs. Brown ware was generally made with a residual clay with a lot of natural silt, sand, or other inclusions and was fired at relatively low temperatures in poorly controlled fires. It is rare in Utah. Gray ware, made from tempered clay (amended with crushed rock, sherd, or sand) and fired at a higher temperature in a controlled neutral or reducing atmosphere (little or no oxygen available), is the most common class of ancient pottery throughout the Four Corners area. White ware was made similarly to gray ware but with the addition of more highly smoothed and often slipped and/or polished surfaces and decorated with designs in black carbon- or mineral-based paint on a gray or white background. Red ware was made similarly to white ware but with relatively iron-rich clay fired in an oxidizing atmosphere, allowing the iron in the clay to bond with the oxygen and turn orange or red, depending on the amount of iron in the clay.

Within these broad technological and functional ware classes, formally named wares with capitalized names are defined for pottery that was made in a certain way, with certain materials, in a certain geographic area for which the wares are named. Examples include San Juan Red Ware, Tusayan White Ware, Chuska Gray Ware, and many others. Each formally named ware encompasses a series of named "types" that replaced one another through time, each characterized by a distinctive decorative style. For example, San Juan Red Ware was made in the San Juan River drainage and includes the stylistically distinctive types Abajo Red-on-orange (eighth to ninth centuries), Bluff Black-on-red (ninth to early tenth centuries), and Deadman's Black-on-red (late ninth to early eleventh centuries). Pottery types of different formal wares that were made in different regions at about the same time often share a similar design style and are called analogous types. For example, Dogoszhi Black-on-white, an eleventh to twelfth century type in the Tusayan White Ware series from northern Arizona, is stylistically similar and therefore an analogous type to a stylistic variety of Mancos Black-on-white, a type in the San Juan White Ware series made at the same time in southeastern Utah and southwestern Colorado. The term "style" is often used informally to refer to the style of decoration shared by analogous types, and can be used to describe pottery whose type is unclear. For example, the analogous types Dogoszhi and Mancos Black-on-white, as well as several other types in the Four Corners region, share the "Dogoszhi style" of design, and a sherd or pot of this style can be assumed to date to the eleventh or twelfth century even if it doesn't fit comfortably into one of the named types of that period. It is, in fact, often easier to identify the style and approximate age of a sherd or pot than it is to identify its area of manufacture and assign it to a specific type.

At any given time during the late Basketmaker–Puebloan occupation, the people in a given region were using both utility (brown or gray) ware and service (white and/or red) ware pottery, so a site of a given age is likely to contain at least two and often three technological ware classes of pottery. Gray ware is typically most abundant, followed by white ware and red ware. By identifying the specific named pottery types on the site and tallying their relative abundance, archaeologists can identify the cultural affiliation of the site's

inhabitants, the approximate date(s) when the site was in use, and patterns in their trade relationships with other regions. Undocumented removal of even one diagnostic sherd can impair the ability to correctly identify the age, cultural affiliation, and trade connections of a site.

A pottery type typically includes a range of different vessel forms, including bowls of different sizes and jars of different sizes and shapes. If the ware, type, and style tell us the region and approximate date of manufacture, vessel forms provide important clues to pot function (what the pots were used for), and that tells us something about the behavior of the occupants of a site and how that site may have functioned in a larger community. Vessel forms vary differently in the utility ware versus the service ware classes. In the utility wares, bowls occur occasionally but jars are overwhelmingly dominant. In the service wares, bowls and jars are both common, in various sizes and shapes. Cooking pots (identifiable by bottom sooting) are typically gray or brown utility ware with a wide mouth to allow stirring and dipping and a round bottom to allow for gradual dispersion of heat from the cook fire. Jars designed to hold or transport a quantity of water, other liquids, or pourable solids (shelled corn or other seeds, for example) have small necks and are commonly called ollas, pitchers, or seed jars depending on their shape. Canteens, made for transport of a personal water supply, have even smaller necks (just large enough to drink out of and easily stop up) and lugs for suspension. Pitchers and mugs held personal servings of liquids. Multichambered small bowls were commonly used to hold different colored pigments, presumably for use in body or artifact painting. Unusual human or animal effigy forms likely held liquids for special ceremonial functions. Seed jars were typically used as cache pots, containing stored seeds, jewelry, or other valued material. Bowls were used for mixing and serving food. Ladles and scoops were used as dippers.

The size of the largest vessels in a room or site provides clues about the size of the group that the vessels served. Sites or households that hosted communal feasts often have larger bowls, sometimes with exterior painted designs that would be visible to the participants in the feast. Archaeologists are very interested in variation in vessel forms and sizes associated with different households or different rooms or room suites, and what this implies with regard to room or room suite function, household size or status, and so forth.

The Ancient Pottery of Southeastern Utah

Southeastern Utah lies mostly within the area dominated by Mesa Verdean ceramics, which include types in the San Juan Red Ware, San Juan Gray Ware, San Juan White Ware, and Mesa Verde White Ware series. But it lies close to the Kayenta region of northern Arizona, and types from the Tusayan Gray Ware, Tusayan White Ware, and Tsegi Orange Ware series that were made there also occur commonly in southeastern Utah, especially west of Blanding. Types traded from other regions such as the Chuska Valley, Chaco Canyon, and Zuni–Gallup regions in New Mexico and Arizona also occur in Utah but much less commonly. This chapter will focus primarily on the Mesa Verdean types in the museum's collection and secondarily on types from the Kayenta production region.

General Characteristics of the Mesa Verdean and Kayenta Wares

Pottery from the Mesa Verdean (northern San Juan) ceramic production region can generally be distinguished from that made in the Kayenta production region by their distinctively different temper additives and, in the case of the white wares, by differences in surface treatment and design.

Mesa Verdean pottery from the northern San Juan region (San Juan–Mesa Verde White Ware, San Juan Gray Ware, and San Juan Red Ware) is typically tempered with crushed igneous rock found in local gravels derived from the various mountain uplifts in the area. Beginning in the AD 900s, crushed sherd became a common tempering agent only in the white ware types. Crushed sandstone in several varieties was also used.

Pottery from the Kayenta region is typically tempered with well-rounded and uniformly sized quartz sand grains, evenly and abundantly distributed in a well-mixed clay matrix. The center of the sherd may be dark gray from carbon content in the clay. Crushed potsherd temper, usually with some sand grains, is the only temper commonly found in the Tsegi Orange Ware series. It is also found occasionally in the Pueblo II–III white ware types and very rarely in the gray wares.

The sherd- and sandstone-tempered varieties of Mesa Verdean pottery can be difficult to distinguish from the sand-tempered types made in the Kayenta region, or the sand-, sandstone-, or sherd-tempered types typical of the Chaco/Cibola production region of northwestern New Mexico. In these cases, an experienced analyst will make a subjective assessment of the overall combination of other pottery attributes, including form, finish, and design, to decide whether it most resembles typical pottery from one production region or another.

Basketmaker III Pottery (AD 400–750)

The earliest ceramic assemblages in the San Juan region consist entirely of bowls and gourd-shaped jars of plain brown ware, identified throughout the Colorado Plateau as "Obelisk Utility." It is often polished and sometimes smudged to a solid black. The clay appears to be self-tempered with an abundance of silt and fine sand, but added temper is absent. This type is very rare in Utah and occurs only as occasional small sherds in the museum's collections.

After about AD 500, the early brown ware gave way in the northern San Juan area to rock-tempered, harder-fired types in the San Juan Gray Ware and San Juan White Ware series (Figure 5.2; see also Figure 3.4). Chapin Gray, the earliest type in the San Juan Gray Ware series, is an unembellished gray pottery that occurs in various forms, with no surface decoration or texture except for protruding temper particles. Bowls occur rarely, and wide-mouth and narrow-mouth jars are common. The cooking pots are wide-mouth, globular vessels with vertical or everted (turned out) rims. The narrow-mouth forms resemble gourd shapes, are sometimes polished, and evolved in later periods into the various white ware jar forms. A similar but sand-tempered analogous type from northern Arizona and northwestern New Mexico is Lino Gray of the Tusayan Gray Ware series. The simple, plain gray jar style shared by these and other early analogous types from other regions is called Lino style, after the type of that name.

The only white ware type made in Basketmaker III times was Chapin Black-on-white, a relatively crude and simple decorated type, virtually always in bowl form, with coarsely prepared rock temper, bumpy surface due to protruding temper fragments, and simple geometric and life-form designs rendered in either iron

Figure 5.2. Basketmaker III ceramics (AD 450–750).
Basketmaker III pottery includes plain gray ware jars and black-on-white bowls with simple designs. These examples were recovered by archaeologists from the floor of a burned pithouse at the Casa Coyote site in the U.S. Highway 191 right-of-way south of Blanding, associated with tree-ring dates in the late AD 600s. *Left*: Chapin Gray (ECPR 8615); *right*: Chapin Black-on-white (ECPR 9775). (Photo by B. Hucko.)

(typical) or carbon paint on the bowl interior. These designs typically radiate out from the center or occur as "floating" elements on the side of the bowl. A polished variant of the type has sometimes been referred to as "Twin Trees Black-on-white" or "Twin Trees Variety" of Chapin Black-on-white. Chapin Black-on-white is the earliest clearly defined service type in the Mesa Verde region. Analogous similar types that were imported from surrounding regions include Lino Black-on-gray from the Kayenta region and La Plata Black-on-white from northwestern New Mexico. The decorative style shared by these various analogous types, like that of its gray contemporary, is called Lino style.

Although red ware had not yet made its appearance as a common type during the Basketmaker III period, late Basketmaker III pottery assemblages sometimes contain small amounts of a distinctive polished red ware with a thick, bright red slip on a light gray or white paste, known as "Tallahogan Red" imported from the Kayenta region (if the temper is quartz sand), or "Dolores Red" from the Mesa Verde region (if the temper is igneous rock or multilithic sand). No whole vessel of either type has yet been recovered in Utah, and none occurs in the museum's collections. The earliest of the San Juan Red Ware types, Abajo Red-on-orange, also occurred in very small quantities by the end of the period, but is described below under Pueblo I, when it became common.

Figure 5.3. Pueblo I ceramics (AD 700–900).
The Pueblo I period witnessed the replacement of plain gray *(rear)* by neckbanded *(right front)* utility pots, the refinement of white ware (see Figures 5.5 and 5.6), and the rise of the San Juan Red Ware tradition. *Clockwise from top*: Chapin Gray pitcher, Site 42Sa6686, White Mesa (ECPR 8788); Bluff Black-on-red pitcher, BLM ARPA, provenience unknown (ECPR 8682); Moccasin Gray pitcher, Utah Navajo Development Council (UNDC)/Utah Navajo Trust Fund (UNTF), provenience unknown (ECPR 3578); Bluff Black-on-red pitcher, 42Sa700, Edge of the Cedars Pueblo (ECPR 8927); Bluff Black-on-red canteen, UNDC/UNTF, provenience unknown (ECPR 3847). (Photo by B. Hucko.)

Figure 5.4. Late Pueblo I gray ware and red ware ceramics (AD 800s).
By the late Pueblo I period, ceramic assemblages in southeastern Utah were dominated by gray ware jars with wide, clapboarded neckbanding and bowls and jars with black-painted bold designs on an orange background. These pots were collected by archaeologists from a documented cache found by Ray and Jeanne Halsey in Butler Wash. *Back two*: Mancos Gray jars (ECPR 8357, 8356); *front*: Bluff Black-on-red pitcher (ECPR 8358). See Figure 5.6 for an example of the white ware type that typically accompanies these types. (Edge of the Cedars photo by D. Westfall and W. Hurst.)

Figure 5.5. Chapin Black-on-white bowls.
Back left: provenience unknown (ECPR 3222); *back right*: Woodrat Knoll site (ECPR 8783); *front*: provenience unknown (ECPR 3629). (Edge of the Cedars photo.)

Pueblo I Pottery (AD 700–900)

The Chapin Gray and Chapin Black-on-white types and their southern analogues continued to be made throughout the Pueblo I period, but with increasingly fine temper, smoother surfaces, and (in the case of the white wares) more sophisticated and complex designs. These types were joined by new red ware, gray ware, and white ware types that distinguish Pueblo I site assemblages from those of the previous period (Figures 5.3–5.5; see also Figure 3.5).

The Pueblo I period in southeastern Utah is marked by the appearance of significant amounts of two types of San Juan Red Ware, Abajo Red-on-orange and later Bluff Black-on-red. The oxidized San Juan Red Ware tradition appeared without precedent in the early 700s and would constitute a major part of the ceramic assemblages in this region for the next three centuries. The earliest in this series is Abajo Red-on-orange, a finely made type with bright red paint forming bold geometric design patterns on an unslipped orange surface. Bowls are the dominant form, but gourd-shaped jars, seed jars, effigy bird jars, and other forms also occur. Few whole Abajo Red-on-orange vessels have been recovered, and no vessels of this type are found in the collections at Edge of the Cedars. Bluff Black-on-red, with black manganese paint in bold designs on an orange background, made its appearance by AD 800 and was the dominant red ware type for the rest of the period. During the late 800s, a washy red slip appeared occasionally on Bluff and late Abajo vessels, foreshadowing the rise to dominance of Deadman's Black-on-red in the next period.

During the late 700s, gray ware potters began to experiment with leaving structural coils exposed on jar necks as a decorative texture. The earliest "neckbanded" type, Moccasin Gray, typically had two to six broad and flattened coils left exposed on the upper neck of the jar. The body of the jar below the neck was left plain gray with smoothed coils. This type evolved in the middle 800s into an early version of the type Mancos Gray, which continued the wide-neckbanded tradition but with clapboarded coils (overlapping, with the bottom of each coil hanging out over the coil below). This early, clapboarded version of Mancos Gray dominated gray ware assemblages through AD 900, the end of the Pueblo I period. An analogous type to both Moccasin and Mancos Gray is Kana'a Gray, a sand-tempered, wide-neckbanded type made in northern Arizona and northwestern New Mexico.

During the late 800s, Chapin Black-on-white evolved into and was replaced by two white ware types with polished, matte, or (rarely) slipped surfaces and more complex designs. East of Montezuma Canyon, the dominant new white ware type was Piedra Black-on-white, with a mineral-painted design system dominated by parallel sets of three or four narrow lines, the outer lines embellished with triangles. At Edge of the Cedars and the surrounding area, the dominant new type was White Mesa Black-on-white, a distinctive type with organic or organic-looking paint and a design system with fine to ultra-fine lines, often organized in bands. The designs on White Mesa Black-on-white sometimes resemble Piedra, but with much finer line work (Figure 5.6). This type occurs mostly in the form of bowls, with jars occurring only rarely. Most of the service ware jars in southeastern Utah in that time period were red ware. The nearest neighboring analogous white ware type at this time is Kana'a Black-on-white, a carbon-painted, sand-tempered white ware with thin-line and dot-ticked design elements similar to White Mesa Black-on-white, made in the Kayenta region starting in the late 800s.

Pueblo II Pottery (AD 900–1150)

Pueblo II ceramic assemblages (Figures 5.6–5.9; see also Figure 3.6) throughout the Four Corners area are characterized by the rise of indented corrugated utility types, the appearance of red-slipped red ware types, and diversification of white ware design styles. Mancos Gray, White Mesa Black-on-white, and Bluff Black-on-red continued to be made well into the 900s, but were joined by later types that replaced them by the end of that century. The wide-clapboarded style of early Mancos Gray gave way first to late Mancos Gray with narrower clapboarded or rounded coils that extended farther down onto the shoulder of the jar. By the turn of the century, Mancos Gray was largely replaced by Mancos Corrugated, as neckbanding gave way to indented-coil corrugation. The earlier Mancos Corrugated specimens are typically corrugated only on the neck and upper shoulder of the jar, the bottom part of which is left plain gray, like their neckbanded predecessors. The earliest indented corrugated is highly experimental and diverse, and often termed "exuberant" because of the distinctly large, deep, and pronounced indentations, which are commonly aligned to form vertical or diagonal ridges. Neck corrugation quickly became smaller and expanded to cover the whole vessel surface below the rim. During the course of the period, the nearly vertical rim of the bell-shaped Mancos Corrugated pots began to evert outward, evolving into a moderately everted late Pueblo II–Pueblo III type named Dolores Corrugated (Figure 5.9; see also Figure 4.13).

In the San Juan White Ware series, the Pueblo II period witnessed the replacement of White Mesa Black-on-white by Cortez Black-on-white, which in turn evolved into Mancos Black-on-white, out of which evolved McElmo Black-on-white. Cortez Black-on-white is relatively uncommon west of Montezuma Canyon, where there was a significant decline in population and San Juan Red Ware types were the dominant service ware during the early Pueblo II period. Cortez differs from White Mesa in its resemblance to the Chacoan (New Mexico) type Red Mesa Black-on-white. Extensive repopulation of southeastern Utah in the 1000s coincided with the replacement of Cortez Black-on-white by Mancos Black-on-white, a highly variable type. Mancos Black-on-white vessels typically exhibit a thick, crazed (crackled) slip or no slip, unevenly smoothed bowl exteriors, sporadic to moderate polishing, and thin, tapered rims (see Figure 5.10 for an unusual example). Designs are rendered in black mineral paint, and design systems incorporate elements of several different styles that occur on distinct types in the Tusayan White Ware series in the Kayenta region (Sosi, Black Mesa, and Dogoszhi Black-on-white), and in the Chaco/Cibola White Ware series in New Mexico (Gallup and Escavada Black-on-white). Late in the Pueblo II period, McElmo Black-on-white made its appearance. This type is distinguishable from Mancos by its thicker walls, bluntly rounded or squared-off rims, and bold designs, often laid out in a band. The classic examples are decorated with carbon paint, but mineral-painted examples also occur, creating some difficulty and inconsistency among analysts in separating late Mancos Black-on-white from mineral-painted McElmo.

During the late Pueblo II period, a distinctive variety of Mancos and McElmo Black-on-white appeared in the Utah assemblages. This material is characterized by a dark gray paste and a white slip, and occurs with increasing frequency from east to west. It probably represents the use of Chinle Formation clays that are exposed in the uplifted mesas west of Comb Ridge and around the Elk Ridge uplands. A dark paste variant of the San Juan Gray Ware series had been evident in regional ceramic assemblages since Basketmaker times, but its incorporation into the White Ware series did not happen on a large scale until the late Pueblo II period.

Figure 5.6. White Mesa Black-on-white (late Pueblo I–early Pueblo II, AD 850–950).
White Mesa Black-on-white is one of the most recently recognized types in southeastern Utah. This is the dominant white ware type in the Pueblo I assemblage from early village contexts at Edge of the Cedars Pueblo. *Left*: 42Sa700, Edge of the Cedars Pueblo (ECPR 8934); *back right*: Edge of the Cedars Pueblo (ECPR 7260); *front*: Cottonwood Wash, an example that combines classic Kana'a Black-on-white design elements with the typical band layout of White Mesa Black-on-white (ECPR 6015). (Photo by B. Hucko.)

Figure 5.7. Early Pueblo II ceramics (AD 900s).
The early Pueblo II period in southeastern Utah is recognizable by its mix of Mancos Gray neckbanded and Mancos Corrugated with its bold corrugation, together with Red Mesa style white ware and Deadman's Black-on-red. The red ware is actually much more common than the white ware in this region. *Center*: Red Mesa or unusually fine Cortez Black-on-white seed jar, UNDC/UNTF, provenience unknown (ECPR 3609); *clockwise from upper right*: Early Mancos Corrugated cooking jar, UNDC/UNTF, provenience unknown (ECPR 2893); Deadman's Black-on-red bowl, UNDC/UNTF, provenience unknown (ECPR 3667); Cortez Black-on-white bowl, UNDC/UNTF, provenience unknown (ECPR 3403); Red Mesa or Cortez Black-on-white small seed jar, UNDC/UNTF, provenience unknown (ECPR 3498); Mancos Gray cooking jar, USFS (ECPR 8405). (Photo by B. Hucko.)

Figure 5.8. Late Pueblo II ceramics (AD 1025–1150).
Late Pueblo II ceramics reflect continuing evolution in all wares. Deadman's Black-on-red is replaced by the early Tsegi Orange Ware types from the Kayenta region. Gray ware is corrugated over the entire jar surface, and the near vertical rims are beginning to show hints of the everted rim that would become typical in subsequent generations. White ware is decorated in a variety of distinct styles, but usually with only one style appearing on each pot. (Montage of B. Hucko photos.)

Upper left photo, counterclockwise from back: unusual four-cornered Mancos Black-on-white olla, said to have been discovered during excavation of a water line trench near the intersection of 200 South and 100 West streets in Blanding, L. B. Redd Collection (ECPR 4106); Medicine Black-on-red seed jar, a trade type from the new red ware production center in the Kayenta region of Arizona, UNDC/UNTF, provenience unknown (ECPR 3844); canteen of Tusayan Black-on-red, the most common late Pueblo II red ware type imported from south of the San Juan River after the end of the San Juan Red Ware tradition, UNDC/UNTF, provenience unknown (ECPR 3281); Deadman's Black-on-red bowl, the last red ware type made in the northern San Juan region, UNDC/UNTF, provenience unknown (ECPR 10020); Mancos Black-on-white Sosi-style large seed jar, UNDC/UNTF, provenience unknown (ECPR 3547). *Upper right photo*: Mancos Black-on-white Puerco-style bowl, UNDC/UNTF, provenience unknown (ECPR 3657). *Lower right photo*, clockwise from upper right: Mancos Black-on-white Dogoszhi-style cross-hachure jar or pitcher, UNDC/UNTF, provenience unknown (ECPR 3270); Mancos Black-on-white bowl, UNDC/UNTF, provenience unknown (ECPR 3155); Mancos Black-on-white Dogoszhi-style seed jar, UNDC/UNTF, provenience unknown (ECPR 3088); possible Gallup Black-on-white pitcher or large mug, UNDC/UNTF, provenience unknown (ECPR 3296). *Lower left photo:* large jar, Mancos Corrugated, L. B. Redd Collection, provenience unknown (ECPR 8795); small jar, Mancos Corrugated, UNDC/UNTF, provenience unknown (ECPR 3469).

Figure 5.9. Late Pueblo II–early Pueblo III culinary pots from Westwater–Five Kiva Ruin.
These four jars from Westwater–Five Kiva Ruin, 42Sa14, two miles south of Edge of the Cedars State Park, capture the transition between the typical Pueblo II (*right front*) and early Pueblo III (*right rear*) corrugated jar forms in southeastern Utah. The yucca leaf nets stabilized cooking pots that were beginning to crack, allowing them a second use-life as dry storage containers. The supporting juniper bark rings are museum supports, not part of the original artifacts, although similar juniper support rings were sometimes attached to yucca support nets. *Left to right*: Mancos-Dolores Corrugated, from the midden (ECPR 8791); Mancos-Dolores Corrugated, from the midden (ECPR 8794); Dolores Corrugated, from the large pit structure main chamber (ECPR 8793); and Mancos Corrugated, from subfloor Pit 8 in the large pit structure (ECPR 8792). (Edge of the Cedars photo.)

Figure 5.10. Late Pueblo II animal effigy pot (ca. early AD 1100s).
This rare ceramic effigy of an unidentified animal (possibly a bighorn sheep) was found eroding from a cutbank in Slickhorn Canyon. It was collected and documented by archaeologists from the Bureau of Land Management, who identified no associated artifacts or features. That isolation is itself an interesting and important context. Unusual isolated artifacts may sometimes mark the locations of shrines associated with agricultural fields, trails, or other places of significance. It is difficult to identify this vessel's type without chipping it to create a fresh exposure of the ceramic paste. It resembles specimens from New Mexico that have been classified as Escavada Black-on-white, but visible paste properties more closely resemble Mancos Black-on-white from the northern San Juan. (Edge of the Cedars photo, ECPR 8822.) (See Chapter Six for notes on discovery and Figures 6.3–6.5.)

Figure 5.11. Pueblo III ceramics (AD 1150–1300).
Several trends are evident in pottery from the Pueblo III period: culinary pots continued the tradition of overall indented corrugation but with strongly everted rims; white ware became thicker in the vessel wall, generally better polished, and often more complexly decorated with combinations of styles that were kept discrete in the previous period; and the red ware tradition continued to be dominated by imports from the Tsegi Orange Ware production centers south of the San Juan River (mostly polychrome types by this time). (Photo by B. Hucko.)

Back row, left to right: Mesa Verde Corrugated jar, UNDC/UNTF, provenience unknown (ECPR 3465); Mesa Verde Black-on-white olla, Dugout Ranch, Indian Creek area, (ECPR 8786); Mesa Verde Corrugated jar, UNDC/UNTF, provenience unknown (ECPR 3520).

Middle row, left to right: Mesa Verde Black-on-white "allover style" bowl, UNDC/UNTF, provenience unknown (ECPR 3627); Mesa Verde Black-on-white mug, BLM, found by Steve Burtenshaw family, Cottonwood Wash (ECPR 8593); Tusayan Polychrome Style A bowl, UNDC/UNTF, provenience unknown (ECPR 3255); Tusayan Polychrome Style B Bowl, UNDC/UNTF, provenience unknown (ECPR 3260).

Front row, left to right: McElmo Black-on-white bowl, UNDC/UNTF, provenience unknown (ECPR 3217); Mesa Verde Black-on-white unusual ring vessel with missing spout, UNDC/UNTF, provenience unknown (ECPR 3559); Mesa Verde Black-on-white round mug, UNDC/UNTF, provenience unknown (ECPR 3456).

During the 900s, Deadman's Black-on-red quickly replaced Bluff Black-on-red as the dominant San Juan Red Ware type and held that position into the middle 1000s. This type differs from its predecessor in its thin, bright red (iron-enriched) slip or wash and its finer-lined, more carefully rendered designs in a manganese paint that often exhibits a metallic luster. Vessel forms continued to include a variety of bowls and jar forms, including animal and bird effigies.

Deadman's Black-on-red and the San Juan Red Ware series ceased to be made around the middle or late AD 1000s, when they were replaced by Tsegi Orange Ware types made south of the San Juan River in the Kayenta–Navajo Mountain area. These types continue the stylistic evolution of the San Juan Red Ware series, and the early Tsegi Orange Ware types (Medicine and Tusayan Black-on-red; see Figure 5.8) can be easily mistaken for Deadman's Black-on-red. They are distinguishable from the earlier type by their crushed potsherd temper, which in the more obvious cases is evident as numerous, scattered yellowish specks in the vessel surface. This often gives the Tsegi Orange Ware specimens a slightly more orange-red cast as compared to the earlier Deadman's. The early Tsegi Orange Ware types were decorated with linear geometric designs (Medicine Black-on-red) or Dogoszhi-style hachured ribbons (Tusayan Black-on-red) similar to those on late Deadman's. By about AD 1100, polychrome variants with allover-exterior red slips and interior decorations made their appearance in the types Citadel Polychrome and Cameron Polychrome. These types constitute a small but persistent element of ceramic assemblages into the following period, after AD 1150.

Pueblo III Pottery (AD 1150–1300)

Pueblo III ceramic assemblages (Figure 5.11; see also Figures 3.7–3.9) are dominated by the Mesa Verde White Ware types McElmo and Mesa Verde Black-on-white; egg-shaped San Juan Gray Ware pots with overall indented corrugation and significantly everted rims (Dolores and Mesa Verde Corrugated); and occasional black-on-red and polychrome vessels from the Kayenta region's Tsegi Orange Ware series. Gray ware utility pots became increasingly egg-shaped and rim-everted through time, with the moderately everted Dolores Corrugated of the late Pueblo II–early Pueblo III period being replaced by the strongly everted Mesa Verde Corrugated type during the course of the period.

Mancos Black-on-white continued to occur in small amounts well into the Pueblo III period, but white ware assemblages were dominated heavily by the thicker walled and often better finished and carbon-painted Mesa Verde White Ware types; McElmo and Mesa Verde Black-on-white. McElmo is the earlier of the two types, dominating early Pueblo III assemblages and giving way to the more elaborate Mesa Verde Black-on-white in middle and late Pueblo III assemblages. Large bowls and ollas are the dominant vessel forms, with mug forms occurring frequently and kiva jars occurring rarely. The dark paste, western variant of the white ware types became increasingly common during the period, particularly in the area surrounding Elk Ridge. Long-distance trade in ceramics declined, then virtually ceased during the period. Flagstaff and Tusayan Black-on-white from the Kayenta region occur very rarely, and the highly elaborate later type Kayenta Black-on-white is virtually nonexistent in Utah.

Red Ware types also become increasingly scarce through time during the Pueblo III period, and in southeastern Utah are largely restricted to the Tsegi Orange Ware types. Tusayan Black-on-red continued

to be imported throughout the 1100s and into the 1200s, but the polychrome types were more common (Figure 3.8). Tusayan Polychrome replaced Citadel and Cameron Polychrome as the dominant red ware of this period. Assemblages dating to the 1200s occasionally contain late polychromes that incorporate white into the design, such as Kietsiel Polychrome and Kayenta Polychrome. Very rare examples of contemporaneous White Mountain Red Ware types (Puerco and Wingate Black-on-red, Wingate and St. John's Polychrome) also occur in Utah's Pueblo III assemblages, in trace amounts and mostly east of Montezuma Canyon.

Pueblo IV Pottery (AD 1300–1600)

Puebloan pottery from the centuries following the late thirteenth century depopulation of southeastern Utah is extremely rare. A few sherds of Jeddito Yellow Ware (Hopi, fourteenth to sixteenth centuries; Figure 5.12) have been documented, and a rare cache of Pueblo IV Hopi yellow ware pots was found in Canyonlands National Park. The pots are now in the custody of the National Park Service. Edge of the Cedars has no Pueblo IV vessels in its collections, except for a few of unknown provenience in looters' collections, probably found in Arizona. No Pueblo IV pottery from New Mexico has been identified in Utah.

Navajo and Ute Pottery (AD 1400–1900)

Pottery attributable to Navajo or Ute potters has been rarely identified in southeastern Utah. These ceramics are typically fired at a relatively low temperature, with a carbon-darkened, brown ware or brown ware-like paste that is sometimes flecked with mica. Both cultures made wide-mouth utility pots with rounded, pointed, or flat bottoms. Navajo pots (Figure 5.12) are typically better made and harder fired, with sand or

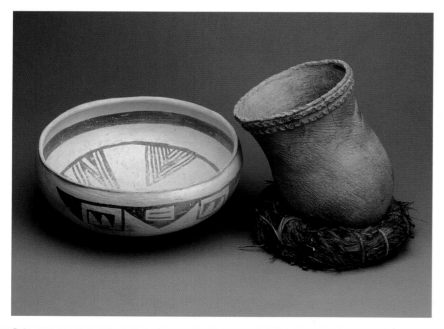

Figure 5.12. Late prehistoric and protohistoric ceramics (AD 1300 –1900).
The late prehistoric and protohistoric cultures in southeastern Utah made and left few pots in their archaeological record, but sherds of them occur occasionally and are an invaluable clue to late occupations that left few other traces. *Left*: Jeddito Black-on-yellow (Hopi), ca. AD 1400, UNDC/UNTF, provenience unknown (ECPR 8316); *right*: Navajo utility ware, late AD 1800s, provenience unknown (ECPR-87031). (Photo by B. Hucko.)

potsherd temper and a surface striated diagonally from being wiped by a corncob or other abrasive object when damp. Navajo pots are often decorated with a pinched or appliquéd band below the rim. Ute pots are typically brown or black with coarse sand temper. Their surfaces are often striated from being wiped when wet with a hand, a wad of juniper bark, or some similar material, or in the more obvious cases with lines of fingernail indentations that can superficially resemble Puebloan corrugation. No vessels of either class, from documented archaeological contexts, are held by Edge of the Cedars Museum, though there are some sherds in the museum's research collections.

Southeastern Utah has a rich and deep history of pottery production that tremendously enriches and empowers its archaeological record. Most of the pottery types found in the region are represented among the museum's collections. Unfortunately, the majority of the whole specimens lack adequate documentation of their discovery context, and their usefulness is limited to presentation as examples of known types. A significant and growing number of pots in the collection, however, were collected under controlled conditions with appropriate documentation. These have added and have potential to contribute further to our understanding of ancient ceramic technology and its diverse roles in the lives of our ancient predecessors.

Chapter Six
Stewardship

While some Navajo believe they can enter ruins or handle artifacts without retribution, others will avoid them; their stories of restless spirits, guardian snakes, and animal bile sizzling in the fires of sealed kivas end up protecting both the ruin and the Navajo. The corollaries of avoidance become respect and preservation.

Ellen Meloy, *Raven's Exile*

The Human Connection

Southwestern travel guidebooks, at least the ones published in the past dozen years, usually include an obligatory chapter on the topic of stewardship and cultural resource protection. Whether the message is repeated on trailhead bulletin boards, spoken by the backcountry ranger, or echoed in stark tones on the pages of the hiking guide, most seasoned visitors to the Southwest are attuned to the mantra and mentally check off the do's and don'ts, the etiquette for visiting deserted villages and places where others once lived. "Take only pictures, leave only footprints," "leave no trace," "don't lean on the walls," and "leave artifacts where they are found" collectively offer sound advice for a minimum-impact experience in the backcountry while preserving the fragile remnants of human activity for others to learn from and enjoy.

We hear that sometimes overused term, "stewardship," a word often paired with environment and resources, but what does it really mean to us on the human level, and what does it mean for the protection of irreplaceable archaeological resources?

Webster's Third New International Dictionary defines stewards as those "called to exercise responsible care over possessions entrusted to them." The key notions in this definition are the phrase "responsible care" and the word "entrusted." Both concepts imply appropriate behavior and respectful conduct. The words also imply a degree of personal integrity and a standard of appropriateness. In a cultural resource context, stewardship translates as responsible behavior and choices, or how we choose to act in the presence of the past. Personal integrity is precisely the point of cultural resource stewardship.

Most humans are fascinated with other people. It's part of the hardwiring, a survival strategy. We are also intrigued with the mystique of the past. In seeking ways to experience the mystery, we cling to the realm we know best: the material, sensory world. A polished fragment of exquisitely painted pottery or a faultlessly flaked point of red chert can serve as links to previous worlds, the misty human past, offering an opportunity to touch and vicariously experience that long-ago place and time. The act of holding an ancient sherd or arrowhead facilitates a relationship between observer and antiquity. To memorize the carefully drawn lines and then to replace the sherd in its bed of dust is a choice, a measure of integrity, of respect. It is stewardship.

Stewardship, then, is really about connection, the human connection. To be an effective steward, either for the land or of archaeological resources, there must be a relationship established, a philosophical and emotional link between mind and place. It is that relationship of trust and respect that links us in a continuum with

the humanity that has silently slipped into the breath of the desert. Stewardship is also a process, a path that begins with appreciation, admiration for the people and things of the past. Arising from that admiration are care and concern, followed by the desire to protect.

When trekking the canyons and visiting the seemingly abandoned stone structures, take time to recall that a family once called this place, this space, "home." For some of the descendants of the families who laid the stones for the walls and farmed the terraces a thousand years ago, who fashioned and painted the pots, the villages are not abandoned, but rather, still alive with the songs, the stories, and the intangible connections to the ancestors. These places are still "home." Remember to act accordingly, as a guest of treasured friends. Remember that each of us is the responsible caretaker.

Most of us would agree with the behavioral ideals required by site etiquette. However, as in most aspects of living, it is the choices we make when facing the dilemma of opportunity that determine who we really are. In spite of the laws and stinging penalties created to protect the vestiges of the past, in spite of positively framed reminders of how we are to behave, surface artifacts continue to vanish, images made eons ago on cliff walls continue to be removed or defaced, and sites continue to be disturbed or destroyed for development. Priceless connections are irrevocably denied to future generations, in unspoken contempt for the human continuum.

There is a plaque on our office wall, a reminder that proclaims, "The past belongs to the future but only the present can preserve it." This clever quip, restated, might read, "It is only our choices today that can ensure, to some degree, that these fragile places will survive another moment in time." In the end, the elements and the environment will slowly reclaim the artifacts, the standing walls, the desolate hearths, and the inscribed rock images. Until that time, it is the human connection that will preserve them.

Stewardship in Action

In 2005 Edge of the Cedars Museum worked in partnership with the Monticello Field Office of the Bureau of Land Management (BLM) to create a special exhibit. *Discovery!* traces the stories of people who did the right thing and in doing so became models of the ideal of cultural stewardship. Imagine the excitement of hiking in the deep canyons and on lonely mesa tops and finding a lost and forgotten but complete pot, or big-horn sheep effigy pitcher, or shell pendant, or cache of digging sticks. The human connection transcends time when seeing an artifact that has been in the same place for eight hundred years and more, left there by the last human being to touch it so long ago. Many questions come to mind then. Who were they? Why did they not return for it? What was its use? And most of all, what do I do now? This last question is the one that brings up issues of appropriate behavior and respect for the people who lived in the past. For the hikers in these stories the answer was clear, and seeing that the objects were in danger of being lost, stolen, or destroyed, they made the right choice. They hid the artifacts with brush and rocks, made careful notes of the locations, smoothed footprints to hide their tracks, and quietly left all as it had been before they came. Back in town they contacted the land managing agency or the museum. Later, they returned with the archaeologist to show the way to their discoveries and assist with excavation, documentation, and recovery. The pieces were brought to the museum where they could be studied and enjoyed by scholars and visitors for years to come. Here are a few of their stories.

A Set of Nested Bowls

As we entered the mouth of the canyon I noticed an archaeological site on the canyon bottom with pottery sherds and several stone features. Upon inspection I noticed that the streambed had been cut significantly into the site during a recent flood event, exposing a cutbank through the heart of the site. We dropped down into the dry wash to look at the site profile and to see what artifacts might have washed out. I followed the cutbank downstream several meters from the site features, and lo and behold, there were two bowls sticking out of the cutbank.

I grew up in Cortez, Colorado, and spent much of my life tramping around the canyon country. I have seen many archaeological sites, but never anything like this. I was thrilled because I know what a rare find this is. I am an archaeologist by training, so reporting such things is ethically ingrained for me. Reporting it to the BLM provides all citizens the opportunity to see and enjoy these fine pieces, rather than have them hidden away in a private place.

Wayne Howell, Gustavus, Alaska, 2004
Wayne is a professional archaeologist and an
ethnographer for the National Park Service in Alaska.

Figure 6.1. Nested bowls in situ close-up.
(Photo courtesy of the Bureau of Land Management.)

Figure 6.2. Nested bowls in cutbank.
These bowls were found by hikers Wayne
Howell, Kim Ney, and Nate Borson of Gusta-
vus, Alaska, and Bluff, Utah, in March 2004.
Two complete bowls and one partial bowl
were found eroding out of a sand dune in a
cutbank near Comb Ridge. The innermost is
a Deadman's Black-on-red style bowl with a
crack from the rim to the center (Pueblo I–II:
AD 875–1000) (ECPR 8814). The second
bowl of the set is a complete Mancos Black-
on-white bowl (Pueblo I–II: AD 875–1000)
(ECPR 8815). The outermost bowl is a large
Tusayan Black-on-red rim fragment (Pueblo
II: AD 1050–1150) (ECPR 8816). This
fragment was still embedded in the sediment
behind the two bowls visible in the photo.
Likely most of this outer bowl was washed
away. Notice the depth of the pots. This is an
indication of how much sediment has been
deposited over the top of the site in approxi-
mately one thousand years. (Photo courtesy of
the Bureau of Land Management.)

Animal Effigy Pitcher

I found the effigy vessel while I was exploring the north face of a cliff that lies at the junction of two canyons on Cedar Mesa. Along the way I was looking for signs of dwellings, grain storage structures or rock art. Not wanting to double back over my original path, I decided to rock-hop down a ravine of jagged chunks of earth. While descending, my gaze was focused more on my choice of step than on detecting archaeological treasures. Then, while falling in mid step to my mark, I glimpsed what I thought was a girl's toy purse. Knowing this was absurd, I arrested my descent to take another look. There in the soft soil trapped between boulders lay a perfectly preserved, partially buried Anasazi pot.

Figure 6.3. Animal effigy pitcher in situ.
This ceramic animal effigy pitcher is decorated in the San Juan White Ware style known as Mancos Black-on-white. The pitcher has four legs (two shown in this photo). Figure 5.10 shows that there are grooves on each foot like the cloven hoof of a desert bighorn sheep. Note the short curled tail and long snout. Above the eyes are two circular depressions where ears or perhaps horns may have broken off, or it is possible that the pitcher handle represents the horns (ECPR 8822). (Photo courtesy of the Bureau of Land Management.)

My first impulse was to pick it up. I wanted to hold it; I wanted to figure out what it was. I'm glad I didn't. I took the entire crew (wife, kids, brother, father, nephews and nieces) up the canyon and into the boulders to see what lay hidden in the cracks above. To their astonishment, my family saw what few will ever see: a pot resting in its actual place of origin. After taking several photographs, we placed the pot effigy safely in a crevice beneath the boulder above and covered the gap with the remaining sagebrush. We carefully noted the location of the site and went back to camp.

Ever since I was a child I always wondered what it was like for the Wetherills to discover the cliff dwellings at Mesa Verde and Grand Gulch. Although the discovery of an effigy pot is infinitesimal in comparison, I think the feeling is the same. It is as if the people just left and will be back soon, almost like they are on vacation. I have heard descriptions of people who have found pristine dwellings and reach down to see if the coals in the fire are still hot. There is something special about objects that survive from the past. They are like time portals to another age. Just one look and you are back in time to a period where there are no highways, airplanes, or even the English language. They help put the progression of time into perspective.

Quite frankly, I did not know what to do when I found the effigy vessel. It took a lot of talking and a bit of reason to figure out just how one goes about reporting such a find. For me, it is clear that these artifacts belong to no one other than the actual people who made them hundreds of years ago. Everyone should be given the opportunity to connect to our past through these discoveries. Museums are the ideal place for artifacts of antiquity. Museums provide a safe repository for artifacts, which, in principle, should be on display for the public to view.

James Murray, Tucson, Arizona, 2003

Figure 6.4. James Murray and the animal effigy pitcher prepared for transport from the field to the museum.
(Photo courtesy of the Bureau of Land Management.)

Figure 6.5. The Murray family proudly displays their find.
Sitting in front: James; *from left to right*: Amy, Gabe, Matt, Ellen, Norm. Not pictured (but part of discovery): Jessica and Jeremiah Murray. (Photo courtesy of the Bureau of Land Management.)

Eleven Digging Sticks

I have an archaeological site on Cedar Mesa named for me—the Sandy B. Site. That means more to me than having the artifacts I discovered hanging out on my bookshelf gathering dust.

There's little I love more than poking around the desert in search of any evidence of those who came before, eking out their existence amid pinyons and junipers, slickrock and sunshine. Unlike pothunters looting ancient sites, my friends and I are merely curious hikers seeking connection to the Ancestral Puebloans. Potsherds, manos, chippings from flint knapping, rock art, and ruins all fall under our definition of "loot." We know better than to take it, have no need for it, rarely find anything of significance as more and more people truly loot the canyons of these treasures. On one trip in 2000, I found some serious "loot." I knew it but didn't quite know what to do.

We were on a ledge above our hiking companions at a point north of them looking down into a small alcove. I shouted down, "Anything there?" The response came back, "Nothing but some petroglyphs." That was enough to perk my interest so I scrambled to that level and joined my companions in the alcove. After twenty-five years of exploring the Colorado Plateau, occasionally in the company of archaeologists, I recognized that there was more than "nothing" there. To me, we were looking into an undisturbed Basketmaker site with stone-lined cists, manos, and metates. As far as I could tell there was no evidence of later habitation except for the bones of a dead cow.

Figure 6.6. Three digging sticks.

These three wooden artifacts are part of a cache of eleven such objects that were recovered from the Sandy B. Site. Wooden paddle-shaped or sword-shaped artifacts similar to these have been found in several other localities on the Colorado Plateau. They have been described as "digging sticks," "hoes," or "sword-like weapons." Most, like these, are made from oak, are 1–1.15 meters long, and are finely smoothed and sealed. The flat, blade-like portions of some of the Sandy B. Site artifacts are battered along the edges, suggesting that they were used to strike or beat something. Were they used to dig for planting or building structures? Were they seed-threshing tools or perhaps weapons? Were they used during the Basketmaker occupation of the site or stored there at a later time? The wooden object on the top was selected for analysis. A wood sample from the handle end yielded a radiocarbon date of AD 220–350, which dates the manufacture and use of this tool to the Basketmaker II Period (AD 50–500). Pollen and spectrographic analysis of the blade revealed no concentrations of plant pollen or inorganic minerals; hence, a food-related activity was not confirmed. Future use-wear analysis will involve examining the artifact edges and surfaces under a high-powered binocular microscope and possibly a scanning electron microscope. If the tool was used as a digging stick or as a hoe, then abrasion marks and possibly polishing from sand grains should be seen. If the tool was used as a thresher, then striations or shallow cuts should be visible. Impact fractures may indicate use as a weapon. (Edge of the Cedars photo, *top to bottom*: ECPR-8819, 8820, 1884.)

Figure 6.7. Sandy Bielenberg and Jasmine.
(Photo courtesy of Ann Bond.)

While eating lunch on a sunny rock outside the alcove, contemplating Basketmaker life in this place, something caught my eye under a foot-high overhang. Certainly out of context was a row of several 1½ inch diameter sticks laying side by side. Though I have deep respect for sites, conscientiously avoiding walking on or over walls, replacing each potsherd in its exact spot, following the rules…curiosity got the best of me. Because these sticks definitely could not have arrived at that spot nor in that precise layout on their own, I picked one up. To our surprise, awe, wonder, and amazement, that stick turned out to be an intact wooden tool, a meter long, made of two pieces of wood joined with a lashing of yucca fiber, an overcoat of leather, another wrapping of cord then pitched with pine sap. Picking up that tool revealed another beautifully carved paddle about the same length. What were they—farm tools? Hoes? Harvesting implements? Evidence that Anasazi paddled rivers? In all we could count parts of eleven sticks but knew better than to disturb them anymore. I carefully replaced the one I'd picked up, doing my best to return the site to the way it looked before I disturbed it. Then came the dilemma and discussion of what to do next. There was no question that this was an important find. Together we swore to not reveal the location to anyone. We brushed away our tracks and left.

What were we to do? Years ago archaeologists Fred Blackburn and Winston Hurst supported the idea of leaving things in place for a "living museum." I remember finding a note on the original ladder in Perfect Kiva asking people to respect it and leave it in place. (Now the original ladder is at Edge of the Cedars in Blanding, and a replica is at the site.) What if we kept the tools a secret but someone else found them and took them home? With so many people crawling around the canyon, not much has been left in place; instead, more artifacts are found on someone's bookshelf or on eBay. Some people think artifacts should be cached somewhere near their original place for professional guides to share with their guests on high-dollar archaeology trips. Isn't hiding them in a cache, swathed in plastic, the same as hiding them under a bed or placing them on a bookshelf? Did the tools want to be taken out only to live in the dark basement of a museum?

I was puzzled. Ethically I didn't know the solution. I do know that each year more and more of this cultural heritage vanishes. Potsherds are most noticeably absent from sites where there had been so many a few years earlier. Back in the '70s, when I started exploring canyons, I would sit for hours in middens admiring countless exquisite black-on-white sherds, where now perhaps there are a few small pieces of gray ware but not much else. I remember finding manos, beads, bones, and bits of woven sandals in a number of ruins. I wish I'd kept my own record of those small discoveries because now those sites have been cleaned out by too many people with too little appreciation and reverence, and too much of a culturally ingrained sense of materialism—the need for wanting, owning, possessing— lured by magazines touting "the best hikes," guidebooks which take away the joy of discovery, and websites giving GPS locations for sites.

I left the tools in place but they would not leave my mind. I felt guilty for having disturbed them. We had noticed some insect damage, and I was worried about insects obliterating them. I was curious about their use. For months afterwards, I searched books and museums for similar implements but found nothing as exquisite. Finally, I met with Sally Cole, occasional hiking companion and renowned rock art specialist. I showed her my notes and a photograph. She too had never seen tools like this except as petroglyphs along the San Juan. She knew they merited retrieval.

On April 1, 2001, we led a group of archaeologists and BLM employees to the site. We spent the day surveying, mapping, and photographing the site, and excavating the tools, carefully wrapping each one to hike them out to be studied and preserved at Edge of the Cedars. More than three years later, in the summer of 2004, I received a phone call from Sally saying that the tools had finally been carbon-dated to the year 230 A.D. Nearly 1,800 years had passed since a Basketmaker farmer stashed these implements in a dry sandy overhang. I was thrilled.

Will this discovery make a difference in what we can learn about Basketmaker people? I hope so. Is it okay for nine of the eleven to be in safe storage in a dark cupboard? I don't know, maybe a bit of soul is gone from that site. Should we have left them there to be termite treats? I think not. Saving something nearly 1,800 years old in order to know the Anasazi has value. What I do know for certain is that I do have a deep reverence for these people of the past, touched by their handiwork. I know that I have no need for their things, but definitely a need to be in the places they lived, seeing evidence of their lives. When artifacts are taken for personal collections or profit, we all lose. I wish that more people visiting these places would share my views.

Sandy Bielenberg, Durango, Colorado, 2004

Figure 6.8. A page from Bielenberg's field notebook that details one of the finds. (Courtesy of Sandy Bielenberg.)

Figure 6.9. Excavating the artifacts.
BLM archaeologist Kathy Huppe carefully excavates one of the wooden objects from the site. (Photo courtesy of the Bureau of Land Management.)

Figure 6.10. Removing the artifacts.
Marie Tuxhorn, Phil Gezon, and Scott Edwards transport the artifacts from the site. (Photo courtesy of the Bureau of Land Management.)

Owl Canyon Olla

This hike was on the last day of a weeklong hiking trip. I, a retired middle school principal from Boring, Oregon, was joined by Michael Shay, a middle school principal from Durham, Oregon; Greg Kebbekus, brother-in-law and school counselor from Madison, Wisconsin; and Jim Beard, a southeast Utah resident and avid hiker on Cedar Mesa. We always schedule a hiking day or two with Jim when we come out once or twice every year. All of us have had a longtime interest in the Anasazi and desert societies and have fallen in love with the way Cedar Mesa tends to present herself to hikers and explorers who care to walk softly, notice, and pay attention. We talk a lot about learning by emergence—being open to new vistas, new questions, and new awareness.

On that morning of March 30 we gassed up in Blanding and headed west, not knowing where exactly we would hike that day. We'd previously arranged to meet Jim in the parking lot at the Kane Gulch Ranger Station. In our regular discussion of where to go and what to do, the only consensus was to hike somewhere new to us that day, without any expectations other than to see what the day would bring. As we discussed two options, neither of which was more compelling than the other, Jim suggested, "Let's just go hike somewhere in Owl Canyon since it's closer and we're getting a late start."

Early in our hike we stopped to do the requisite adjusting of pack straps, unwrapping granola bars, and looking at our maps. While I waited for my companions I casually looked back in the direction from which we had just come. Jim had just finished saying, "Well, I can play guide and show you where everything is, or I can just walk along pretending I've never been here before and let you find sites on your own." Michael—as he always does—answered that we should just wander along and enjoy what the hike presents to us. At that moment my eyes picked up a gray-white arc shape in a shadow beneath a boulder. Through the binoculars I knew in an instant what I was looking at. It was definitely one of those out of place forms and shapes, not fitting into the natural background. I exclaimed, "You've got to see this" and beckoned everyone over to me, automatically assuming Jim was playing some game—that he already knew about it—so I didn't call him. He quickly came over to us and used his binoculars to look where I pointed, saying, "Wow."

I dawdled behind as we walked over, saying to Michael, "It must be Jim playing a joke on us. It is probably just some large pottery fragments, and he just wants to see us all excited and then have a good laugh with us when we get there. He must have known about this, or he wouldn't have suggested we break for a minute here to plan the rest of our hike." As a result, I, the cynic, was the last one to get to and view this most precious pot.

We hung out there for a while, photographing the pot. We were all excited about our find. Jim kept assuring us that he had not known about this pot and had passed right by it multiple times. When we resumed our hike we all felt that whatever we saw or wherever we went the remainder of the day was a bonus—that we'd already seen the climax early on and it was all downhill from here.

We agreed that we needed to tell authorities promptly because of the location. We took a GPS reading and marked it on our maps. Interestingly, we all agreed that we wouldn't go back out immediately, but would continue to hike the remainder of the day. Our thinking was that we would talk about what we found and come up with a clear, ethical process concerning when, how, and who we would tell. Out of that long discussion, we were all in agreement that Jim would call a BLM law enforcement ranger that he knew as soon as he got home.

We would mention it to no one in the meantime. We would also never print or post our photographs with a reference to its location. Furthermore, our email and regular mail to family or friends would not call attention to

Figure 6.11. Owl Canyon jar vicinity–Owl Canyon rim.
(ECPR 05003.) (Photo courtesy of Charles Juenemann and Greg Kebbekus.)

Figure 6.12. Owl Canyon jar in situ.
This jar is a Mesa Verde Corrugated olla dated to Pueblo III (AD 1150–1300). (Photo courtesy of Charles Juenemann and Greg Kebbekus.)

Figure 6.13. Michael Shay, Charles Juenemann, and Greg Kebbekus at the Owl Canyon discovery site.
(Photo courtesy of Charles Juenemann and Greg Kebbekus.)

the precise location. Jim called the BLM ranger and she invited us to meet with her at her office the next morning. We gave her our GPS readings and she copied our photographs as a first stage towards full documentation. She also took a written transcript of our story and shared with us the interesting process that the government goes through with antiquities.

Later Jim went with the BLM ranger to document the pot and assess any potential that others might also find it. While this was happening, others in the BLM office contacted the appropriate Native American tribe and described the circumstances and likelihood of discovery and removal by pothunters or some casual hiker. When the ranger returned to her patrol vehicle and called the BLM office, she received a go-ahead to accession the pot to Edge of the Cedars Museum, and a BLM archaeologist assisted her with this process that same day.

The museum curator studied the pot and eventually a decision was made by the staff to include it in the Discovery! display in the lobby of Edge of the Cedars Museum, where it is now. All of us drop into the museum whenever we are nearby to see "our pot," but of course it never was ours to begin with. We were only the finders, and helped do the right thing. Later, we also learned that artifacts, even pots, are not always accessioned to a museum or federal repository. Sometimes the appropriate Native American tribe decides to leave certain important objects in situ, in accord with their own spiritual beliefs. This concept is known by some as "The Outdoor Museum": artifacts may remain in situ for others to see, photograph, and hopefully to leave as found.

We hope our families, our kids and grandkids, can continue to learn from this rich experience, as have we.

Charles Juenemann, Boring, Oregon, 2005

Figure 6.14. Charles Juenemann with Owl Canyon jar in situ.
(Photo courtesy of Charles Juenemann and Greg Kebbekus.)

Figure 6.15. BLM law enforcement officer views photo of pot.
(Photo courtesy of Charles Juenemann and Greg Kebbekus.)

Big Pots and Bone Tools

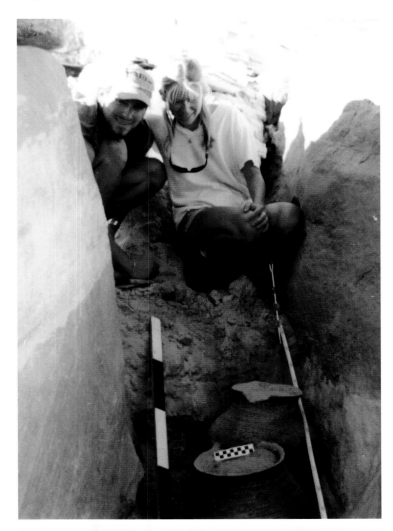

Figure 6.16. Alan and Tracy Dierking with pots at the Bernstein-Dierking site.
(Photo courtesy of the Bureau of Land Management.)
(See also Figure 4.13.)

Tracy Bernstein and Alan Dierking of Salida, Colorado, were hiking in Comb Wash when they found the exposed rims of two large pots hidden in a narrow alcove beside a sandstone cliff. They were attracted to the area because of rock art located on the cliff face and just happened to see the ceramic rims of the pots. They decided to do the right thing and report their find to someone who would also do the right thing for the pots.

On their way home they stopped in Blanding and told personnel at Edge of the Cedars Museum about their discovery. They were referred to the BLM office in Monticello. Tracy and Alan offered to return to the site to show the BLM archaeologist and ranger where the pots were located.

Recovering the pots presented a problem for the archaeologist: how to transport the pots, which were cracked along the sides, back to the museum but not disturb the fill within the pots. The fill would need to be recovered and analyzed. The problem was solved by wrapping cord around the outside of each pot, placing them in large boxes with packing material, and carrying them out with a tough framed backpack and a strong back. Tracy and Alan helped with the recovery process, and both large pots made it safely to the museum.

The contents were excavated at the museum field lab. The soil within each pot was screened through fine sieves to recover cultural artifacts and materials such as plant pollen. Plant pollen is useful for study of environmental conditions from the time the pots were originally placed in the site. Useful samples for analysis were obtained from one pot, a Dolores Corrugated olla from the late Pueblo II period. The second pot, a Mesa Verde Corrugated jar (Pueblo III), contained basket fragments. Stacked in the bottom of the pot, large on top of small, were five bone tools (Figure 4.13).

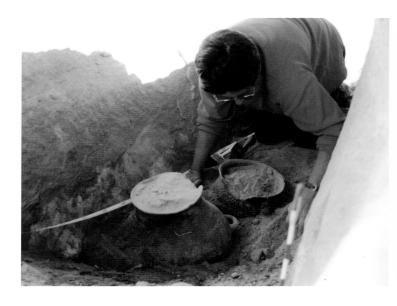

Figure 6.17. BLM archaeologist Nancy Shearin excavates pots. (Photo courtesy of the Bureau of Land Management.)

The sediment in the Dolores Corrugated olla contained pollen from local vegetation, including plants that are typical of a pinyon-juniper woodland and a sagebrush understory with various grasses and shrubs. This pollen was likely deposited by the wind. Sediments also contained a large amount of corn pollen. This may have been present in the pot or in the basket placed inside of it. The relatively large quantity of corn pollen in the sediment suggests the presence of corn pollen rather than ground corn.

Pollen residue on the bone tools indicates the tools were likely used as scoops. Beeweed, grass, cattail, and buffaloberry pollens were also found, suggesting the tools may have been used as scoops for these plant foods as well. Protein residue was found only on the mule deer bone tool. This may reflect human handling.

(Portions excerpted from Cultural Resource Information Report, Bernstein-Dierking Discovery Site, BLM, Monticello, Utah. 2004.)

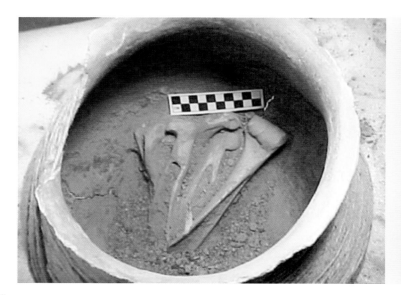

Figure 6.18. Back in the lab, the pots are prepared for the excavation of the contents. (Edge of the Cedars photo.)

The Macaw Feather Sash

Figure 6.19. Kent Frost in the cave where he found the macaw feather sash.
(Photo courtesy of Dewitt Jones/*National Geographic* Image Collection, NGM 1982.) (See also Figure 4.30.)

Perhaps the most rare and unusual of all of the objects in the museum's collection is the macaw feather sash. In 1955, backcountry guide Kent Frost of Monticello discovered it in a remote canyon in what is now south Canyonlands National Park. The technique of using feathered cords is known from only a few Basketmaker period cave sites (AD 750–950). The sash was taken from a cave site without documentation of any artifacts associated with it. However, the reported presence of certain pottery types in this cave site suggested that the sash dated to approximately AD 1050–1150. Radiocarbon dating finally established the date as AD 1150.

The sash contains over one thousand feathers from the scarlet macaw, a parrot native to Mexico. This demonstrates that the Ancestral Puebloan people had a vast trading network. Because the method of tying the feathers is understood primarily from an Aztec artifact in Mexico, it is possible that the feathered cords were made there and traded into our area. On the other hand, buried macaws have been found in several locations in the Southwest, suggesting that some live birds were traded—so the feathered cords may have been made here. It is likely, however, that the entire piece was constructed locally because the cords are attached to the pelt of an Abert's squirrel, a species of squirrel that in Utah lives only in the Abajo Mountains. The bright colors and fragility likely indicate the sash was used for ceremonial purposes. One of the things seldom seen in prehistoric artifacts is how colorful they might have been. While one or two of the feathered cords are missing, it is startling to see how beautifully these bright colors are preserved.

The following account of the discovery of the sash is excerpted from a 1993 interview with Kent Frost by another backcountry guide, Vaughn Hadenfeldt of Far Out Expeditions (Bluff, Utah).

…And then there was one trip. We were on a commercial tour in Lavender Canyon and we was up near that cleft arch and we had an open jeep and it started sprinkling along, it was probably along in June or some time that time of the year, and it started raining hard so we jumped out of that and run over just a little ways over the bottom of the canyon to a little long overhang that was on the north side of the canyon. And we was sitting there and the sand is about 3 or 4 inches deep in the bottom of this overhang and it looked like it was probably river sand that had been transported up there or something and there were a lot of cornhusks also along with this sand the leaves were poking up above the surface. So anyway we was sitting there and I all of a sudden started moving my legs around on the surface. I wasn't digging for anything because the sand was just shallow and here comes a little ball up about 3 or 4 inches long and about 2½ inches in diameter and it came to the surface. And here it looked like a piece of leather and so I picked it up and I unrolled it, it had strings tied around it and I unrolled it and here it was this mask or skirt—the famous macaw feather sash that come up to the surface there. And I didn't know what to think about it…and this woman that was on the trip—my wife and I were there together with her on just this one camping trip—and so she thought this was real good so she took it to California with her when she left. And later she sent it to University of Northern Arizona they run archaeology studies on it and made a report on it and things like that. And then she kept it for years and I think she clipped one of those long streamers on it. Her name was Becky and I think Becky clipped out one of those long streamers. And anyway, we wrote a letter to her that they have the museum here in Monticello and we told her we'd like to have that back to the country where it came from, if she'd send it back so she did. And so it was in the Monticello museum for several years. And then we took it out of there because they didn't have any kind of security or anything. We put it in a bank box for years and then later we took it down to the Edge of the Cedars Museum in Blanding and so that's where it is now.

Kent Frost, Monticello, Utah, 1993

The sash was on temporary loan to Edge of the Cedars Museum for many years. In July 2006 Frost permanently donated the sash to the museum. A special climate-controlled and secured exhibit case was designed and built for the sash so that it would be available for the enjoyment and wonder of visitors for years to come.

The Utah Site Stewards Program

Following in the footsteps of other successful archaeological site stewards programs in Arizona, Colorado, and New Mexico, the Utah Site Stewards Program began at Edge of the Cedars State Park Museum in 2000. Under the direction of museum staff and a volunteer coordinator, the program was organized with the support of the Utah Division of State History and the Bureau of Land Management. The purpose of the site stewards program is to work with federal and state land managing agencies to protect and preserve archaeological sites in San Juan County and to educate the public about the importance of cultural resources. Volunteers are generally local residents, though some come from southwestern Colorado and throughout Utah to participate. These concerned and interested citizens are trained to be the eyes and ears of the public lands manager. Each is assigned an archaeological site to monitor for damage due to overuse or other causes. They are trained to act as a guide to visitors they may encounter at the site, providing information such as culture history and explanation of pottery and other artifact styles. They also offer guidance on how to enjoy cultural resources appropriately, encouraging a "leave no trace" approach.

Figure 6.20. Utah site stewards and Grand Canyon Trust volunteers record a large surface site along the San Juan River. (Photo by Liam Downey.)

Figure 6.21.
Barbara and Phil
Brunner recording
visitor impacts at
River House ruin
on a joint project of
the Utah Site Stew-
ards Program and
the Grand Canyon
Trust.
(Photo by Liam
Downey.)

Figure 6.22. Utah
site steward working
near Cedar Mesa.
(Photo by Liam
Downey.)

Another Kind of Stewardship—The Great Flood of 2004

On the Tuesday before Thanksgiving 2004, five minutes before closing, a visitor came out of the lower exhibit hall and said to Museum Director Teri Paul, who was at the front desk, "Excuse me, is there supposed to be water flowing down the stairs?" A moment later the alarm went off. Paul ran to the lower hall and saw that water was indeed running like a waterfall down the stairwell and raining through the ceiling. Marcia Hadenfeldt, curation assistant, moved to call 911 and all staff members who had left for the day. By the time the water main was turned off there were four inches of standing water in the lower exhibit hall and lobby. Immediately the task of moving objects and exhibits out of harm's way began. The publisher of the local paper, the *Blue Mountain Panorama*, heard the 911 call on his scanner and was the first neighbor on the scene; he assisted in moving paintings out of the auditorium. The Blanding Volunteer Fire Department and more neighbors began showing up with wet-dry vacs and mops, and staff and their families joined in the rescue effort.

Ultimately it was discovered that a rupture in a high-pressure, three-inch-diameter pipe in the fire suppression system in the second-floor ceiling caused the flood. The museum was closed for five months while ceilings, carpets, plaster, several murals, lighting, and exhibit cases were replaced. Fortunately, none of the artifacts were damaged because everything had been exhibited inside secure glass cases. Text panels on a temporary exhibit were destroyed, but were easily replaced. Ironically, the flood actually benefited the museum; using the insurance payment the museum was enhanced and updated by the remodel. Without the help and stewardship of the good people of Blanding and Bluff this disaster might have been much worse.

Figure 6.23. The repository. Facilities Manager/Historic Replicator Andrew Goodwin demonstrates the compact storage shelf system that was added after the remodel 2005. (Photo by T. Paul.)

Glossary

AD: Anno Domini (in the year of the Lord). The convention of counting years forward from the traditionally accepted year one on the Gregorian calendar.

Anasazi: The Anglicized form of the Navajo word for the people who built the ancient villages. It has been loosely translated as "ancient ancestor" or "ancient enemy." Archaeologists adopted this word as a term to refer to the people who lived in the ancient pueblos.

Ancestral Puebloan: Another term for the Anasazi. This term is generally more acceptable to contemporary Native Puebloan people. It refers to their ancestors in more descriptive terms rather than as "ancient enemy."

Archaeological record: The material remains produced by past human activity. These materials are recovered, studied, and interpreted by archaeologists to reconstruct and understand the past. The archaeological record consists of structures, hearths, burials, pottery, lithics, and any number of items produced or used by humans in the past.

Archaic: A time period from 7000 BC to AD 100 characterized by small nomadic groups of people moving across the landscape to follow seasonal availability of plant and food resources. In the late Archaic, around 400 BC, people in southeastern Utah began to experiment with farming, particularly growing corn.

Artifact: Any object that has been altered by human use or activity. These objects are portable, and may be classified in various categories such as pottery, lithics, and bone.

Assemblage: The group of artifacts found at a particular site, as in: The artifact assemblage found at Edge of the Cedars Ruin included pottery from the Pueblo I and Pueblo II eras.

Athapaskan: A language group that includes Navajo and Apache.

Atlatl: An ancient dart-throwing tool made of a flat stick, with a hook and finger loops at one end and a prop at the other end. It was designed to increase the distance and accuracy of a thrown dart for hunting or warfare. The atlatl was used in North America for nearly ten thousand years and was replaced by the bow and arrow.

BC: Before Christ. The convention of counting years backward from the traditionally accepted year one on the Gregorian calendar. In archaeology, BC is used for dates that are of Archaic age or younger.

BP: Before present. BP years are a timescale used by scientific disciplines to specify when events in the past occurred. Because the "present" time changes, it is standard to use AD 1950 as the arbitrary origin of the BP age scale. The convention is that BP is used for dates that are of Paleoindian age or older.

Cache: A grouping or collection of artifacts stored together.

Ceramic seriation: A method of organizing ceramic pottery types by design attributes, along with dating (e.g., tree-ring dating), to develop a chronology.

Cliff dweller: The term used by explorers in the nineteenth century to describe the ancient people who built masonry structures in alcoves in cliffs in the Southwest.

Clovis: The earliest known Paleoindian complex, dated 11,300 to 10,000 BP, known for well-crafted fluted, lanceolate spear points used to hunt ice age megafauna. It is named for the first Paleoindian site excavated at Clovis, New Mexico.

Complex: A collection of artifact types, forms, or styles, and site types that together are characteristic of a particular culture.

Context: See provenience.

Cross-dating: A method of determining the age of an archaeological site by comparing its artifacts with those of another site of known age.

Curation: The act of properly collecting, identifying, keeping accurate records on, storing, caring for, studying, and exhibiting artifacts.

Debitage: Debris resulting from the creation of stone tools.

Dendrochronology: Tree-ring dating.

ECPR: Artifacts in photos are numbered with ECPR numbers. ECPR stands for Edge of the Cedars Pueblo Ruin. Some ECPR numbers have hyphens, such as ECPR-84-2. Hyphenated numbers are accession numbers—the number assigned to an item when it came in to the museum. In this case ECPR-84-2 means Edge of the Cedars Pueblo Ruin, the second object received in 1984. Some ECPR numbers are catalog numbers and have no hyphen. ECPR 7951 refers to the 7,951st object entered into the museum catalog. Some objects shown in this volume have an accession number because they have not yet been issued a catalog number.

Folsom: An early Paleoindian gathering and hunting culture (approximately 10,000 to 9000 BP). The Folsom point, a fluted spear point, was first found at a site near Folsom, New Mexico. It was important because it was one of the first known associations of man-made artifacts with the bones of extinct Pleistocene (ice age) megafauna that were known to have died out about ten thousand years ago.

Great house: A specific type of prehistoric architecture, typified by the great houses of Chaco Canyon, New Mexico, built during AD 1000–1150. A great house is a multistoried building with exceptionally large rooms, above-ground enclosed kivas (or round rooms), and usually associated with a great kiva.

Great kiva: An exceptionally large (twelve meters or more in diameter), circular, below-ground structure thought to have been used by the Ancestral Puebloans for ceremonies. An example of a restored great kiva can be seen at Aztec Ruins National Monument in New Mexico.

Ground stone tools: Tools made from stone for cutting, grinding, and scraping.

In situ: An artifact found in place is said to be found "in situ."

Jacal: A Spanish word used to describe a structure built of poles and mud. Also sometimes called wattle-and-daub.

Kiva: A semisubterranean circular room in a room block or pueblo used for small clan or family-sized social and ceremonial gatherings.

Lanceolate: A projectile point that is leaf-shaped, tapered at one or both ends.

Lifeways: Everything that makes up the way of life of a particular cultural group.

Lithics: Stone tools or flakes of stone created in the production of stone tools.

Mano: Handheld rounded or loaf-shaped stone used to grind corn or other substances against a larger metate stone.

Metate: Lower milling stone used for grinding corn, grain, seeds, pigments, etc.

Midden: A trash deposit.

Numic: A language group that includes Ute.

Open-twined sandal: A sandal usually made of yucca cord and tree bark, with the components held together with a form of open twining, as opposed to plaiting or weaving. This type of sandal was made during the Southwest Archaic period.

Paleoecology: The study of prehistoric environments. Microscopic plants and pollen found in archaeological sites tell scientists what kinds of plants were growing in the area.

Paleoindian: Archaeological evidence shows that the earliest known human inhabitants of southeastern Utah were groups affiliated with the Paleoindian cultural tradition, dated to approximately 11,000 to 7000 BP. These people produced distinctive, finely made, lanceolate spear points, which were used to hunt now-extinct big game animals such as mammoths and giant bison.

Petroglyphs: Rock art that has been pecked into the rock with a stone tool. The Hopi word is **wu'yas**.

Pictographs: Rock art that has been painted on rock with mineral or organic pigments. The Hopi word is **naatoyla**.

Plano: Plano people made lanceolate, unfluted spear points. By this time period, 9000 to 7000 BP, the ice age megafauna had died out, and hunting shifted to modern large game animals.

Prehistoric: Period before written history.

Projectile point: A category of tools in the broad class of chipped stone artifacts, including arrow points, dart points, knives, and spear points used for defense and hunting. Projectile points, such as arrow points (commonly referred to as arrowheads) are diagnostic artifacts and provide clues to dating a site.

Protohistoric: Period of time between prehistory and history, when a culture has not yet developed writing, but it is known and written about by other cultures. The idea is complicated by the existence of oral traditions as history.

Provenience: Sometimes the term "provenance" is used rather than "provenience." Both refer to the specific location in time and space of an artifact, feature, or structure in terms of map grids, stratified levels, or depth from the surface. Scientists take careful note of the provenience of an object to understand the context of the object within the site and its association with other objects nearby. Once objects have been noted as to their provenience they may be removed from the context of the site, but still be understood within the context through notes, maps, and photographs.

Radiocarbon dating: A method of relative dating where the residual radioactive carbon in a once-living material (bone, wood, seeds, etc.) is measured.

Room blocks: A series of jacal or masonry rooms built adjacent to one another in a row, or in other arrangements, such as U-shaped or L-shaped. Room blocks are also sometimes called pueblos.

Sherd: A piece of broken pottery.

Stratigraphy: The deposit of layers (or strata) of cultural and/or geological materials where the deepest layers of a deposit are the oldest.

Thermoluminescence: A method of dating the age of an artifact such as pottery. The amount of light energy released when an object is heated provides a measure of the time elapsed since the material was last heated to a critical temperature (such as the pot's original firing).

Bibliography

Agenbroad, Larry D., William E. Davis, and E. Steve Cassells
1981 *1980 Excavations on White Mesa, San Juan County, Utah*. Plano Archaeological Consultants, Longmont, Colorado.

Atkins, Victoria (editor)
1993 *Anasazi Basketmaker: Papers from the 1990 Wetherill-Grand Gulch Symposium*. Cultural Resource Series 24. Bureau of Land Management, Salt Lake City.

Beals, Ralph L., George W. Brainerd, and Watson Smith
1945 *Archaeological Studies in Northeast Arizona*, pp. 1–171. University of California Publications in American Archaeology and Ethnology 44, no. 1. University of California Press, Berkeley.

Brew, John Otis
1946 *Archaeology of Alkali Ridge, Southeastern Utah*. Papers of the Peabody Museum of American Archaeology and Ethnology Vol. 21. Harvard University, Cambridge.

Bureau of Land Management Cultural Resource Records. Edge of the Cedars State Park Museum, Blanding, Utah.

Cameron, Catherine M.
1997 The Bluff Great House and the Chacoan Regional System. Paper presented at the 62nd Annual Meeting of the Society for American Archaeology, Nashville.

Cameron, Catherine M. (editor)
2009 *Chaco and After in the Northern San Juan: Excavations at the Bluff Great House*. University of Arizona Press, Tucson.

Casjens, Laurel
1980 *Archaeological Excavations on White Mesa, San Juan County, Utah, 1979*. Unpublished report, Antiquities Section, Division of State History, Salt Lake City.

Dalley, Gardiner F. (editor)
1973 *Highway U-95 Archaeology: Comb Wash to Grand Flat, A Special Report*. Department of Anthropology, University of Utah, Salt Lake City.

Davis, William E.
1989 The Lime Ridge Clovis Site. *Utah Archaeology* 2(1):66–76.

Davis, William E. (editor)
1985 *Anasazi Subsistence and Settlement on White Mesa, San Juan County, UT*. University Press of America, Lanham, Maryland.

DeBloois, Evan
1975 *The Elk Ridge Archaeological Project, A Test of Random Sampling in Archaeological Surveying*. Archaeological Report No. 2. USDA Forest Service, Intermountain Region, Ogden, Utah.

deHaan, Petrus
1972 An Archaeological Survey of Lower Montezuma Canyon, Southeastern Utah. Master's thesis, Brigham Young University, Provo, Utah.

Dohm, Karen
1981 Similarities in Spatial Characteristics of Several Basketmaker II Sites on Cedar Mesa, Utah. Master's thesis, Washington State University, Pullman.

Firor, James, Rand A. Greubel, and Alan D. Reed
1995 *Archaeological Data Recovery at Four Anasazi Sites on White Mesa Along U.S. Highway 191, San Juan County, Utah.* Alpine Archaeological Consultants, Montrose, Colorado.

Forsyth, Donald W.
1977 *Anasazi Ceramics of Montezuma Canyon, Southeastern Utah.* Publications in Archaeology, New Series 2. Department of Anthropology and Archaeology, Brigham Young University, Provo, Utah.

Geib, Phil R., and Dale Davidson
1994 Anasazi Origins: A Perspective from Preliminary Work at Old Man Cave. *Kiva* 60:191–202.

Green, Dee F.
1978 Summary of the First Season, Excavations at Edge of the Cedars Pueblo. Unpublished manuscript, Edge of the Cedars State Park Museum, Blanding, Utah.

Guernsey, Samuel J., and Alfred V. Kidder
1921 *Basketmaker Caves of Northeastern Arizona: Report on the Explorations, 1916–1917.* Papers of the Peabody Museum of American Archaeology and Ethnology Vol. 8, No. 2. Harvard University, Cambridge.

Hall, Ansel F.
1934 *General Report: Rainbow Bridge–Monument Valley Expedition of 1933.* University of California Press, Berkeley.

Hargrave, Lyndon L.
1935 *Report on Archaeological Reconnaissance in the Rainbow Plateau Area of Northern Arizona and Southern Utah: Based Upon Fieldwork by the Rainbow Bridge–Monument Valley Expedition of 1933.* University of California Press, Berkeley.

Harmon, Craig B.
1979 *Cave Canyon Village: The Early Pueblo Components.* Publications in Archaeology, New Series 5. Department of Anthropology and Archaeology, Brigham Young University, Provo, Utah.

Holmes, W. H.
1876 A notice of the ancient remains of southwestern Colorado examined during the summer of 1875. In *Bulletin of the Geological and Geographic Survey of the Territories*, Vol. II, No. 1. Washington, D.C..

Hurst, Winston B.

2000 Chaco Outlier or Backwoods Pretender? A Provincial Great House at Edge of the Cedars Ruin, Utah. In *Great House Communities Across the Chacoan Landscape,* edited by John Kantner and Nancy M. Mahoney, pp. 63–78. Anthropological Papers of the University of Arizona 64. University of Arizona Press, Tucson.

2004a The Professor's Legacy. Paper presented at the Utah Statewide Archaeological Society Conference, Blanding, Utah.

2004b *Archaeological Data Recovery at Casa Coyote (42Sa3775), A Basketmaker III Pit House Hamlet on White Mesa, San Juan County, Utah.* Report prepared for Utah Department of Transportation and the Federal Highway Administration. Abajo Archaeology, Bluff, Utah.

Hurst, Winston B., Catherine M. Cameron, Marc Levine, Christine G. Ward, and Devin A. White

2004 Comb Wash: A Pueblo III Great House Community. Paper presented at the 2004 Pecos Conference, Bluff, Utah.

Hurst, Winston B., and Joel C. Janetski

1985 *The Nancy Patterson Village Archaeological Research Project, Field Year 1984—Preliminary Report No. 2.* Technical Series No. 85-132. Brigham Young University Museum of Peoples and Cultures, Provo, Utah.

Hurst, Winston B., and Joe Pachak

2006 *Spirit Windows: Native American Rock Art of Southeastern Utah.* Rev. ed. Originally published 1992. Blanding, Utah: Edge of the Cedars State Park.

The Illustrated American Sends an Expedition to Explore the Cliff Dwellings of Colorado.

1892 *The Illustrated American.* 2 April:305–308.

Jackson, W. H.

1876 A Notice of the Ancient Ruins in Arizona and Utah Lying About the Rio San Juan. In *Bulletin of the Geological and Geographic Survey of the Territories*, Vol. II, No. 1. Washington, D.C.

Janetski, Joel C., and Winston Hurst

1984 *The Nancy Patterson Village Archaeological Research Project, Field Year 1983—Preliminary Report.* Technical Series No. 85-32. Department of Anthropology, Brigham Young University, Provo, Utah.

Jennings, Jesse D.

1966 *Glen Canyon: A Summary.* University of Utah Anthropological Papers 81. University of Utah Press, Salt Lake City.

Kidder, Alfred V.

1910 Explorations in Southeastern Utah in 1906. *American Journal of Archaeology*, Second Series 14 (3), Journal of the Archaeological Institute of America.

1924 *An Introduction to the Study of Southwestern Archaeology with a Preliminary Account of the Excavations at Pecos.* Published for the Department of Archaeology, Phillips Academy, Andover, Massachusetts. Yale University Press, New Haven.

Kidder, Alfred V., and Samuel J. Guernsey
1919 Archaeological Explorations in Northeastern Arizona. *Bureau of American Ethnology Bulletin* 65.

Lindsay, A. J. Jr., J. R. Ambler, M. A. Stein, and P. M. Hobler
1968 *Survey and Excavations North and East of Navajo Mountain, Utah 1959–1962.* Museum of Northern Arizona Bulletin 45, Glen Canyon Series 8. Northern Arizona Society of Science and Art, Flagstaff.

Lindsay, LaMar, and James Dykman
1978 *Excavation of Westwater Ruin (42Sa14), San Juan County, Utah. First Field Season.* Antiquities Section, Division of State History, Salt Lake City.

Lipe, William D., and R. G. Matson
1971 Human Settlement and Resources in the Cedar Mesa Area, S.E. Utah. In *The Distribution of Prehistoric Population Aggregates,* edited by George J. Gumerman. Prescott College Anthropological Reports 1:126–151. Prescott College Press, Prescott, Arizona.

1975 Archaeology and Alluvium in the Grand Gulch–Cedar Mesa Area, Southeastern Utah. In *Four Corners Geological Society Guidebook, 8th Field Conference, Canyonlands,* pp. 67–71. Farmington, New Mexico.

Lyman, Albert R.
1966 *The Edge of the Cedars: The Story of Albert R. Lyman and the San Juan Mission.* Carlton Press, New York.

1967 From Wagons to Rockets. Unpublished manuscript, Edge of the Cedars State Park Museum Library. Blanding, Utah.

Matson, R. G.
1991 *The Origins of Southwestern Agriculture.* University of Arizona Press, Tucson.

Matson, R. G., and W. D. Lipe
1978 Settlement Patterns on Cedar Mesa: Boom and Bust on the Northern Periphery. In *Investigations of the Southwestern Anthropological Research Group. The Proceedings of the 1976 Conference,* edited by Robert C. Euler and George J. Gumerman, pp. 1–12.

Matson, R. G., William D. Lipe, and William R. Haase IV
1988 Adaptational Continuities and Occupational Discontinuities: The Cedar Mesa Anasazi. *Journal of Field Archaeology* 15(3):245–264.

Meloy, Ellen
1994 *Raven's Exile: A Season on the Green River.* Henry Holt, New York.

Metheny, Ray T.
1962 An Archaeological Survey of Upper Montezuma Canyon, San Juan County, Utah. Master's thesis, Brigham Young University, Provo, Utah.

Miller, Blaine

1976 A Study of a Prudden Unit Site (42Sa971-N) in Montezuma Canyon, San Juan County, Utah. Master's thesis, Brigham Young University, Provo, Utah.

Miller, Donald E.

1974 Synthesis of Excavations at Site 42Sa863, Three Kiva Pueblo, Montezuma Canyon, San Juan County, Utah. Master's thesis, Brigham Young University, Provo, Utah.

Morley, Sylvanus G., and Alfred V. Kidder

1917 The Archaeology of McElmo Canyon, Colorado. *El Palacio* 4:41–70.

Neily, Robert B.

1982 *Basketmaker Settlement and Subsistence along the San Juan River, Utah: The U.S. 163 Archaeological Project.* Report prepared for Utah Department of Transportation. Antiquities Section, Division of State History, Salt Lake City.

Nelson, Sarah M.

1976 *Butler Wash Archaeological Project: Survey Report 1976.* Unpublished report prepared for Bureau of Land Management. Department of Anthropology, University of Denver.

1977 *The Fallen Tree Site (42Sa5512).* Department of Anthropology, University of Denver.

1978 *Cholla Knoll: A Preliminary Report.* Department of Anthropology, University of Denver.

Nickens, Paul R.

1977 *Woodrat Knoll: A Multicomponent Site in Butler Wash, Southeastern Utah.* Department of Anthropology, University of Denver.

Nielson, Asa S., Joel Janetski, and James D. Wilde

1985 *Final Recapture Wash Archaeological Project 1981–1983.* Technical Series No. 85-7. Brigham Young University Museum of Peoples and Cultures, Provo, Utah.

Patterson, Gregory R.

1975 A Preliminary Study of an Anasazi Settlement (42Sa971) Prior to A.D. 900 in Montezuma Canyon, San Juan County, Utah. Master's thesis, Brigham Young University, Provo, Utah.

Severance, Owen

1999 Prehistoric Roads in Southeastern Utah. In *La Frontera: Papers in Honor of Patrick H. Beckett,* edited by M. S. Duran and D. T. Kirkpatrick, pp. 185–195. The Archaeological Society of New Mexico, Albuquerque.

2003 Cultural Dynamics in Southeastern Utah: Basketmaker III Through Pueblo III. In *Climbing the Rocks: Papers in Honor of Helen and Jay Crotty,* edited by Regge N. Wiseman, Thomas C. O'Laughlin and Cordelia T. Snow, pp. 189–203. The Archaeological Society of New Mexico, Albuquerque.

2004 Cottonwood Falls (42Sa5222) and Its Place in Southeastern Utah's Prehistoric Landscape. In *Ever Westward: Papers in Honor of Elizabeth Kelley*, edited by Regge N. Wiseman, Thomas C. O'Laughlin, and Cordellia T. Snow, pp. 139–157. The Archaeological Society of New Mexico, Albuquerque.

2005 *A Controlled Surface Collection and Analysis of Ceramics at 42Sa5222 (Cottonwood Falls), Southeastern Utah.* Report prepared for Edge of the Cedars State Park Museum, Blanding, Utah.

Smiley, Francis E., and Michael R. Robins
1997 Early Farmers in the Northern Southwest: Papers on Chronometry, Social Dynamics, and Ecology. In *Animas-La Plata Archaeological Project Research Paper No. 7.* Department of Anthropology, Northern Arizona University, Flagstaff.

Steward, Julian H.
1938 *Basin-Plateau Sociopolitical Groups.* Washington, D.C.: U.S. Government Printing Office.

Thompson, Charmaine, James R. Allison, Shane A. Baker, Joel Janetski, Byron Loosle, and James D. Wilde
1988 *The Nancy Patterson Village Archaeological Research Project, Field Year 1986—Preliminary Report No. 4.* Technical Series No. 87-24. Brigham Young University Museum of Peoples and Cultures, Provo, Utah.

Thompson, Charmaine, Shane A. Baker, James R. Allison, and Kenneth L. Wintch
1986 *The Nancy Patterson Village Archaeological Research Project, Field Year 1985—Preliminary Report No. 3.* Technical Series No. 86-27. Brigham Young University Museum of Peoples and Cultures, Provo, Utah.

Till, Johnathan Dale
2001 Chacoan Roads and Road-Associated Sites in the Lower San Juan Region. Master's thesis, University of Colorado, Boulder.

Westfall, Deborah A.
2000 Edge of the Cedars: Past, Present and Future Millennia. *Blue Mountain Shadows* 22:21–29. San Juan County Historical Society, Blanding, Utah.

Westfall, Deborah A., Roger A. Moore, and Mark Owens
2003 *Archaeological Investigations at Sites 42Sa17725 and 42Sa20971 on the Bluff Bench and Big Bench, San Juan County, Utah.* Report prepared for Utah Department of Transportation and the Federal Highway Administration. Abajo Archaeology, Bluff, UT.

Wilde, James D., and Charmaine Thompson
1988 Changes in Anasazi Perceptions of Household and Village Space at Nancy Patterson Village. *Utah Archaeology* 1(1):29–45.

Wilson, Curtis J.
1973 *Highway U-95 Archaeology: Comb Wash to Grand Flat, Volume II: A Special Report.* Department of Anthropology, University of Utah, Salt Lake City.

About the Authors

Winston B. Hurst is an independent consulting archaeologist and a widely known and highly respected ceramics analyst who has substantial experience in the archaeology of southeast Utah. He attended Brigham Young University and gained a master's degree in anthropology at Eastern New Mexico University, Portales. During his 1986–89 curatorship at Edge of the Cedars State Park Museum, he developed the analysis format for the pottery from Edge of the Cedars Pueblo. The results contributed to a reconstruction of the role of Edge of the Cedars Pueblo in the regional Chacoan system during AD 1025–1125.

Teri L. Paul has been the museum director and park manager at Edge of the Cedars State Park Museum since 2003. Prior to that she was the curator of education/exhibits from 2001 to 2003. Ms. Paul is also an archaeologist with extensive previous experience in the Great Basin, coastal California, and the Southwest. She holds a master's degree in anthropology and archaeology from the University of Oregon and a bachelor of science in anthropology and museum studies from the University of California, Berkeley.

Rebecca G. Stoneman joined the museum staff in 2005 as the curator of education. Prior to this she worked for the U.S. Forest Service in New Mexico as an archaeologist and as an interpreter. As a district archaeologist, Ms. Stoneman worked with tribal representatives to coordinate forest projects and record cultural history. In her role as interpreter, she organized numerous events and activities for the public that taught about Native American culture and prehistory. Ms. Stoneman holds a master's degree in cultural anthropology from Kent State University.

Deborah A. Westfall has worked at Edge of the Cedars State Park Museum as curator of collections and staff archaeologist since 1999. Prior to her employment at the museum, Ms. Westfall was a professional consulting archaeologist. During this time, she gained extensive experience in directing archaeological excavations in Arizona and Utah, and preparing comprehensive final reports. She holds a master's degree in anthropology from the University of Arizona, Tucson.

From the *Spirit Windows* mural.